SICILY

NATURE, CULTURE AND TRADITIONS

WHITE STAR PUBLISHERS

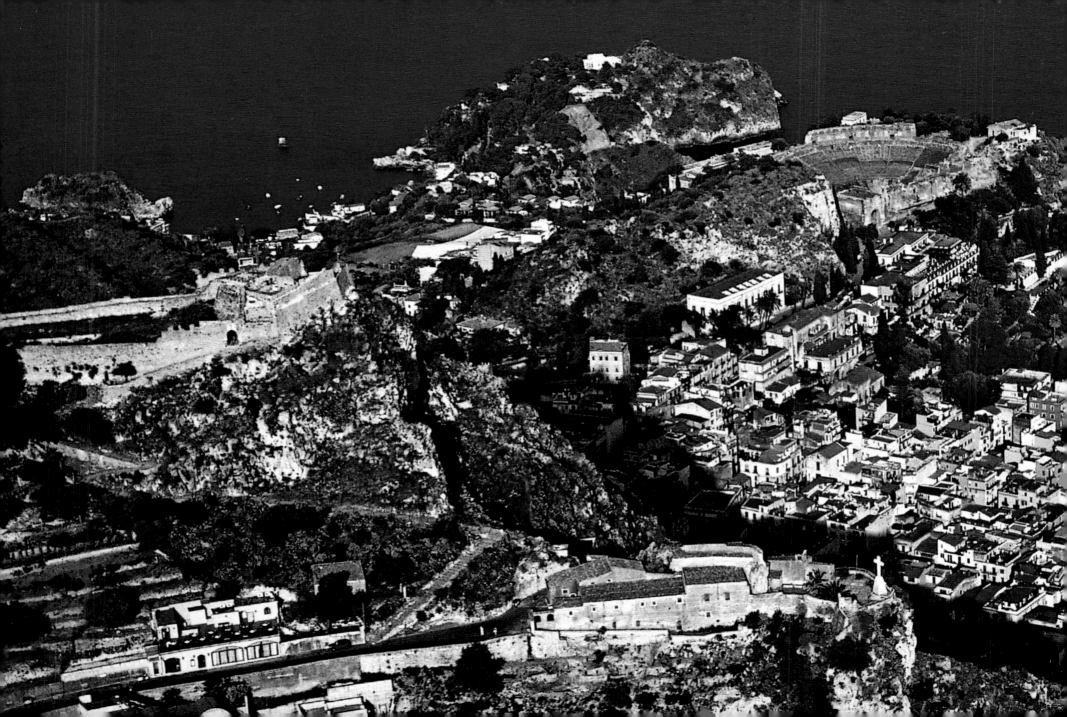

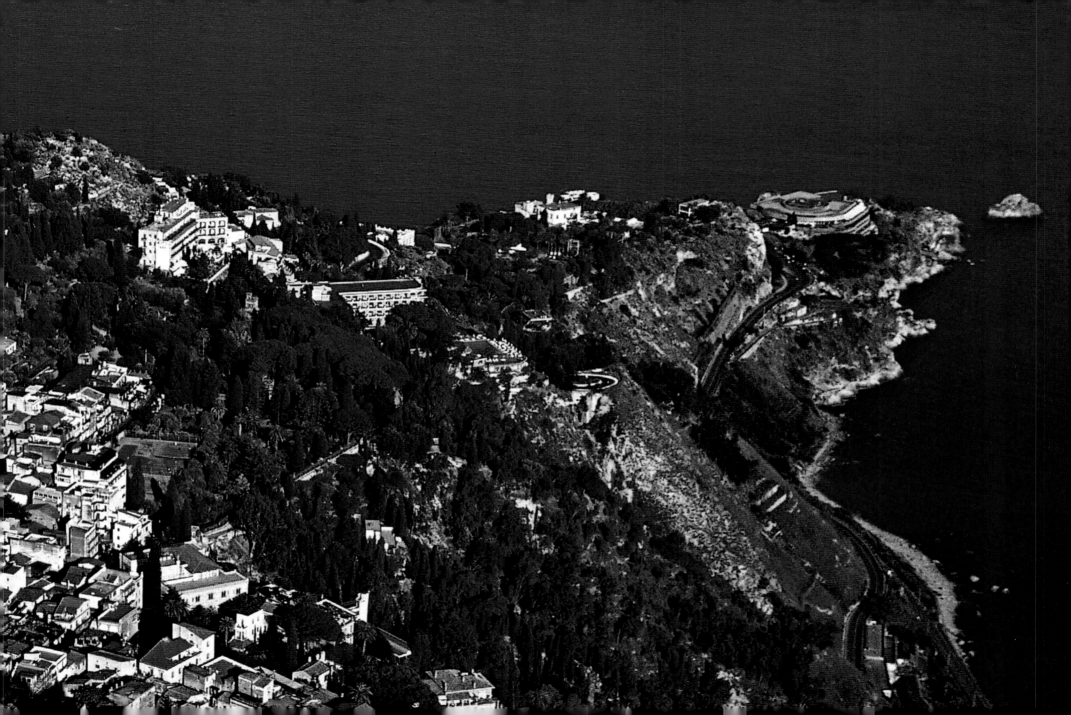

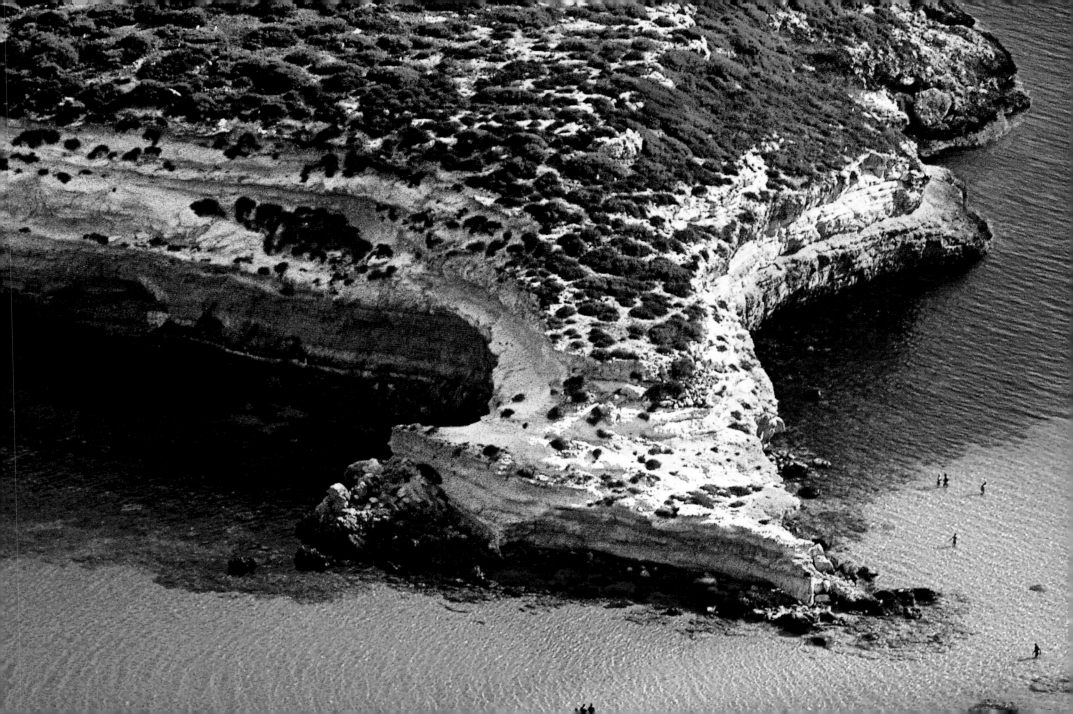

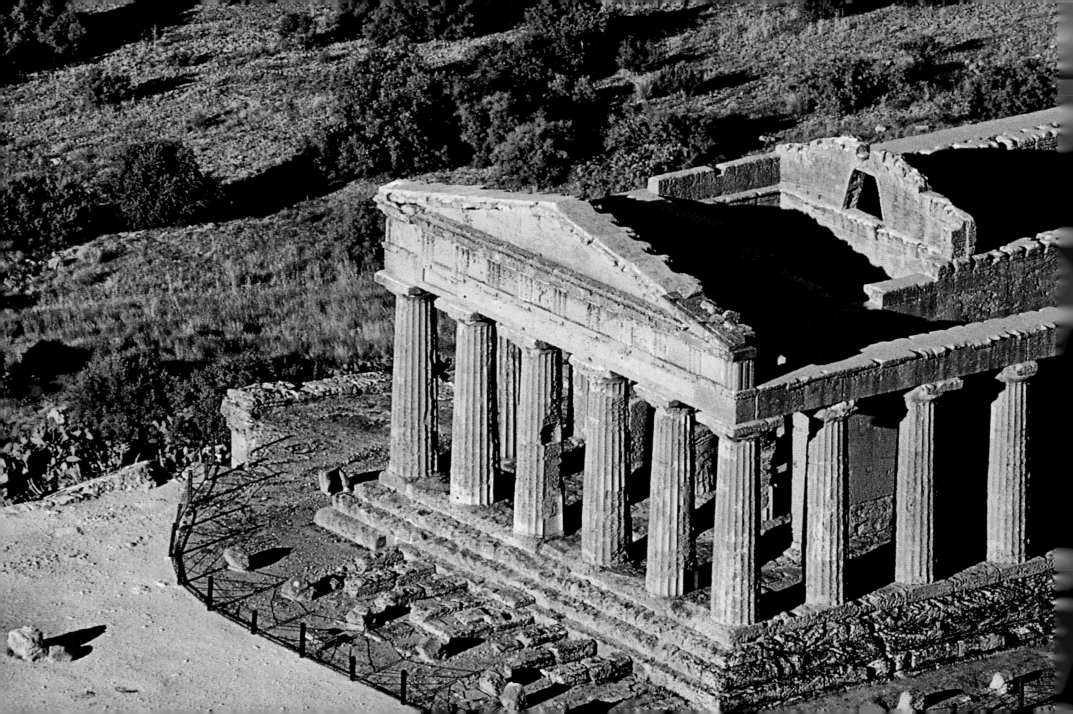

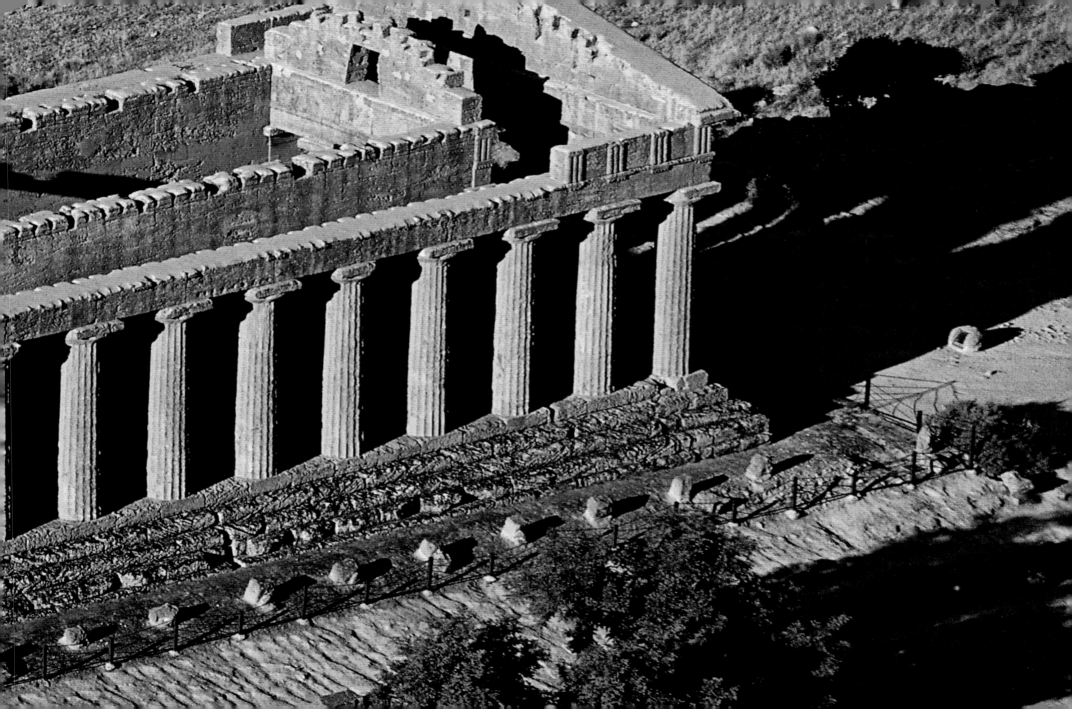

SICILY
NATURE, CULTURE AND TRADITIONS

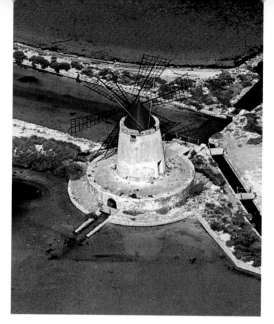

PHOTOGRAPHS
Antonio Attini

TEXT
Maria Cristina Castellucci

Contents

2-3 Taormina, close to Mount Etna on the coast between Messina and Catania, is considered the capital of Sicilian tourism. Its renown can be attributed chiefly to a its location, which has always enchanted its visitors.

4-5 The extraordinary clearness of the seas at Lampedusa (Agrigento); a turquoise hue that brings to mind tropical waters.

6-7 In the Valley of the Temples outside Agrigento there are sacred Hellenistic structures every bit as great as those found in Greece. This is an image of the 5th-century BC Temple of Concordia.

8 Windmills are an unexpected and truly picturesque presence in the vast expanse of salinas that lie between Trapani and Marsala on the western tip of Sicily.

9 Etna, Europe's tallest volcano, is still active. Even so, it is possible to travel almost to the peak, a magical excursion that makes the volcano a popular tourist destination on the island.

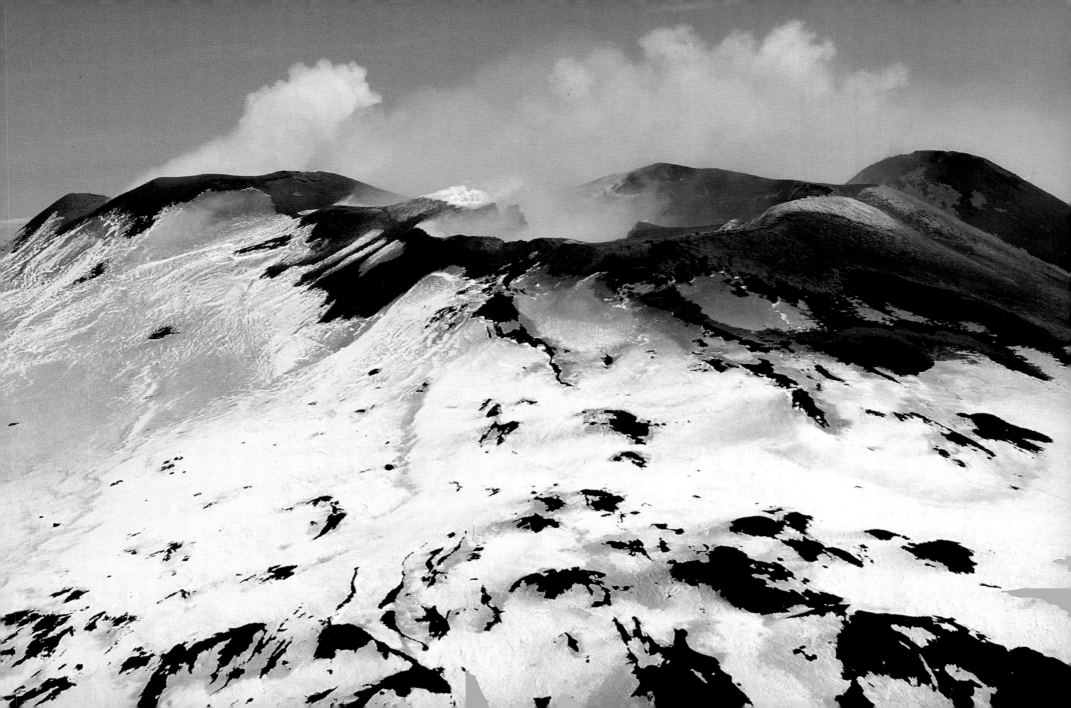

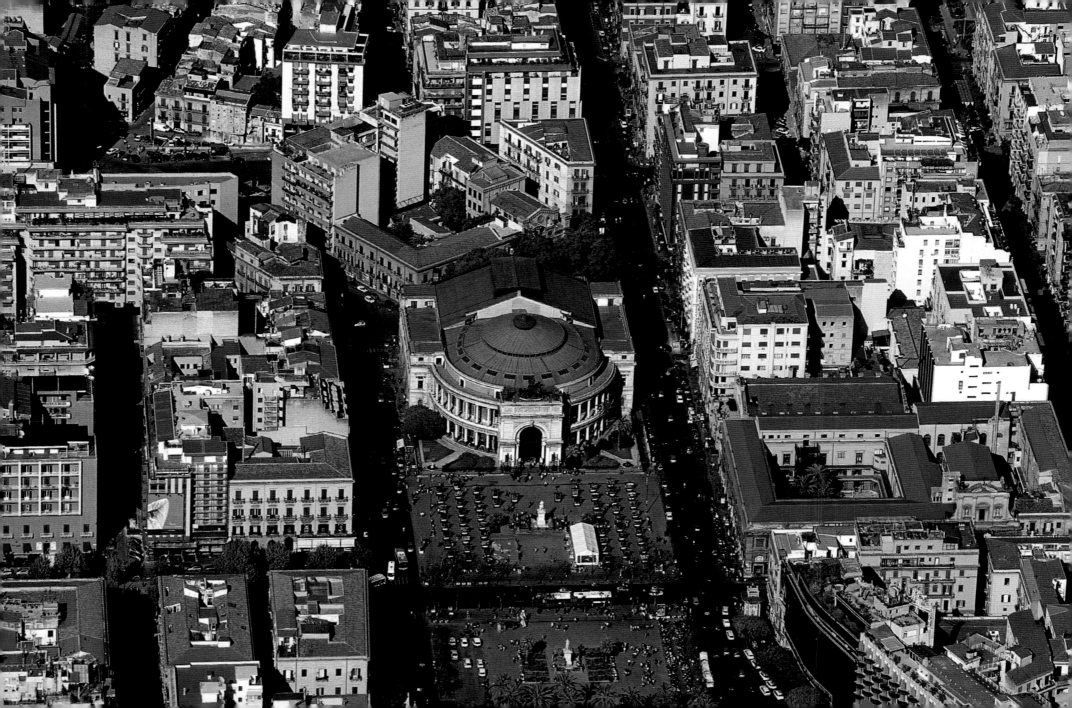

The scholarly compilers of an eighteenth-century encyclopedia, having to deal with the entry "Sicily," established that the distant island was of no real interest except for the wretched activities of the Inquisition. They stated that Palermo had been destroyed (conversely, the city was actually at the peak of its Baroque splendor) and undoubtedly, that was all there was to be said on the matter. At that time, for the French, and also for most European countries, Sicily might as well have been off the coast of Australia. It had been and continued to be a truly remote, unknown place, across a sea rife with danger.

In any case, it was not long before Sicily was "discovered," in that same century, thanks to two travelers: the German Joseph H. Riedesel and the Englishman Patrick Brydone, who included the island in their Grand Tour (the traditional educational journey undertaken at that time) from 1767 to 1770. Their travel diaries, including enthusiastic descriptions of the historic ruins, splendid, varied nature, and local customs and cults aroused the interest of intellectuals, artists and members of aristocratic and upper-class families of the time, persuading them to set off for Sicily. One such traveler was Wolfgang Goethe, who landed in Palermo in 1787, and became one of the chief devotees of the beauties of Sicily. He took home poetic descriptions of the "land where lemon trees flower," overflowing with enthusiasm and even going so far as to write that "without seeing Sicily it is impossible to get an idea of Italy. Sicily is the key to everything."

It is easy to understand why numbers of visitors grew after that. Some sought a wild Arcadia; others ideals of classic beauty; yet others a generic "picturesque." There was no doubt that everyone would be satisfied, because the great island had wild locations, astonishing ruins, refined monuments, and rustic folklore that met all demands.

Nor could things have been otherwise, since sooner or later every Mediterranean (and otherwise) population has set foot on the coasts of Sicily, whether in peace or in war, leaving behind some trace of its culture.

The island's position of strategic importance, in the center of the Mediterranean, the extent of its resources, ensuring farming and stock-rearing, means it has been inhabited since prehistory by people who were in part indigenous and in part from other Mediterranean shores (Sicanians, Siculians, and Elymians, who are all still cloaked in mystery despite much

10 Palermo's neoclassical Politeama Garibaldi theatre was built in 1867-1874. In front of the theatre, two squares form a single, large open space: Piazza Ruggero Settimo, nearest to the theatre, and Piazza Castelnuovo, in the shade of palms and graced by a bandstand (1875).

archeological research). From the eighth century BC the island attracted Phoenician settlers to the west and Greek colonists to the east, who struggled to cohabit. We have them to thank for the foundations of the great, rich cities like Palermo and Siracusa. In the third century BC, the Romans arrived, disposing of local resistance with relative ease, extending their domains to annex the island that was to be their "granary" for many years ahead.

As the Empire declined, following a period of direct dependence on Byzantium, Sicily was conquered by Arabs who came from North Africa in the ninth century BC. The new conquerors colonized extensively and brought new crops (including citrus fruits, sugar cane, cotton, as well as jasmine and other decorative plants), with innovative irrigation techniques – some of which are still in use today – and transformed existing or established new settlements. The traces of that domination are still evident in the urban layout of many old centers, in the language, and in the genes of Sicilians. As far as the latter is concerned, this was not unique to the Arabs, because it is still possible to observe the clear influence of other, quite different figures: the Normans, who in the eleventh century set forth to reconquer Sicily in the name of Christianity and whose Nordic blood is handed down in the light eyes and blond hair of many of the islanders.

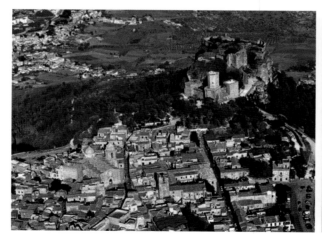 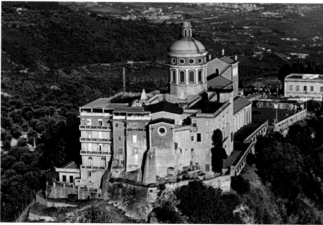

12 left Perched on its solitary peak, Erice (Trapani) is dominated by its massive castle, which was one of the area's most important fortifications for many centuries. On a clear day, we can see as far as Pantelleria.

Norman reign, instituted in 1130 with the coronation of Roger II, brought a heyday of Sicilian history, for the enlightened rule of these sovereigns brought great cultural and economic wealth, thanks, above all, to their farsighted ability to achieve successful cohabitation amongst peoples and religions. In actual fact, the Normans deferred to current inhabitants for many aspects of rule, even absorbing many aspects of lifestyle from the Greeks and, above all, the Saracens.

The Palermo palace acquired the appearance and atmosphere of a sultan's residence, and the monuments of the period still testify to this syncretism in their form, precise symbols of this attitude. Sadly, this was a short reign, and upon the death of the last legitimate heir, the Emperor Frederick II of Swabia (who was also known as *Stupor Mundi*), Sicily tumbled into the chaos of dynastic infighting that cast it first into Charles d'Anjou's French hands, and then into the hands of the Aragonese under the Spanish Crown, and lastly into the dominion of the Bourbons until the onset of the Unification of Italy in 1860.

Today Sicily is often called an "island - continent", or to use a fortunate definition coined by the writer Gesualdo Bufalino, a "plural island." What he actually says is: "there are many Sicilies, we shall never finish counting them. It is green as its carob, white as its salinas, yellow as its sulfur mines, blond as its honey, purple as its lava. There is a Sicily that is *babba*, or so mild as to appear stupid; a *sperta* Sicily, so sly and inclined to the most widespread practices of violence and fraud. There is a lazy Sicily, and a frenetic "

A complex island, therefore, overflowing with contradictions, starting with its not being "enough of an island." Another Sicilian writer, Antonio Borgese, upheld this theory, underscoring that with the Strait of Messina being no more than 2.5 miles [4 km] wide, this was insufficient to ensure Sicilians "authentic" insularity.

In any case, Sicilians are not so much islanders as mountain people: most of the terrain is mountainous or hilly, easily seen in aerial views. The flatlands, with the only exception being the Catania plain, are little more than dots, the coasts are low and accessible, often broken up by steep cliffs. Inland settlements, frequently depopulated by emigration, do survive,

12 center The Madonna Nera sanctuary Tindari (Messina) is the destination of huge pilgrimages of believers, especially on the September feast day of this "black" Virgin. From the sanctuary is a breathtaking view of the coastline beneath and the nearby Aeolian Islands.

12 right The quite barren territory of the island of Lampedusa (Agrigento), the furthest tip of Europe in the southern Mediterranean. The sea makes up for the island's aridity, brimming with underwater life and a rainbow of splendid colors.

however, defending their municipal independence, organized and associated to fend off economic difficulties through initiatives that support agriculture, sheep-rearing, industrial activity, and tourism. The latter being a sector that can rely on a very respectable "base," given that alongside its beauty spots, Sicily boasts the greatest legacy of monuments in Italy, with relics from various eras, from the dawn of prehistory, blended into a quite unique genre of the present.

Sicily is a goldmine for the modern traveler who, depending on personal preferences, can decide on "classic" itineraries, following the route of Greek and Roman culture, or be tempted by a gastronomic curiosity to discover traditional cuisine and fine wines. There is also the opportunity to observe authentic expressions of folklore by attending the Easter rites or the picturesque patron-saint celebrations, or to follow the tracks of Oscar-winning films like the famous *Nuovo Cinema*

Paradiso, and writers like Luigi Pirandello or Tomasi di Lampedusa. Not to mention being able to organize long treks on horseback or by bicycle through the country and over the mountainside, or lazy sailboat holidays.

It is a tough choice, which this book will help to resolve from a unique standpoint, offering the potential visitor the chance of a "bird's-eye view," long before setting off, admiring from the air the loveliest places, the length and breadth of this multiform island: the coast and the islets scattered around it, *green on immobile seas* as Salvatore Quasimodo declared; the divine peak of the tallest volcano, the rocky mountain ranges, and the gentle inland hills; the towns rolling along the coast or gripping the peaks.

It is a flight we all dream of making, sooner or later, gliding high above the world, soaring above the microcosm we call Sicily.

15 Monreale's (Palermo) duomo and the neighboring monastic complex are two of the most prestigious examples of Arab-Norman architecture, a style of building typical of 11th-12th century Sicily.

18-19 The town of Ragusa is built on three points of high ground, separated by ravines, the characteristic Hyblean "cave" or gullies. The town's various districts are connected by bridges and staircases.

20-21 Agriculture is one of the most important sectors of Sicilian economy. There are countless quite diversified crops, and the fields mark out level geometries that are even more fascinating from above, like these to be seen in the countryside near Avola (Siracusa).

22-23 Caltabellotta, in the province of Agrigento, is known for the peace treaty signed there in 1302 that ended the Vesper War and led to Sicily becoming part of the Kingdom of Aragon.

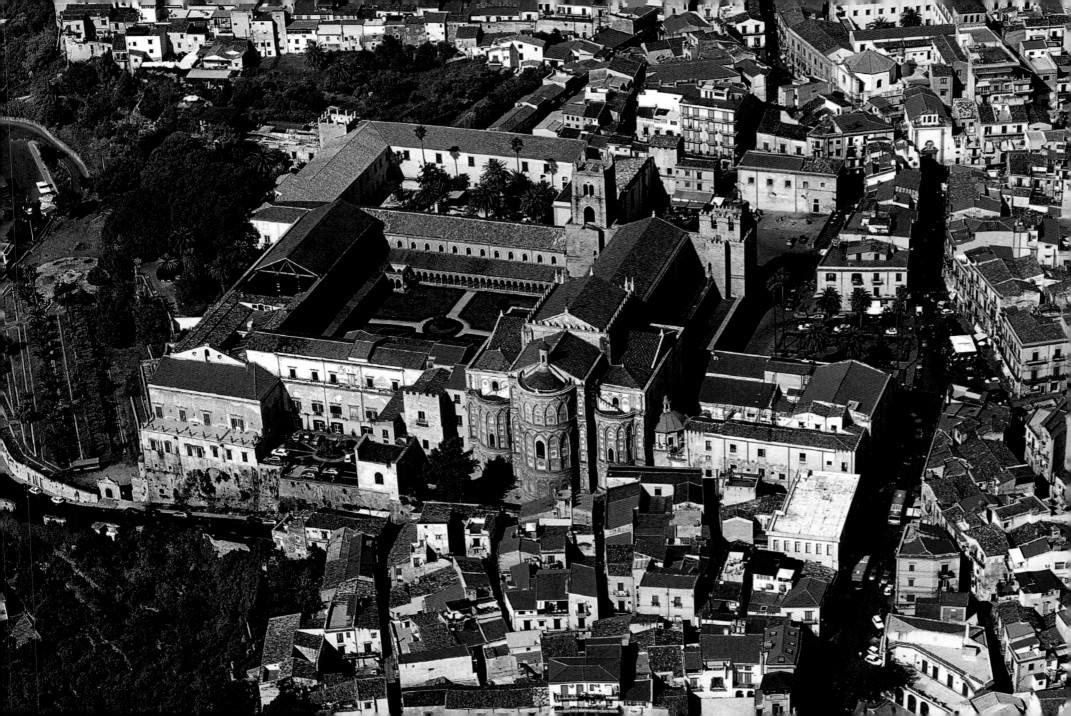

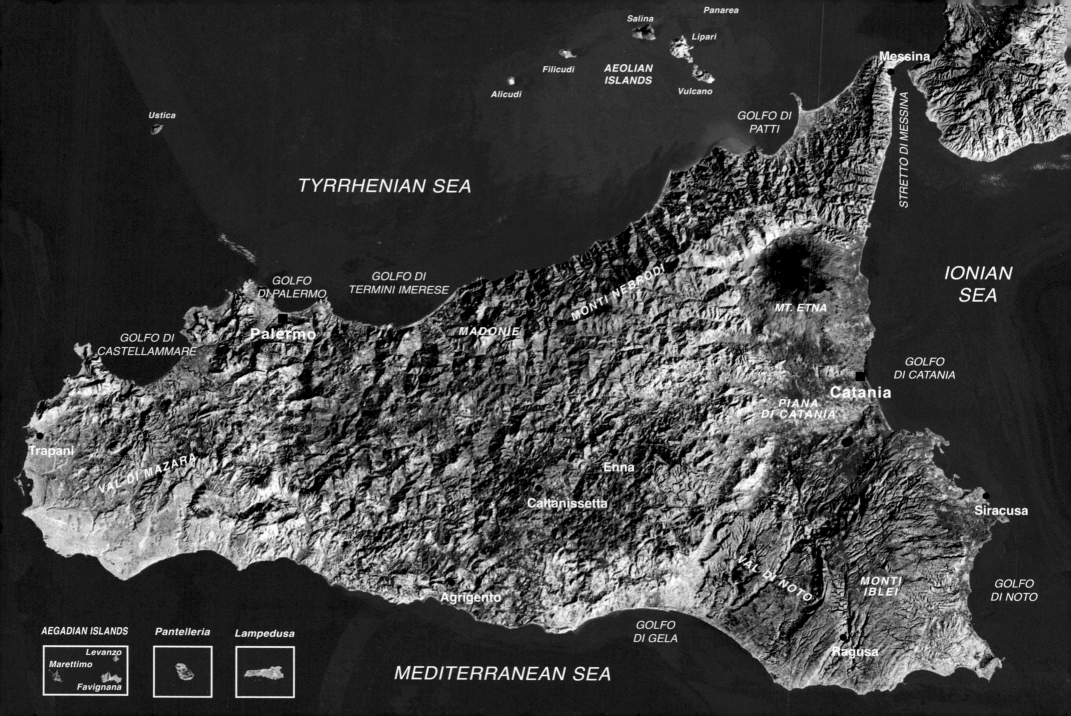

Basic information about Sicily region

- Surface: 25,708 square kilometers
- Inhabitants: 4,972,124 (last census)
- Regional capital: Palermo (682,901 inhabitants)
- Provincial capitals: Agrigento (55,901 inhabitants), Caltanissetta (60,919), Catania (308,438), Enna (28,852), Messina (249,351), Ragusa (69,686), Siracusa (122,896), Trapani (68,417)
- Other important municipalities: Marsala (78,000 inhabitants), Gela (72,500), Vittoria (55,300), Modica (52,900), Bagheria (51,500), Mazara del Vallo (50,700), Acireale (50,100), Paternò (48,400), Misterbianco (44,400), Alcamo (43,900), Barcellona Pozzo di Gotto (41,100), Sciacca (40,600), Caltagirone (37,500), Licata (37,500), Adrano (34,900), Augusta (33,700), Monreale (32,700), Milazzo (32,100), Canicattì (31,700), Avola (31,600), Favara (31,400), Partitico (31,300), Castelvetrano (30,500)
- The terrain is mainly hilly (61.4%); mountains cover 24.4%, plains 14.2%
- Chief rivers: Imera-Salso (144 kilometers), Simeto (113)
- Chief lakes: Lentini (artificial), Poma (artificial), Pozzillo (artificial), dell'Ogliastro (artificial), Pergusa
- Chief islands: Aeolian (115 square kilometers: Lipari 37.3, Salina 26.4, Vulcano 20.9, Stromboli 12.2), Pantelleria (83), Egadi (37.5 square kilometers: Favignana 19.8, Marettimo 12.3), Pelagian (25.5 square kilometers: Lampedusa 20.2), Ustica 8.1
- Tallest peak: Etna (3,323 meters)
- In Sicily 198 municipalities out of the overall total of 390 have less than 5,000 inhabitants
- Population density: 193 per square kilometer
- Natural parks present on Sicilian territory: Parco dei Nebrodi, Parco dell'Etna, Parco delle Madonie, Parco fluviale dell'Alcantara [a river park].

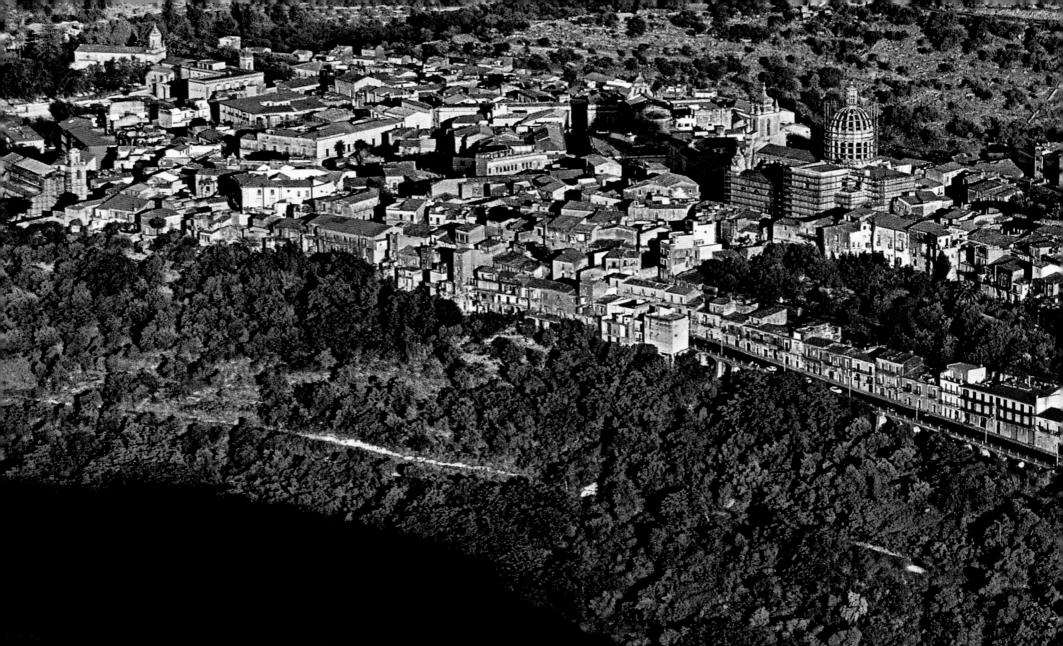

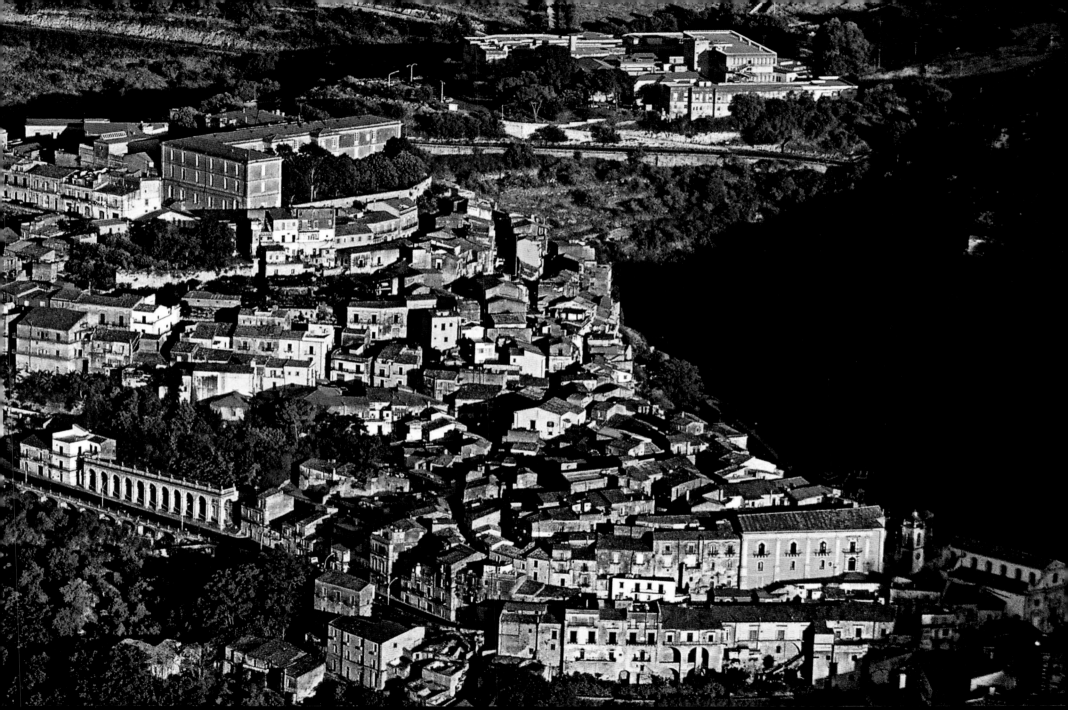

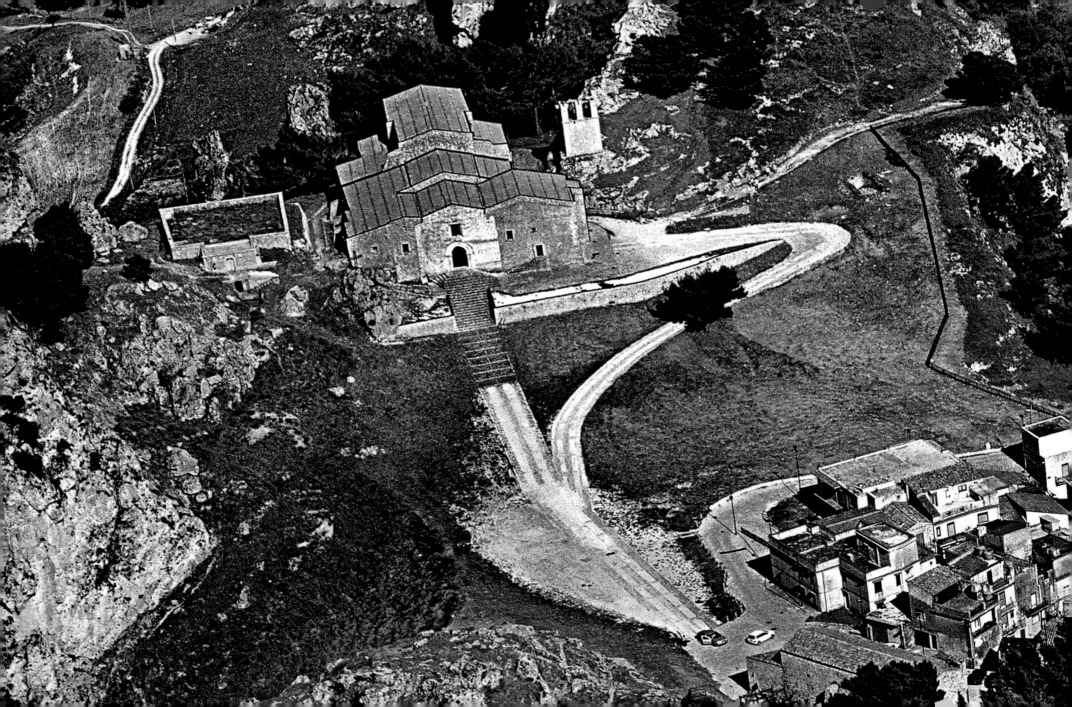

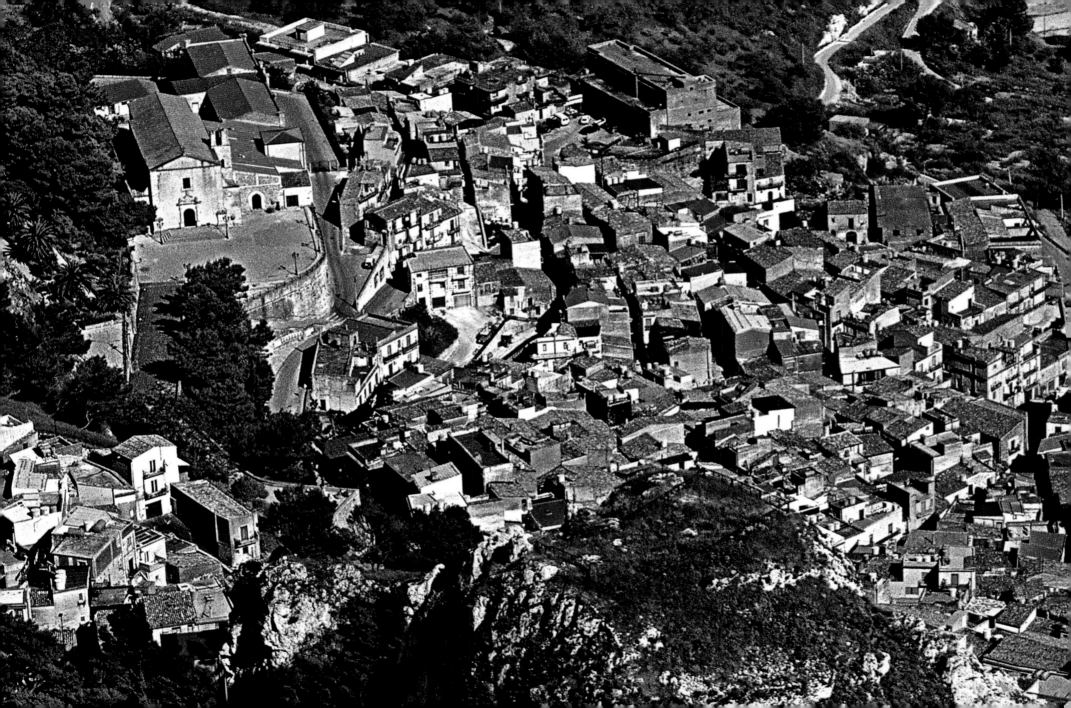

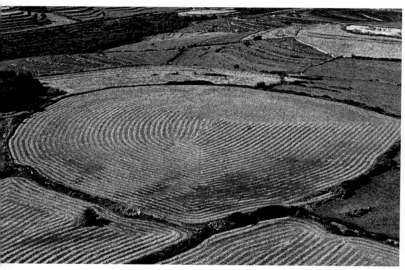
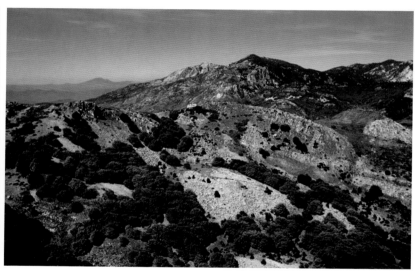

NATURE AND VOLCANOES

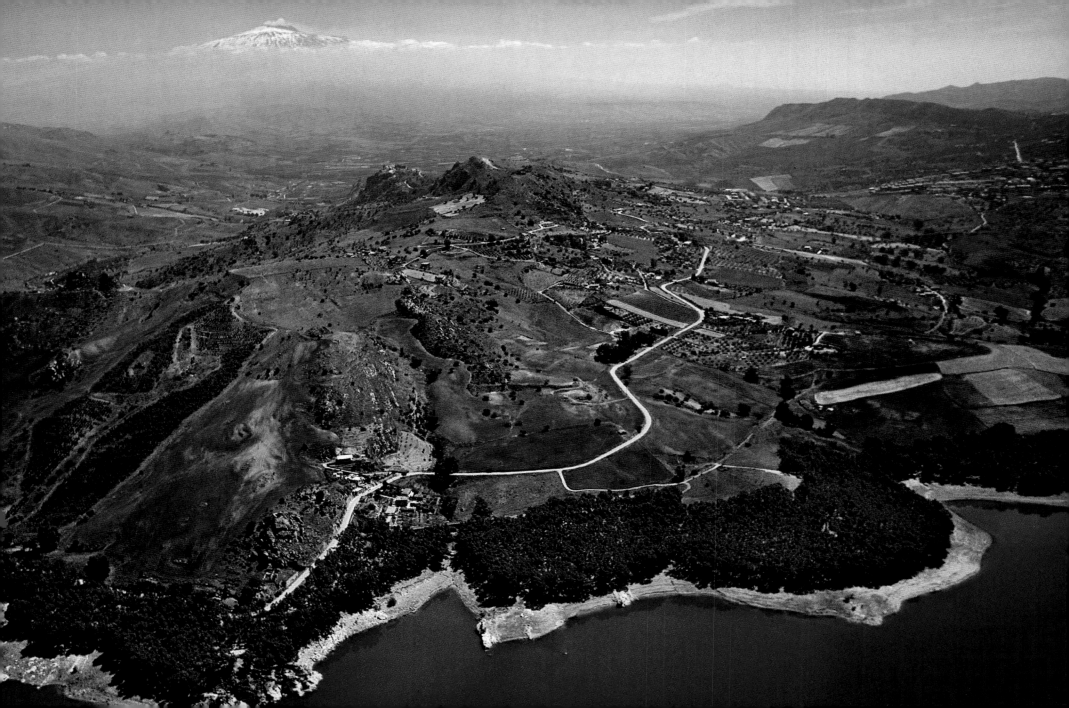

Sicily is an island and, consequently, a sea-locked territory, but it is also a land of sublime peaks, mantled with woods, lakes and rivers, of hills cloaked with vines, fields of corn that dance in the breeze, valleys and plains, exotic plants, and boundless landscapes.

The splendid nature is rich, varied, and often a surprise to visitors. It is a kaleidoscope of the most diverse milieus and, seen from above, reveals the black lavas of Etna and Stromboli; the bright arabesques etched into the limestone by the water; the silver dolomitic peaks of the Madonie range; the white sandy ribbons that edge the southern coast; the golden Hyblean quarries with their honeyed scent; and the palette of myriad hues of red, orange, green and ochre seen in the Nebrodi Mountains.

Over ten percent of Sicily's territory (not counting sea areas) is now protected by parks or by nature reserves that roll seamlessly from one to the next, like in the northeast area of the island, where three parks – the Etna, the Alcantara River, and the Nebrodi – and the smaller reserves create a single expanse of greenery and water of extraordinary beauty and integrity.

Although human negligence has done much to destroy and disfigure its legacy, Sicilian nature still has many intact treasures to offer. First there is Etna, whose volcanic cone is visible even tens of miles away, silhouetted against the crystal firmament, its peak disappearing amidst unruly clouds. The experts say that it rose from the sea, with an immense upheaval of the waves, at the dawn of time, rising and rising until it achieved its nearly 10,000 feet [3,000-plus meters] of height. The same experts illustrate geology and tectonics with skilled ease, using multicolored charts and images. Scientists adore this volcano. They come here to carry out all sorts of studies, with sophisticated instruments and elaborate theories; they come to test machines that will be sent to Mars and they analyze lavas in various phases of solidification. They explore the bowels of

24 left Farmland geometries on the Ragusa Highlands and the varying hues that emerge seem almost to compose a work of art worthy of the greatest painters.

24 right The Madonie mountain chain was formed 200,000 years ago and its center has a large karstic area with sink holes, potholes and grottoes.

25 Although many Sicilian lakes are artificial in origin – here we see Lake Pozzillo, which lies between Agira and Regalbuto (Enna) – they are now an accepted part of the island's natural scenario and have exceptional landscape value.

27 The Madonie mountain range, stretching west and closing the province of Palermo, includes some of the region's highest peaks after the volcanic cone of Etna. This makes both areas extremely popular with hikers and skiers.

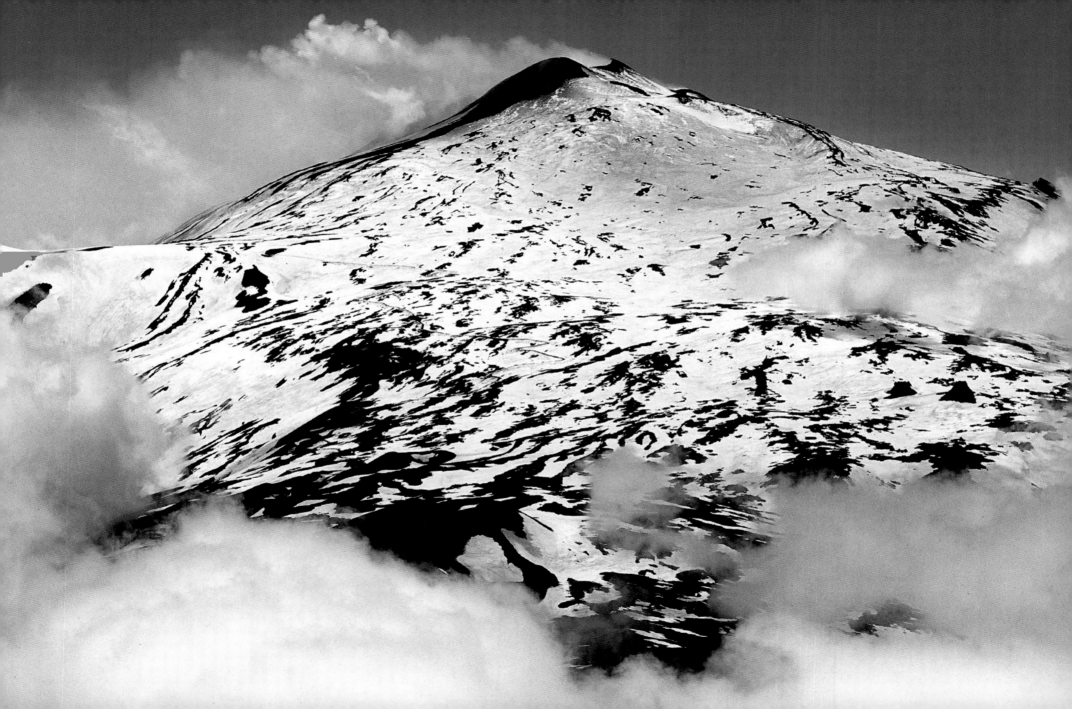

this volcano to examine the caves dug by coulees and cooled by running water; they collect seeds, bark, and burrs for erudite botanical research.

Nevertheless, we do not need to be scholars to love this place where aridity and lushness, reality and myth, wild nature and cultivated land live in perfect harmony. Etna enthralls, as we stand on its slopes and our gaze ranges across the sea's cobalt blue horizon: because we can walk for hours without meeting anyone except the birds of prey that nest amidst the lavas; because every so often the volcano "awakes" like some sleeping giant and treats us to the pyrotechnical spectacle of one of its eruptions. It charms with the intense network of towns showing the obstinacy and creativity of generations of human beings who have plowed and farmed this lava-rich earth, teasing blood oranges and sturdy wines from it, transforming masses solidified by distant eruptions into building blocks, sending their beasts to pasture on the slopes. It fascinates for the variety of habitats, the moonscapes on the peak and the lush green slopes, passing through stretches of solidified lava, colonized by obstinate plants, valleys of primordial appearance, exuberant woods, and caves and gullies, like those of the River Alcantara, the most famous, with basalt molded by the endless flow of water into rocks of fantastic form.

This is one of the island's most important rivers, starting as

 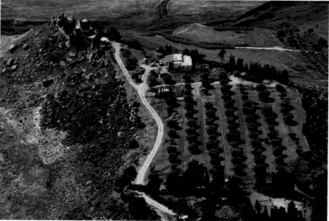 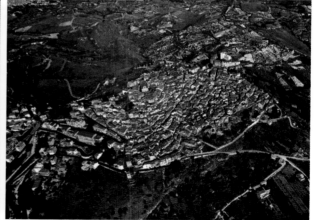

28 left The province of Trapani has the greatest number of vineyards in all of Italy. The rows of vines stretch as far as the eye can see, in orderly symmetries up and down the hillsides, providing this area with an extensively nuanced color palette.

a simple torrent amidst hazelnut groves and corn fields, orange and lemon groves, lapping historic villages huddled behind lava buttresses. Gradually, its waters become richer, tumbling into falls and leaps over rocks smoothed by the current, finally reaching a castle of prisms and columns, of a thousand shades of black and grey, which extend, here and there, to embrace leafy poplars, alders, planes, willows, and orchids on the stony bed of the rugged banks.

The scenario here is quite different from the backdrop at the river source, in the heart of the highest, remotest Nebrodi slopes, among chestnut trees and ilexes, pastures hued with red, yellow, green, and white, depending on the season. How different these mountains are from the often quite stereotyped image of sunny Sicily! Here there is a feel of the Alps – or even Norway – among high-altitude forests and lakes, torrents, cascades, and snowcapped peaks, lonely refuges and fences that protect pastures from cows and romping boars. It is a world apart: sparse pastoral and serene villages with evocative names, populated by mountainfolk with rough hands but gentle eyes, who stubbornly hand down rites and customs dating back to time immemorial, as well as techniques for making charcoal, weaving baskets, and shaping cheeses into the form of doves and deer.

Roaming these mountains is like leaping back in time, to when Sicily was covered with dense maple, beech, and oak forests, when the roads were dirt tracks and the towns were stone and wood and wrought-iron villages. And in many ways, it is still the same: rounded mountain tops are home to griffons and eagles; riverbeds, dug out perpendicular to the slope by flowing waters, are the main access routes; herds of horses pasture freely amongst yews and holly woods; tortoises rest on the pool banks; and the villages are still clinging to the peaks, watchful custodians of the environment, of history, of precious treasures: Norman churches and Byzantine monasteries, noble mansions and craft traditions, the ruins of ancient towns, mysterious megaliths, and legends.

Even the nearby Madonie range, although different for geology and morphology, is an outright paradise: for botanists, thanks to the presence of rare plants – like the Nebrodi firs that grow only here and in very limited numbers; for anthropologists,

28 center Citrus and fruit orchards, olive groves make up the wealth of Sicily. The entire territory is typified by the presence of large cultivated areas dotted with ancient farm villages, many dating back to the 1600s, often built in dominant hillside or mountain foothill locations.

28 right The small town of Giuliana, in the province of Palermo, is protected by an impressive castle built by Frederick II, and is a characteristic maze of lanes and buildings. There is also no lack of Arab traces, convents, and Baroque churches.

thanks to the ancient festivals passed down and still bound to remote pagan rites that aimed to ensure fertility for the earth; for artists, thanks to the presence of priceless testimonies to the creative flair of the human beings who lived and worked on these mountains – aristocratic villas and Michelangelesque paintings, sculpted fountains, and polychrome ceramics. Those who push on to reach the Madonie can also follow nature trails that wind through turkey oak, beech, giant holly bushes, cork, and downy oak trees, cutting back undergrowth of wild tulips, anemones, crocuses and flax. Or they can follow geological itineraries to discover the karstic phenomena that topped the mountains with complex rock embellishments and created the astonishing geomorphological complexity of the Quacella amphitheatre. There are also gastronomy tours for those interested in hearty mountain cuisine prepared with traditional recipes and using typical ingredients like cheeses and cured meats, cereals, mushrooms, and dried fruit. And finally, there are history trails, in the footsteps of ancient peoples who colonized these slopes, building houses and castles and farms.

Likewise, at the other end of the island, we have the Hyblean Mountains, a tall tableland of ancient volcanic origin, with terraces flat in places and rounded in others, that slope down towards the coast, broken up at intervals by deep chasms carved out near the rivers. These caves are where the first Sicilians settled. These quite mysterious peoples dug rock settlements out of the soft limestone that even today soar above narrow, sinuous river valleys, dotted with agaves, euphorbia, and oleander. Pantalica (recently added to the UNESCO World Heritage program), the home of people whose history is practically still unknown to us, Cava d'Ispica, and Cava Lazzaro bear witness to these ancient populations, but are also testimonies of the boundless landscape and natural beauty of this nook of Sicily, alongside the Ippari and Irminio river valleys, Cava Grande del Cassibile, the Anapo valley, and many other localities.

Sicily's landscape is unlike any other, especially from the "bird's-eye" perspective, with the expanses of green and white furrowed by plunging gullies; the towns of golden stone nestled in the heart of valleys, dominating water courses, or scattered along the low, sandy shore; the leafy carob maquis, and stretches of olives; the gleaming coastal swamp waters populated by herons and flamingoes; and the interminable geometries of dry stone walls and snaking rivers.

31 Following a period of depression, Sicilian agriculture has recently recovered some of its glory, mainly thanks to many crops being converted to organic farming techniques. Now the island – and the Ragusa countryside in particular – produces a large percentage of Italy's organic crops.

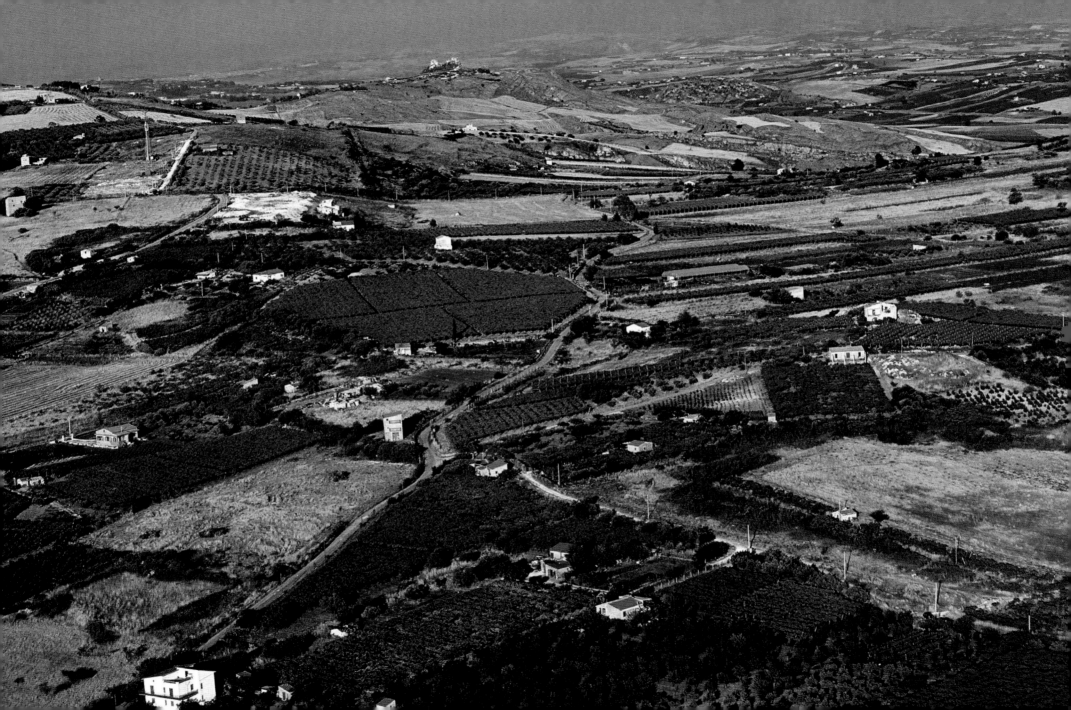

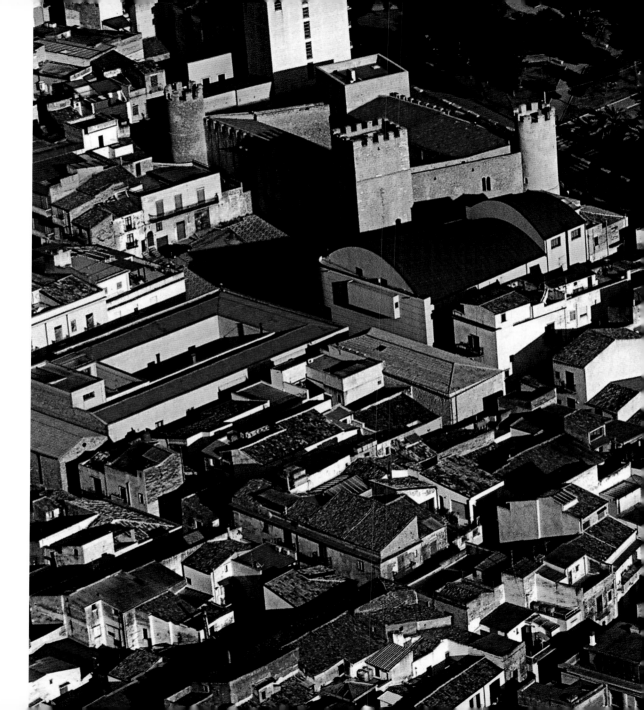

32-33 The small town of Alcamo gives its name to one of Sicily's most famous wines, "Bianco d'Alcamo," celebrated since the 16th century. This pretty town, in the province of Trapani, is also proud of its.

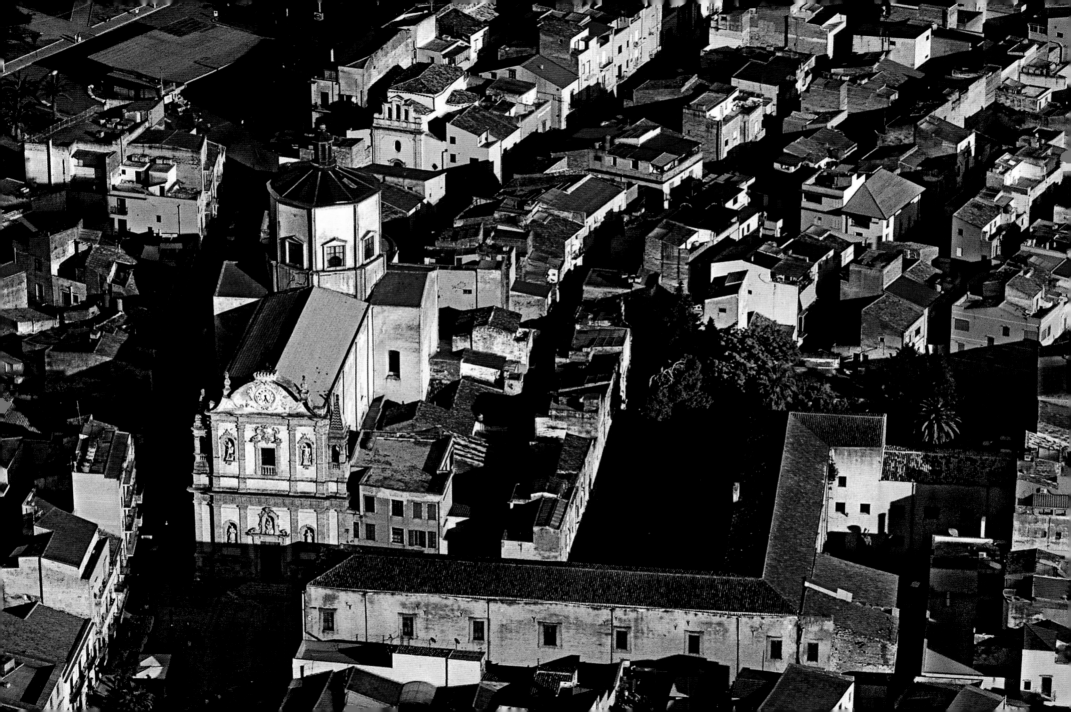

34-35 The great lake at Piana degli Albanesi lies among the hills just a few kilometers south of Palermo, and on its shores there is now a WWF oasis, a haven for lakeside flora and fauna.

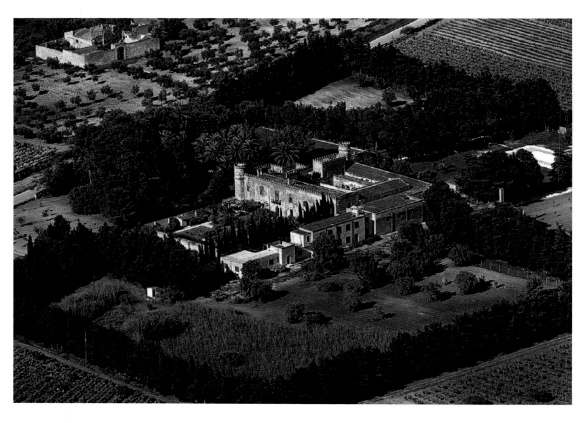

36 Like other farms belonging to local landowners, this one near Sambuca di Sicilia (Agrigento) has been converted into an elegant residence just shy of a castle; a holiday retreat where the gentleman farmer could keep an eye on the harvest while savoring an enjoyable vacation away from the simmering heat of the city.

37 Mixed in with the crops around Sambuca di Sicilia (Agrigento) we glimpse tall rocky spurs, unique geological formations that appear to be elements of decoration installed with the artful intent of stirring some interest into the monotonous landscapes.

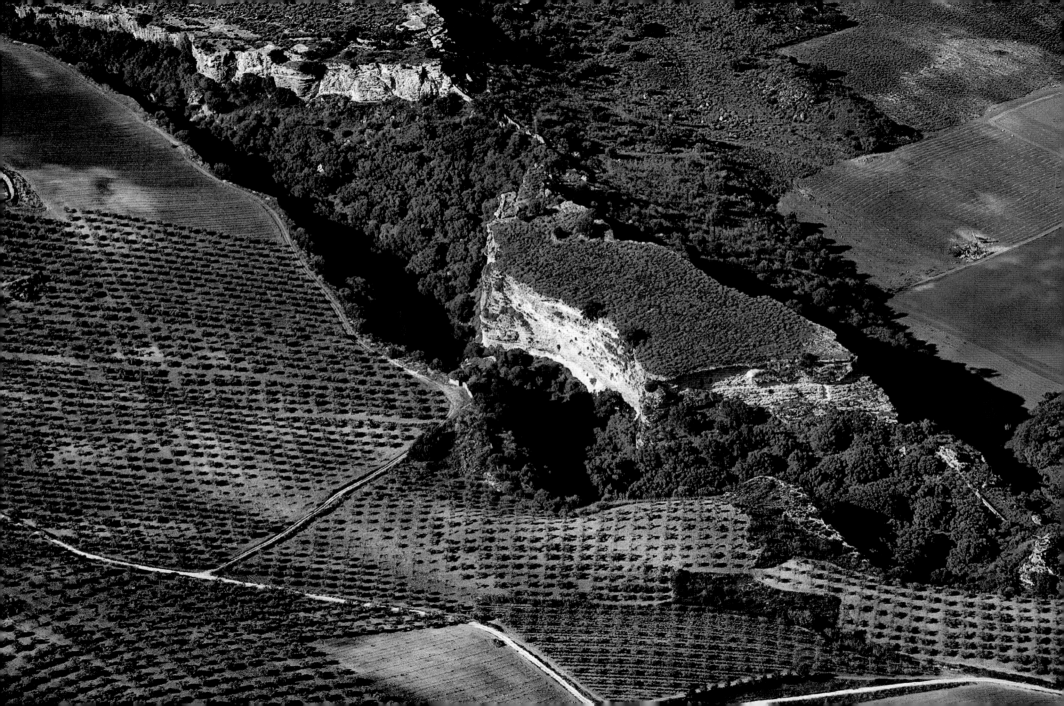

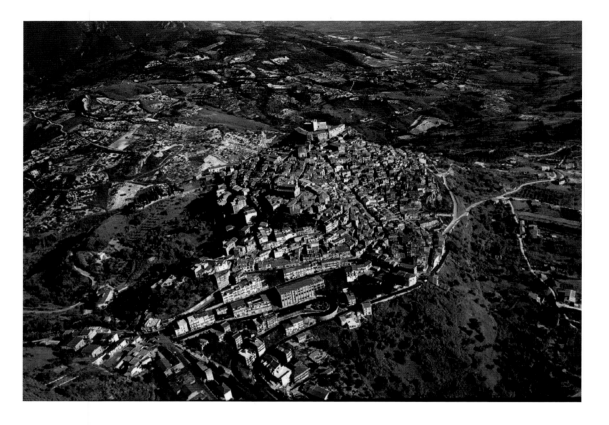

38 Giuliana, in the province of Palermo, is an insular hamlet whose ancient urban layout is more or less intact. In this case we have a town that was founded in the Middle Ages, with unleveled streets that bear the Islamic stamp and hilltop houses practically set on top of each other.

39 Caltabellotta (Agrigento) was founded by the Sicanians, colonized by the Phoenicians, by the Greeks and, finally, by the Romans, but it owes its name to an Arab supremacy that called it Qal'at al Ballut (the "oak fortress"). That period is still reflected in the layout of parts of the town and many words of the local dialect.

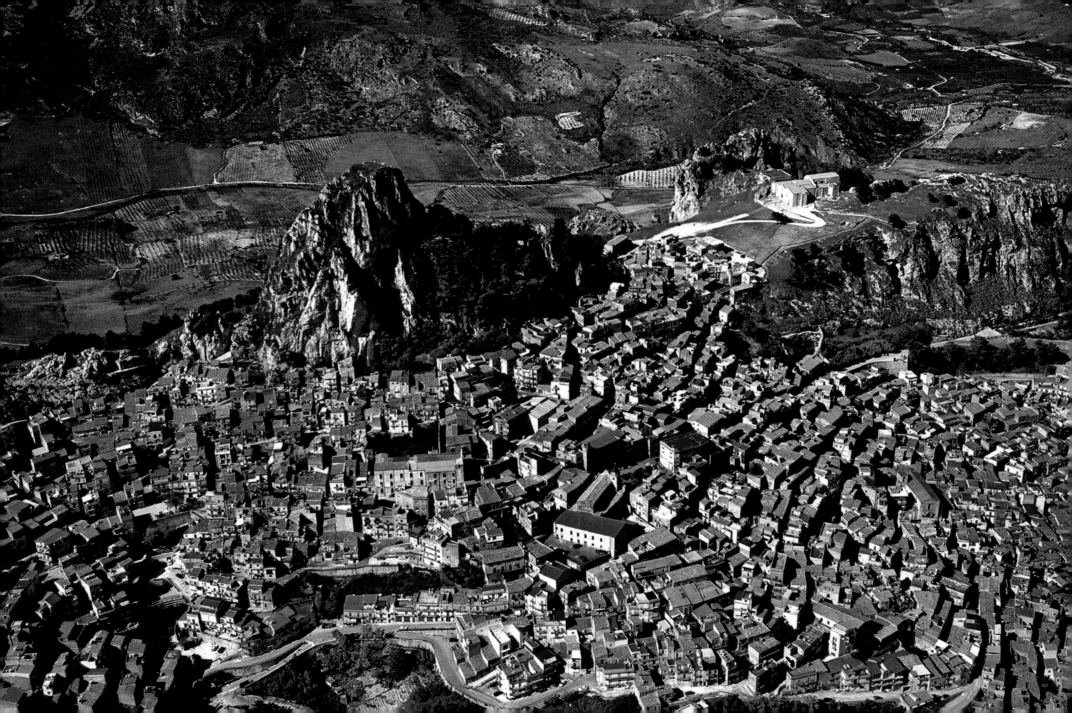

40 and 41 Mussomeli Castle, province of Caltanissetta, (right) is one of the best preserved in Sicily. The castle was built in the 1300s in an architectural style that was defined as "Chiaramonte," paying homage to the most influential family of that period. Its position is astounding, seeming almost to rise straight from the rock, dominating a far-reaching backdrop (left).

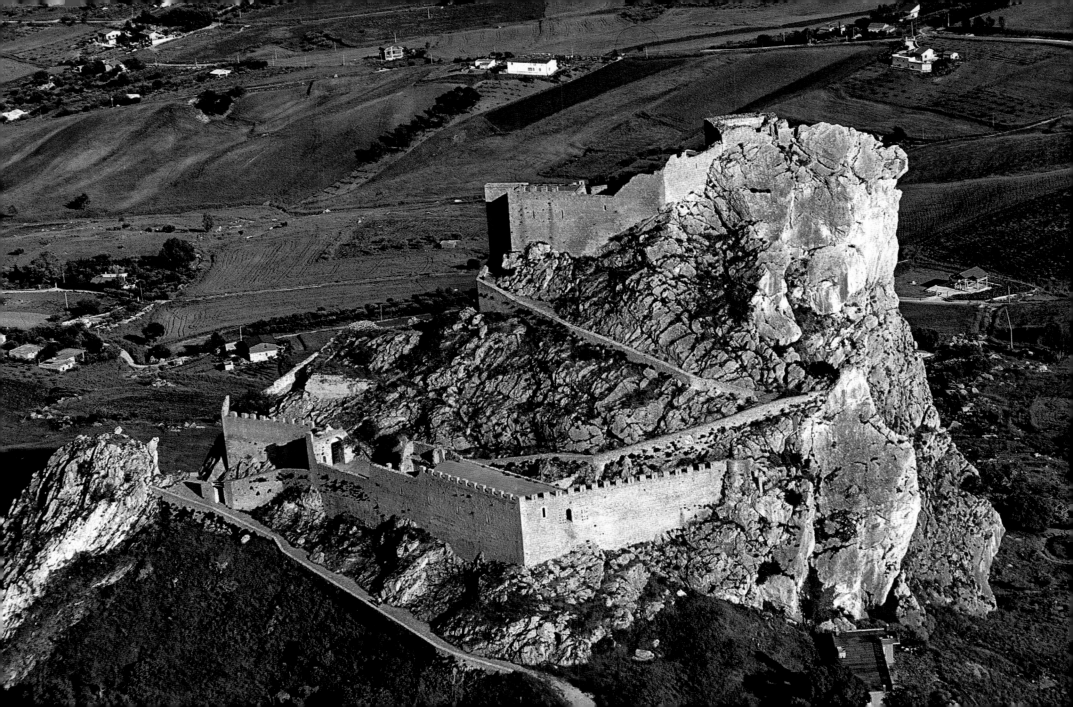

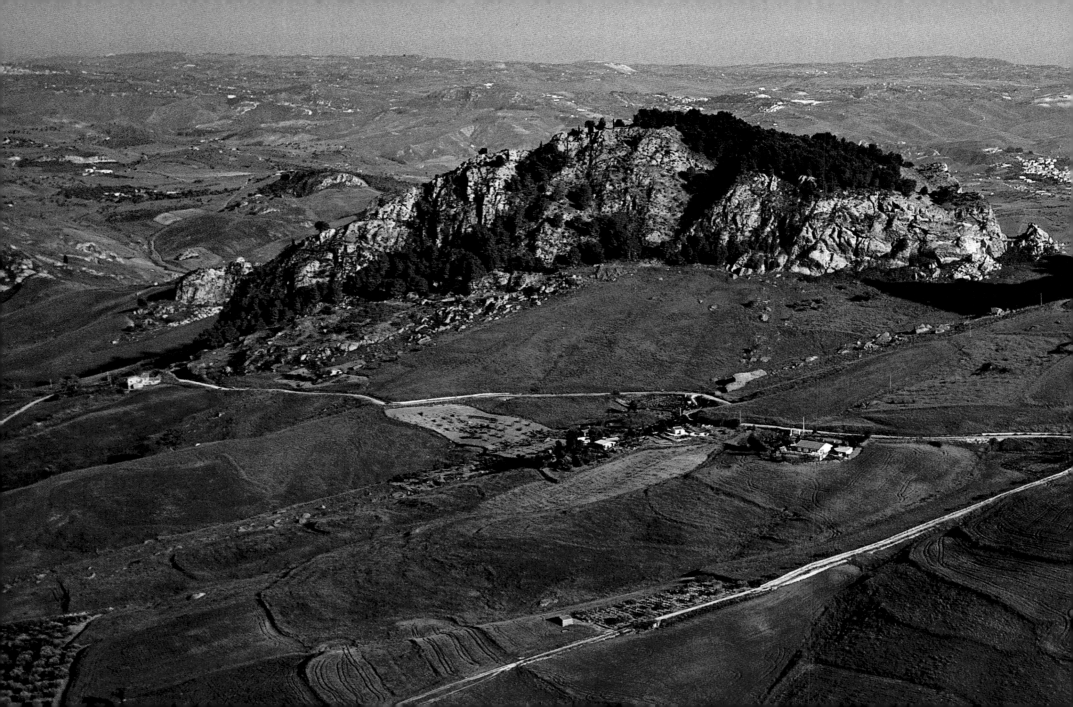

42-43 Near Sutera (Caltanissetta), in central Sicily, the hills are part of a distinctive, undulating landscape, scattered with farms and rural settlements. Here and there eye-catching rock formations emerge, bearing witness to upheavals in the earth's crust over the millennia.

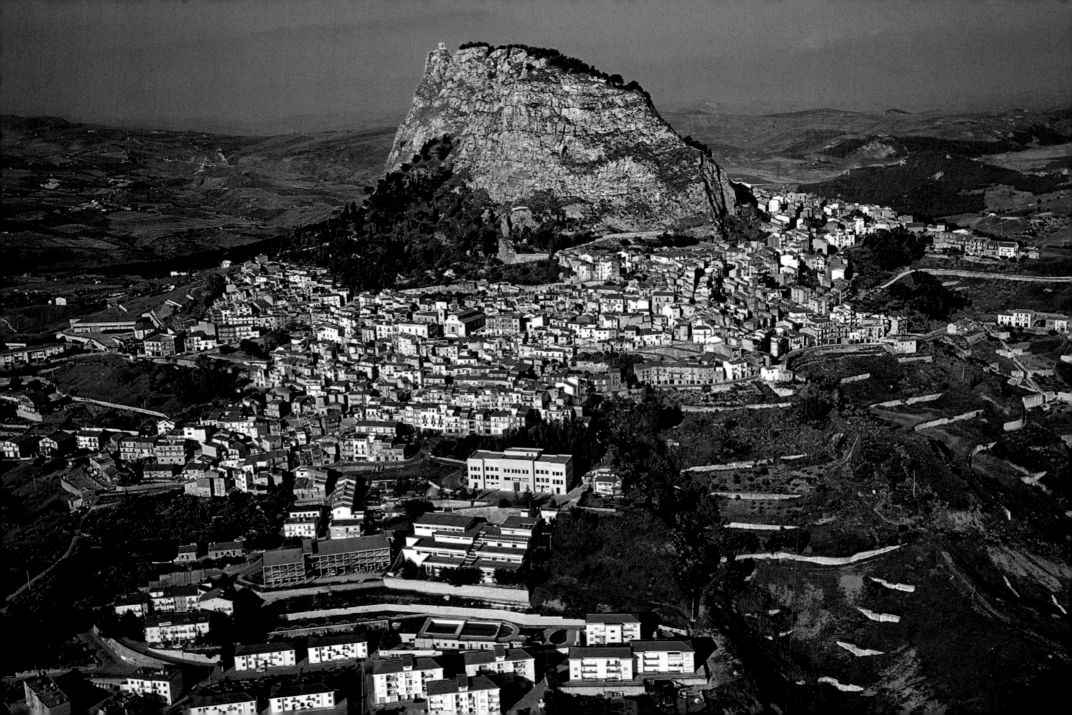

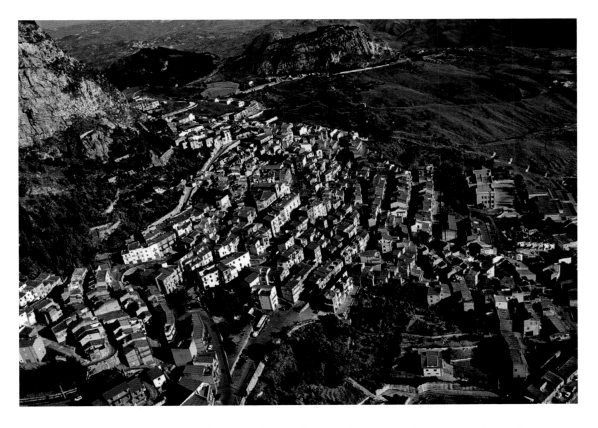

44 At 823 meters above sea level, the San Paolino crag looms over Sutera, a small town in the province of Caltanissetta. Its church was commissioned by Giovanni III Chiaramonte in about 1374, built over the remains of an ancient castle.

45 Sutera, one of Sicily's most picturesque towns, is built at the foot of the San Paolino crag. The town dates back to the period of Muslim domination, when the oldest part, the Rabato quarter was built around the mosque, which is now the Mother Church.

46-47 Between the provinces of Agrigento and Caltanissetta, the soil appears a unique whitish color due to its high clay content. The scenery is distinctive, with large, arid light-colored patches that offset the fields.

48 and 49 A striking range of landscapes, observed from above the countryside around Agrigento, in southern Sicily: cultivated fields and isolated peaks, solitary houses and towns, remote roads, bridges and moors, set together like pieces of an eternally mesmerizing puzzle.

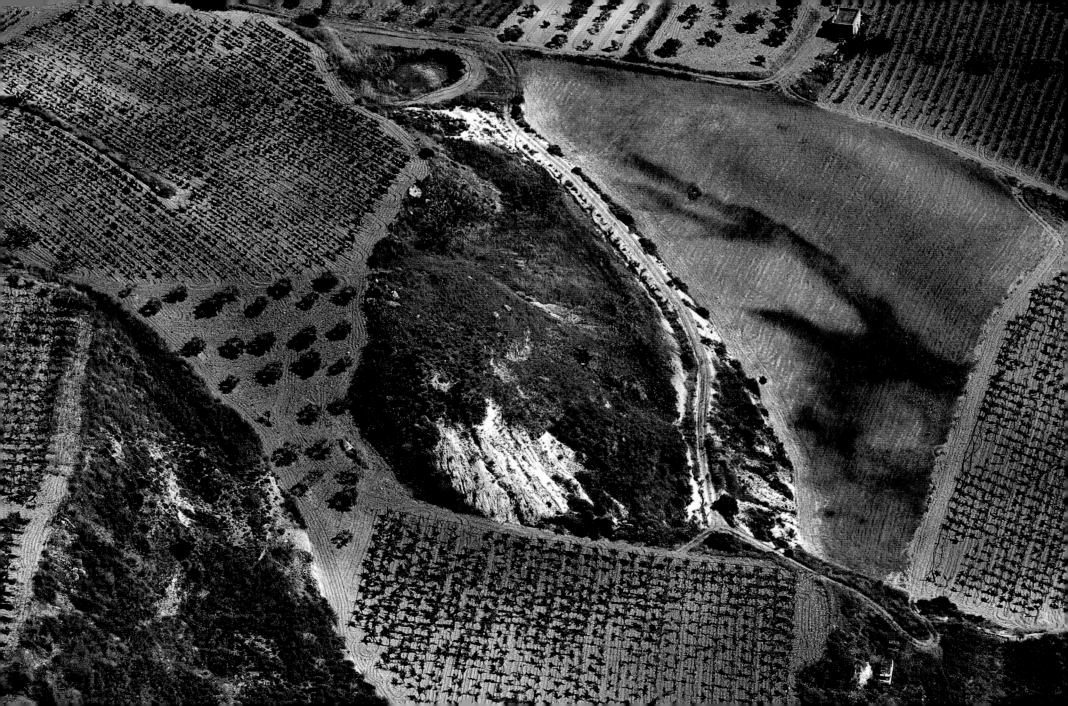

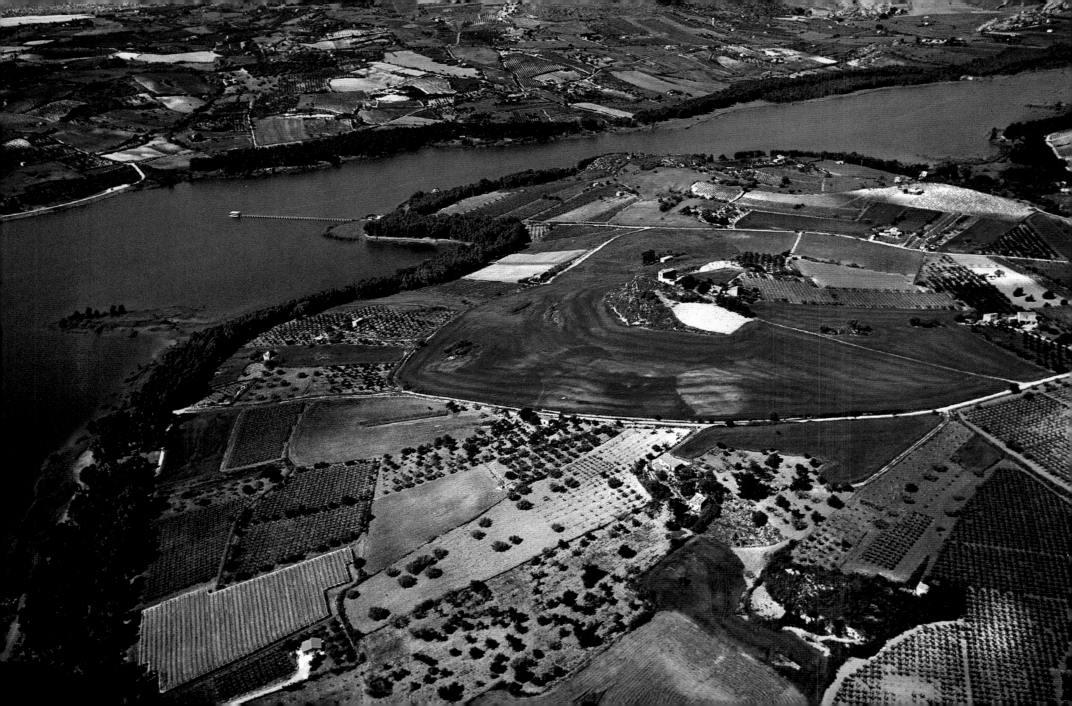

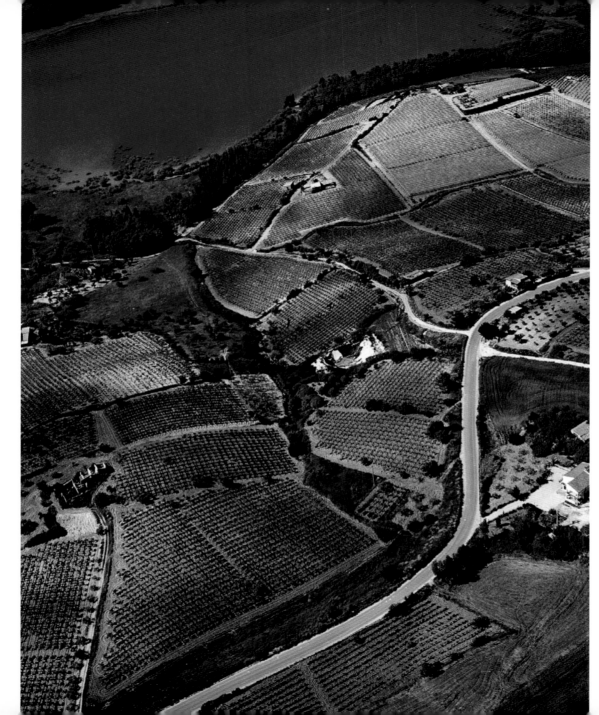

50 and 51 The spring is green here, a palette with a thousand hues. Anyone who believes Sicily to be an arid desert will be surprised to find it is a scenario of endless shades of green, from the palest to the deepest, as can be seen around Lake Naro (Agrigento). As the season flourishes, the landscape will be enhanced with the ruby blossom of the meadows of honeysuckle, golden broom and so many other colors.

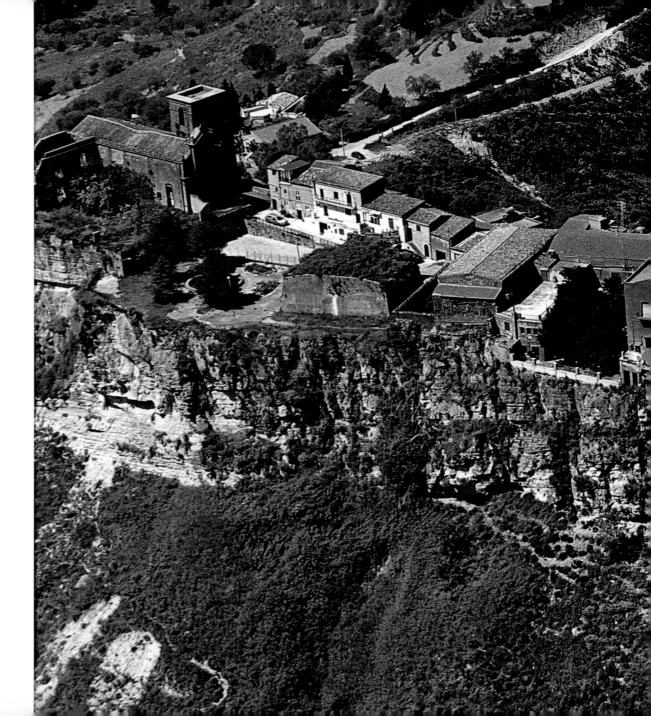

52-53 Calascibetta (Enna) is at the heart of Sicily, a sort of natural terrace. Founded by Count Roger the Norman, who used it as his HQ for besieging and vanquishing Enna, located exactly opposite, on the other side of a deep valley.

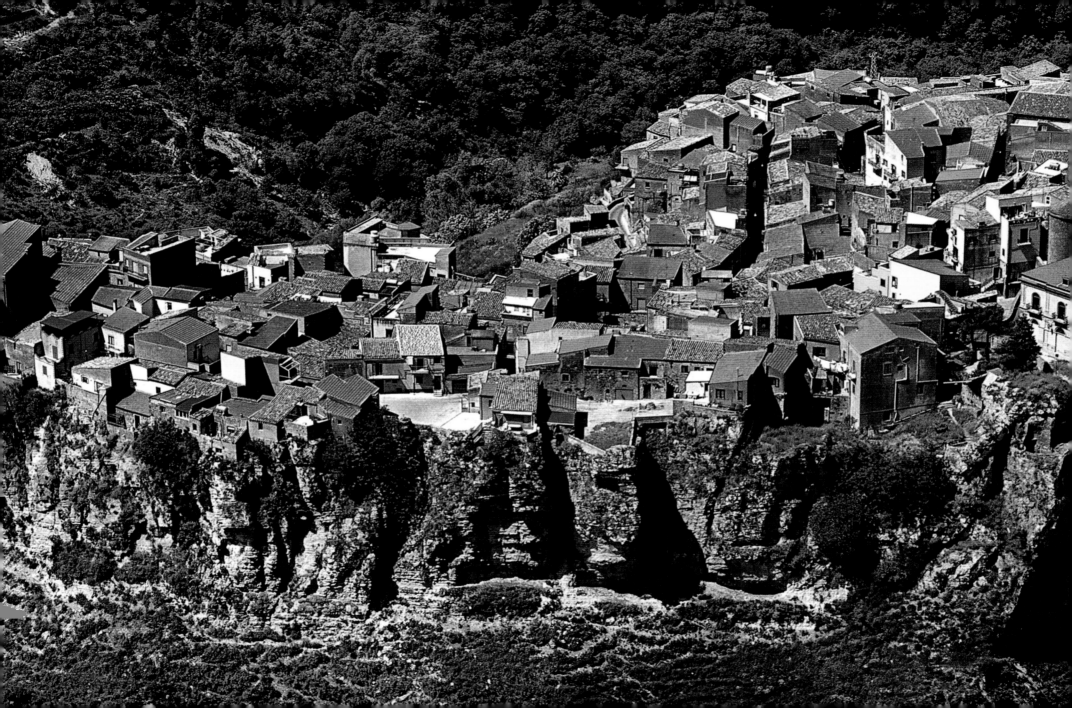

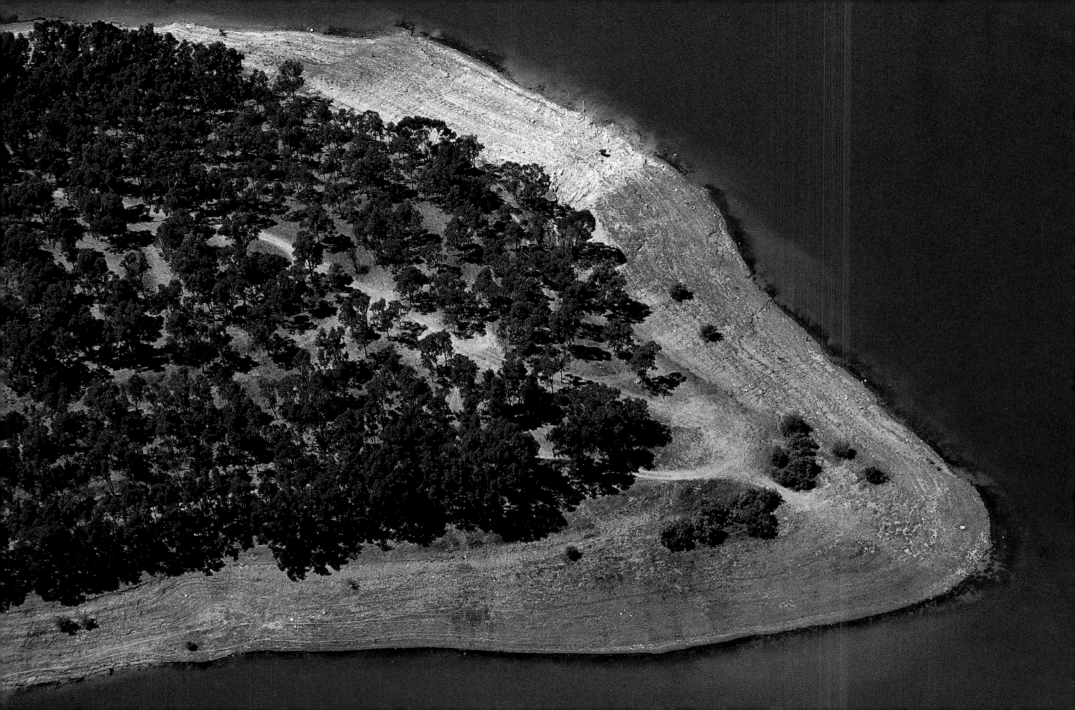

54 and 55 Lake Pozzillo (Enna) was created artificially by installing a massive dam across the River Salso. The lake is six kilometers long and no more than a kilometer wide, containing up to 140,000,000 cubic meters of water. Its position is scenic, with Mount Magari as its northern backdrop, almost skimming its shores with its tree-lined slopes, and cereal fields around the rest of the horizon.

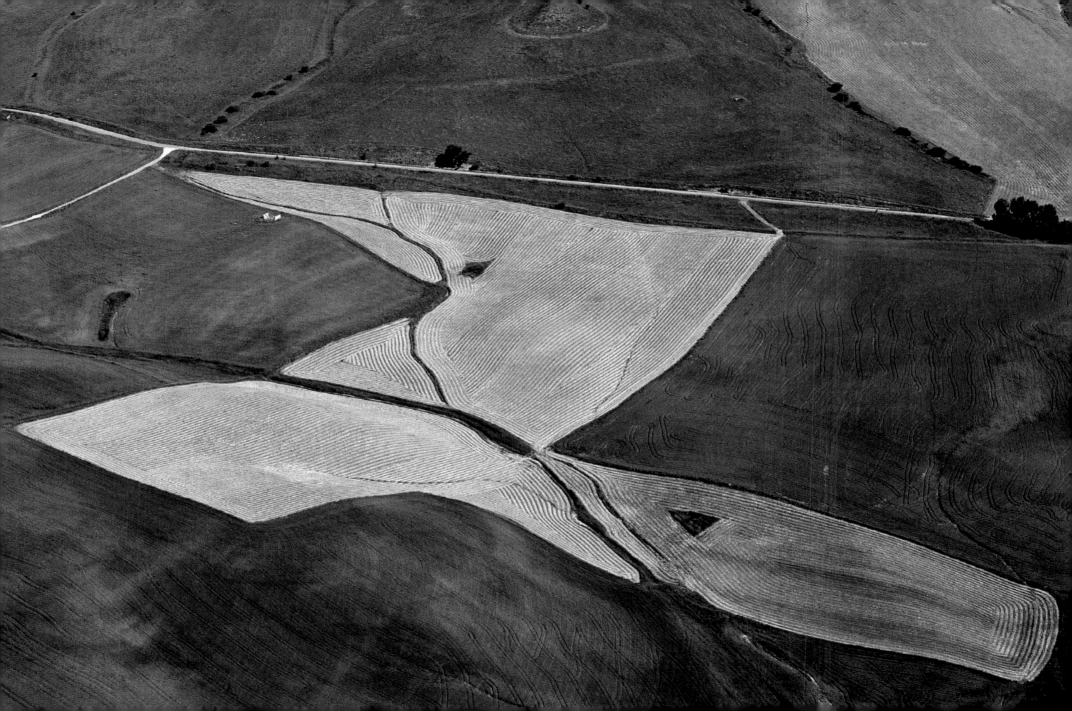

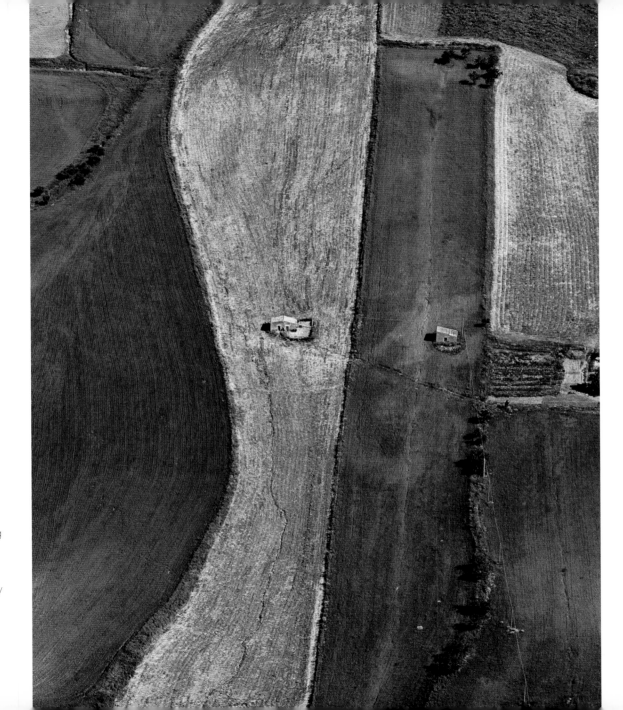

56 and 57 Curious geometries sketch out harsh lines of contrasting colors in the countryside around Enna: as if an artist's hand carefully set out roads, fields, water courses and lakes, woods, villages and lonely houses, as if each single element were intended as part of a giant fresco.

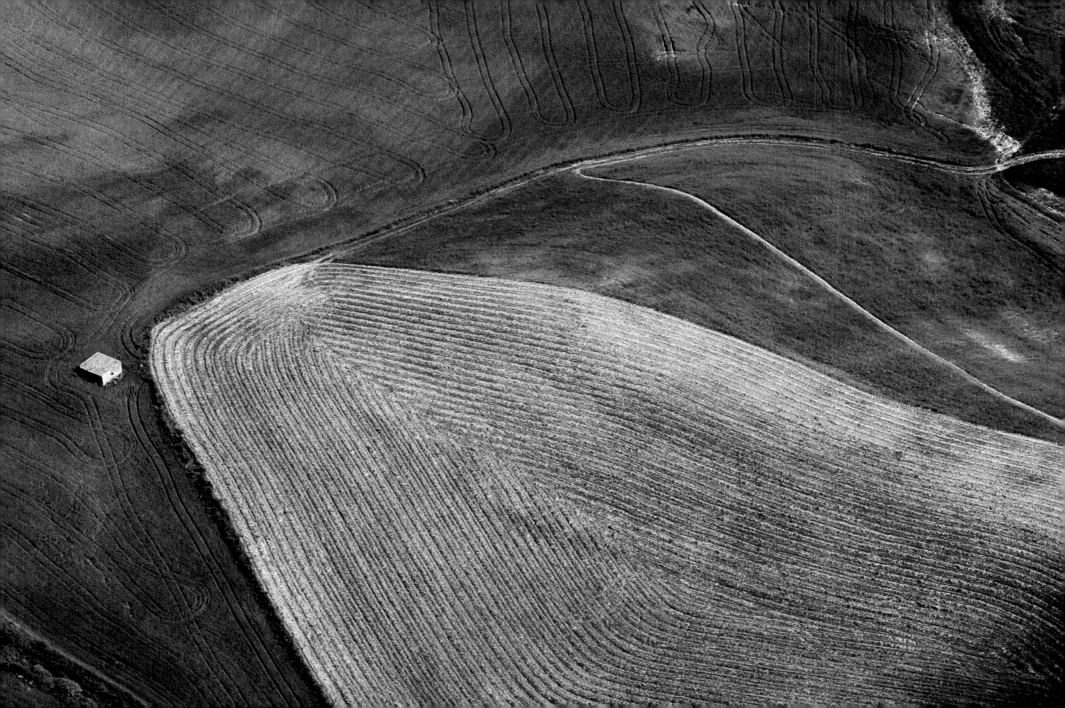

58 The ancient Romans considered Sicily their "granary." Even today, in effect, grain is a prevalent crop on the farms, in particular in the island's central zone. It is no coincidence then, that Enna was the site of a temple honoring Ceres, the goddess of grain and fertility and deemed to be a sacred place where for centuries endless pilgrimages of shepherds and farmers came to seek blessings for their stock and crops.

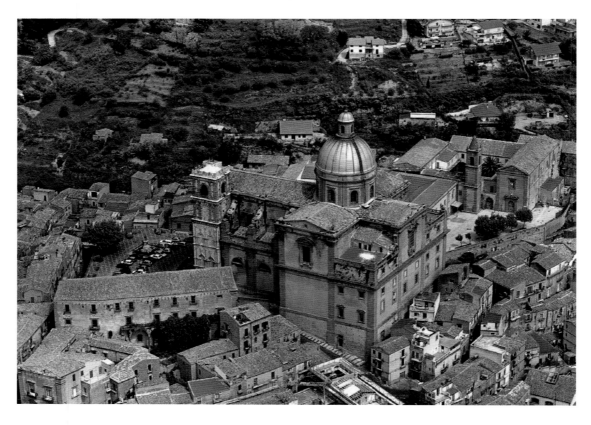

60 and 61 The splendid Roman villa at Piazza Armerina, province of Enna, is famous: a 3rd-century masterpiece brought to light in the mid-1900s, just a few kilometers from town. It is unfortunate that the town's historical center is not quite so famous as it is a picturesque network of medieval streets, stairways and courtyards, with lovely churches and noble mansions, all set around the 17th-century cathedral. The image to the left is a lovely view of the 1600s duomo and to the right we can admire the old Jesuit convent, with its adjacent Sant'Ignazio church (17th century).

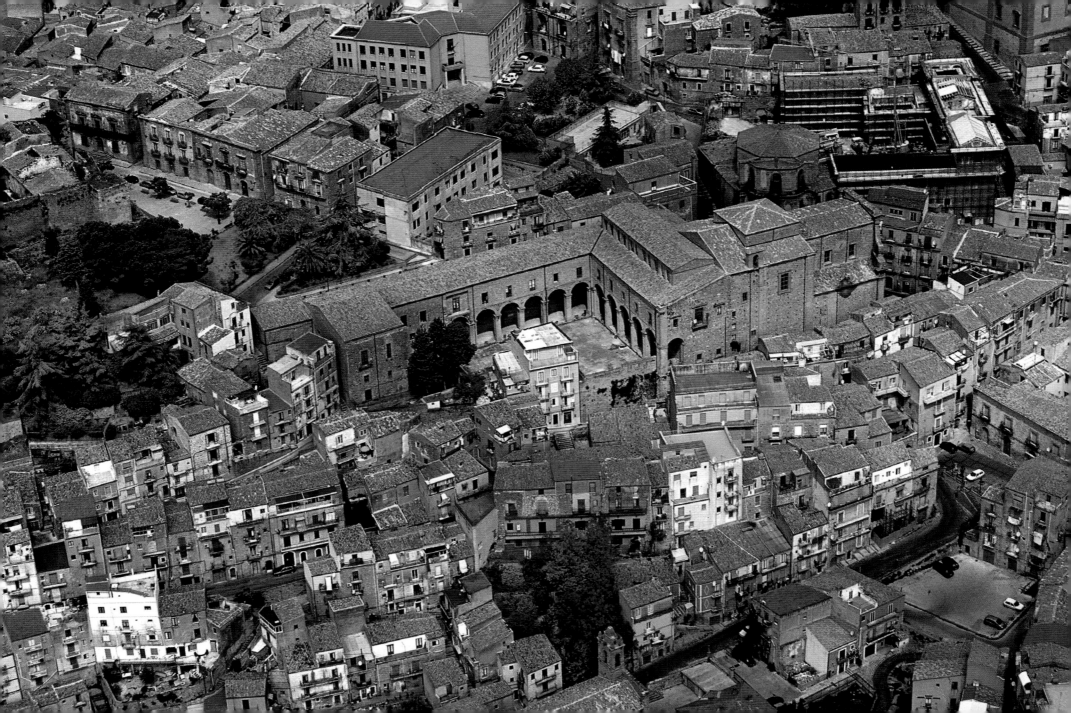

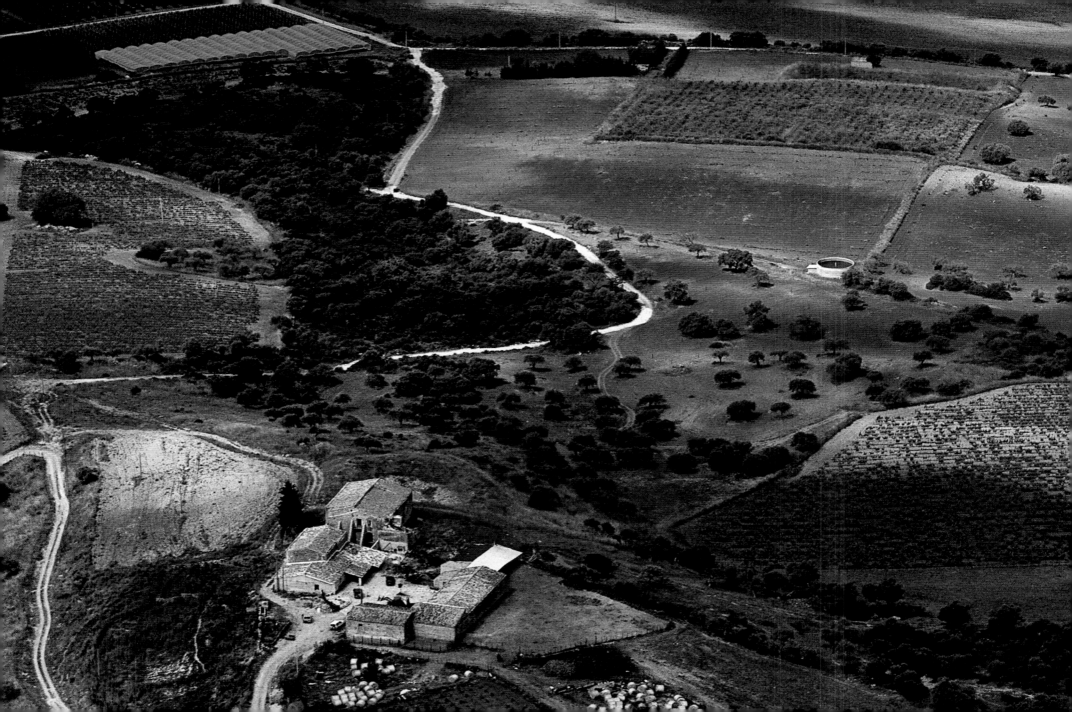

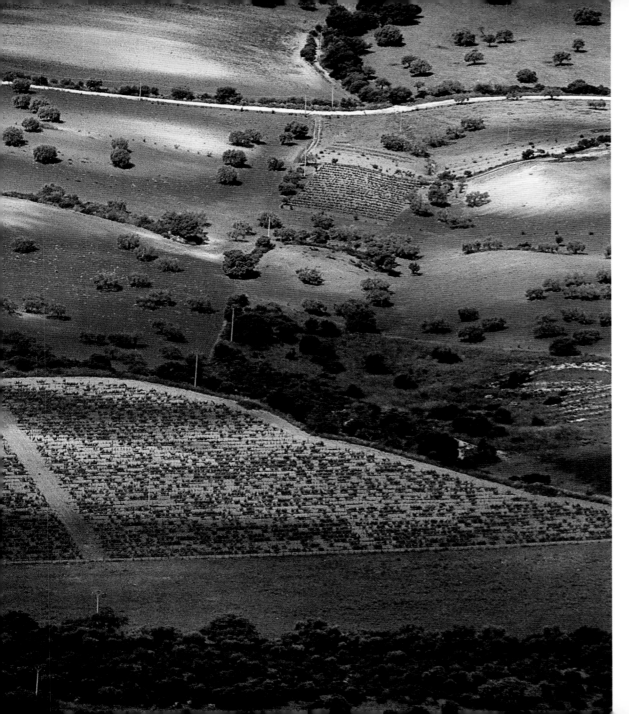

62-63 Right from Roman times, Sicily's inland countryside (here near Caltagirone) was deeply influenced by the creation of large landed estates for exploitation of the territory's agricultural potential. Even today, farmlands stretch for many kilometers and we may travel countless roads before encountering a town or village.

65 Typical Hyblean farmhouses, between Ragusa and Siracusa, once at the heart of farmlands, with abundant space for the owner's residence, accommodation for the laborers and servants, the stores and stalls. Today these buildings are frequently converted into smart holiday homes, hotels and restaurants, amongst other things.

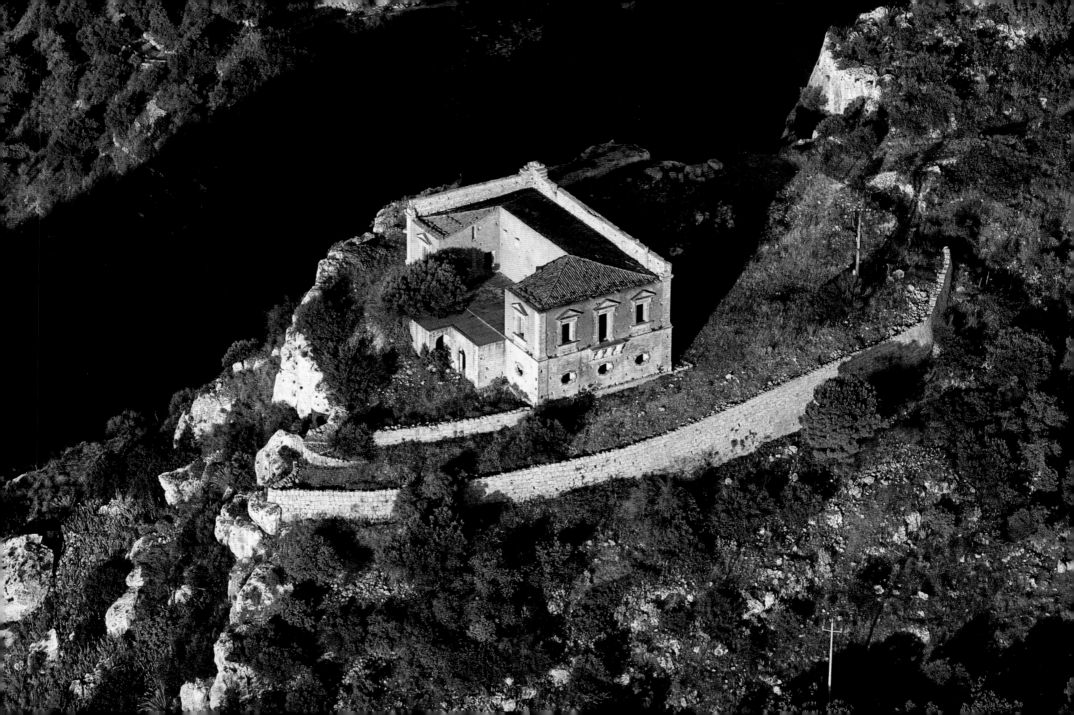

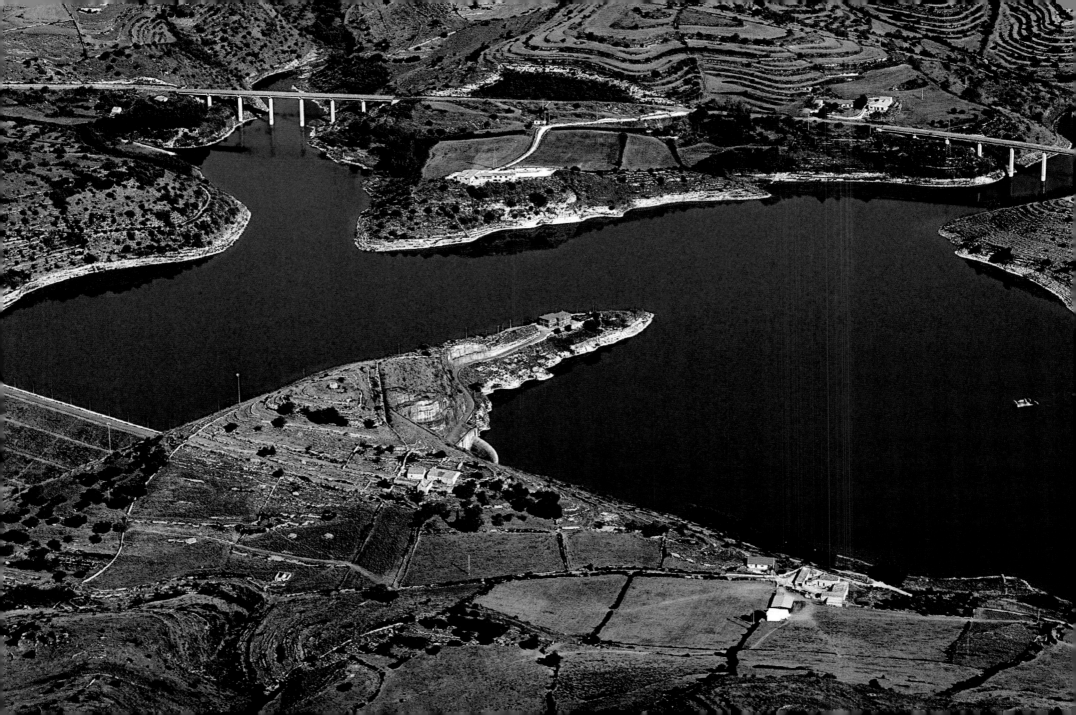

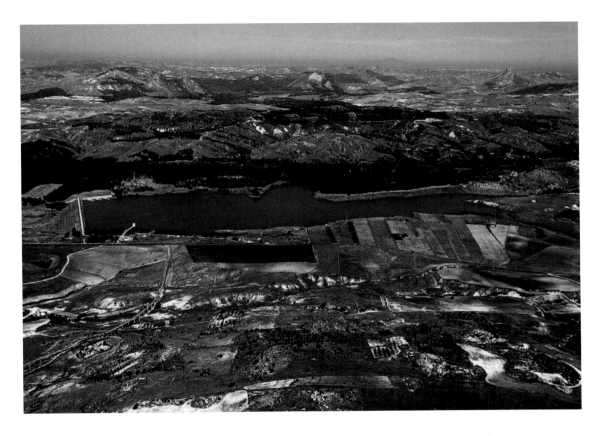

66 Lake Santa Rosalia, a few kilometers from Ragusa, is the furthest south of all Sicily, surrounded by wooded hills that are a truly lovely scenario, especially seen from the height of the viaduct.

67 In the area around Gela (Caltanissetta) there is also the dei Desueri lake, created by hydraulic engineering, installing a dam on the river of the same name, which flows into the lake, there becoming the River Gela. The lake was formed for the irrigation of neighboring farms.

68-69 The Hyblean plateau is of volcanic origin, comprising flat and slightly rounded terraces that slope down to the coast. To increase farmable terrain, these steep terraces were carved with great effort from sheer crags.

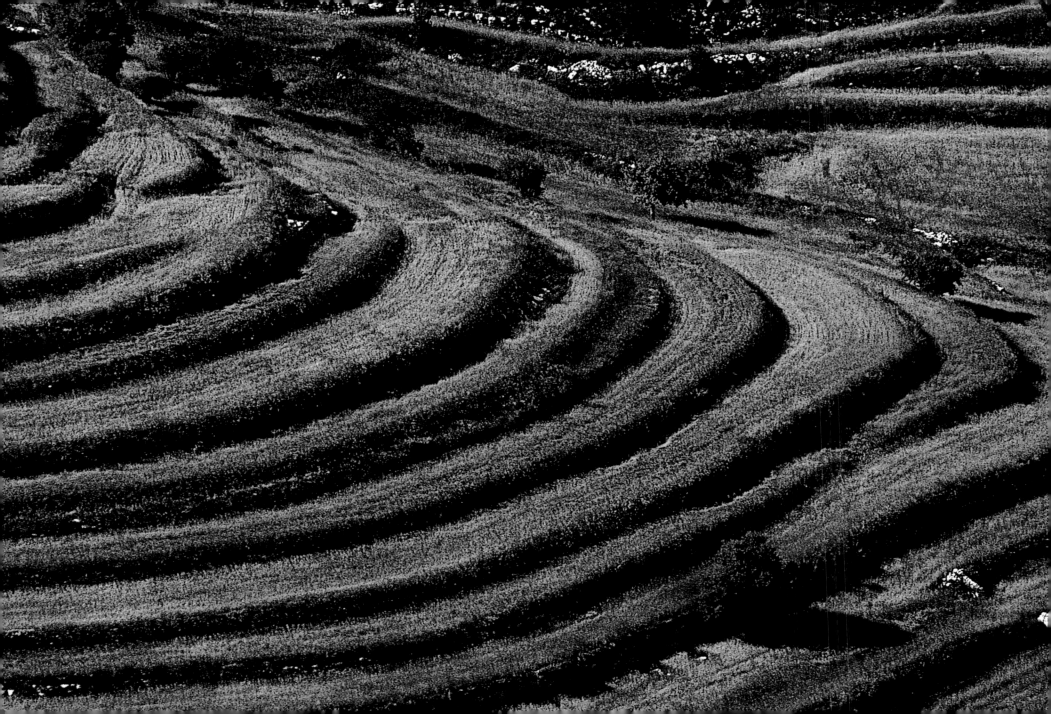

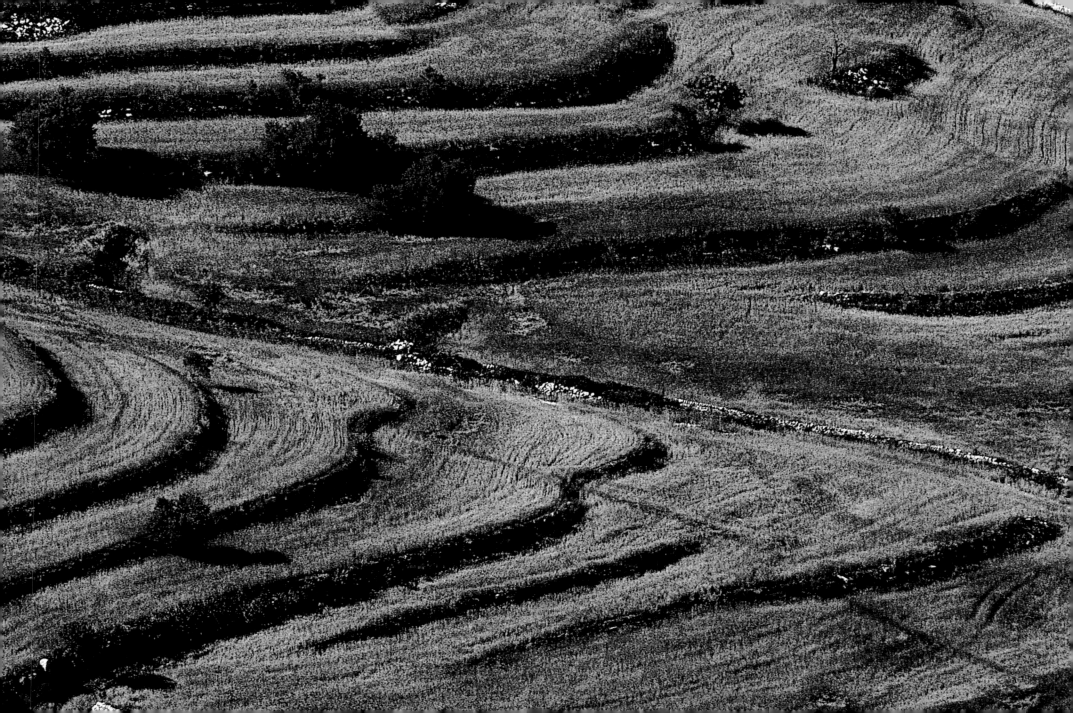

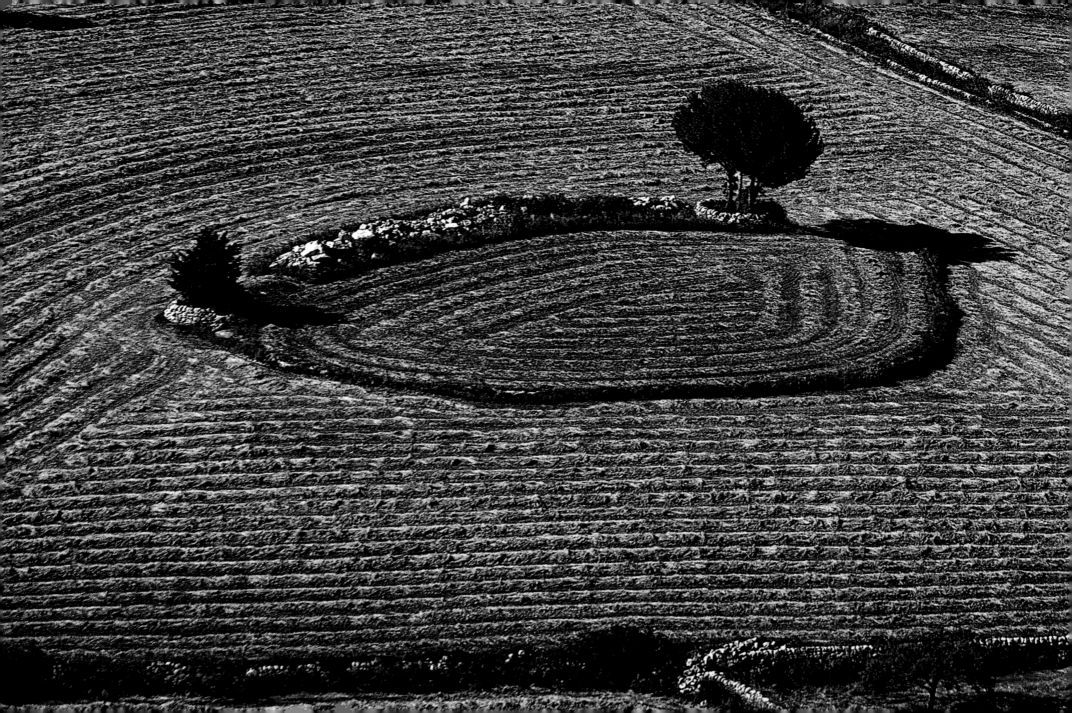

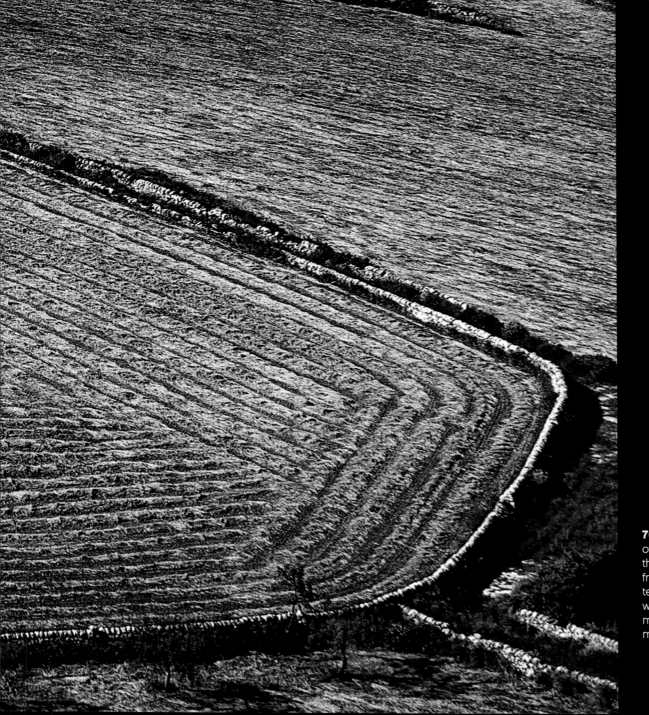

70-71 Unlike other parts of Sicily, the province of Ragusa is unique for the fragmentation of the farms, which were given in emphyteusis from the 1500s. Consequently the entire territory is divided into crofts, called "vignali", with typical low, dry stone walls, which are still maintained and built with the traditional methods of bygone times.

72 Like a gigantic natural patchwork: an aerial observation of the Ragusan countryside offers a striking image of the incredible harmony of the touch of Nature and the hand of human intervention in their molding of the environment.

73 Long stretches of Ragusa province's countryside have retained their bucolic appearance, untainted by modern times, which explains why many outsiders, both from Italy and abroad, have recently opted to purchase holiday homes where they can spend vacations in close contact with nature.

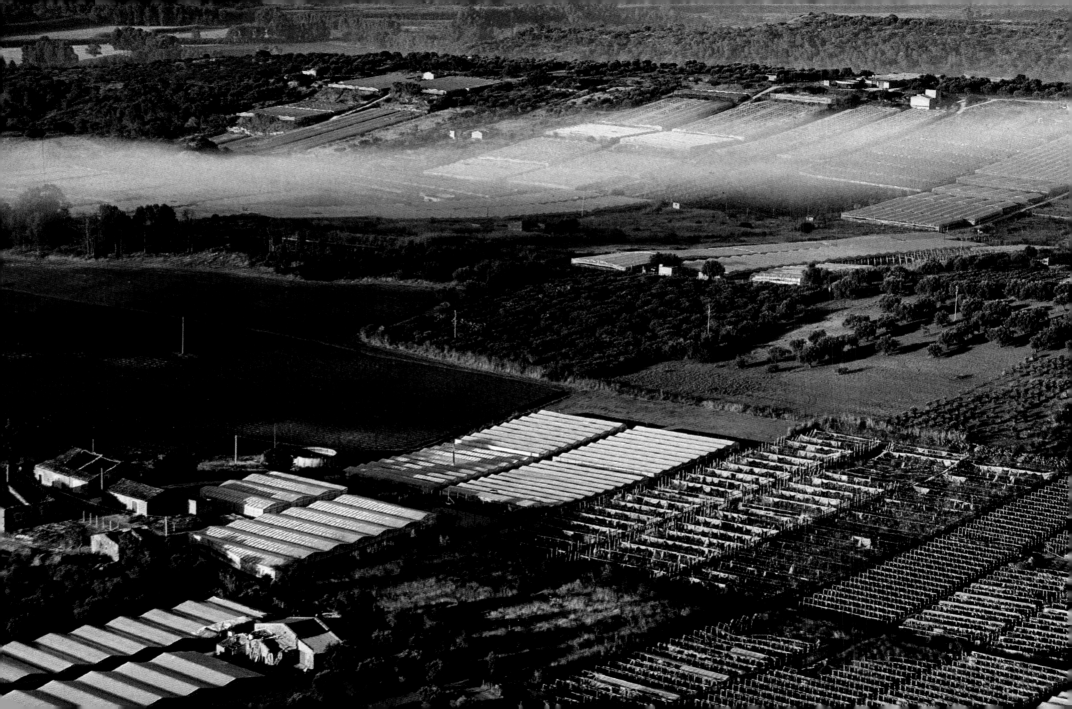

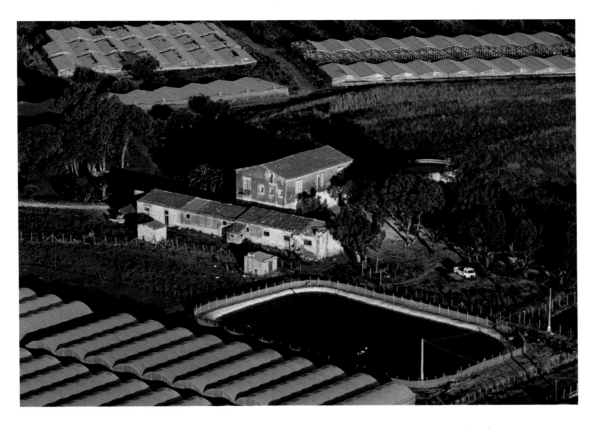

74 and 75 A large area between the provinces of Ragusa and Siracusa is involved
in greenhouse cultivations: this is the set-off point for the trucks that supply many of Italy's
and Europe's markets with fruit and vegetables. Two flourishing sectors are those
of first fruits and flowers.

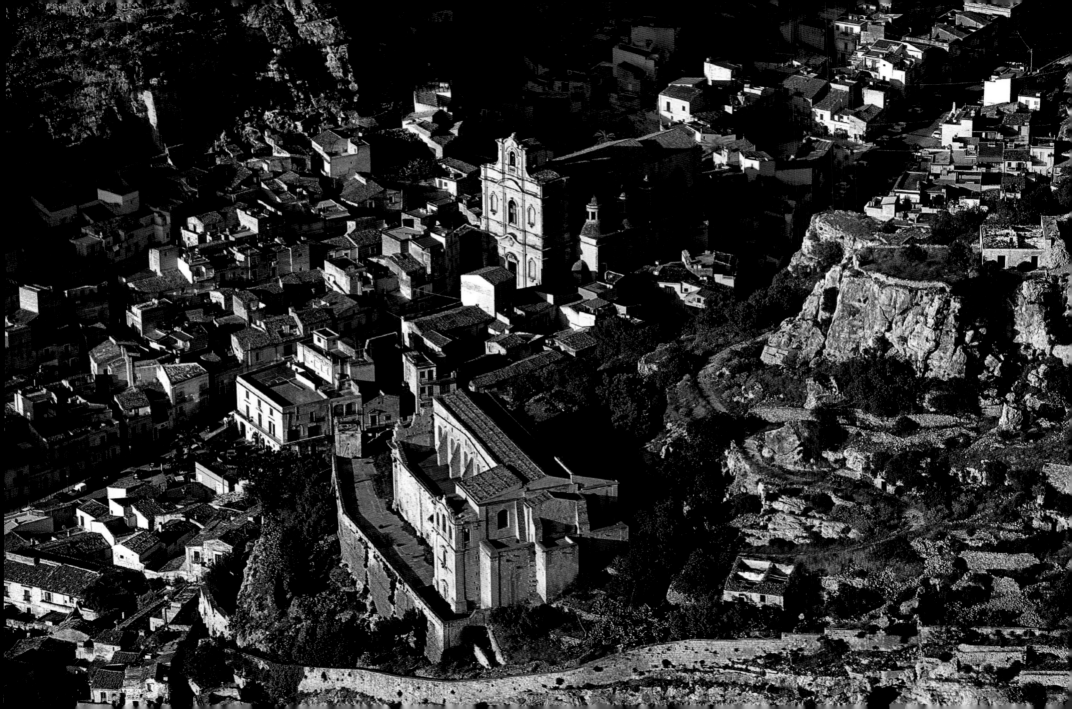

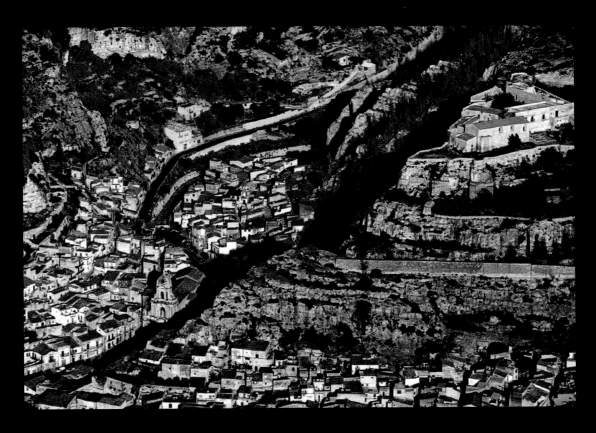

76 and 77 Scicli (Ragusa) is in an especially picturesque location, its stucco houses
clambering over one another at the confluence of three gullies. The entire residential area
was rebuilt in the 1700s, following a devastating earthquake, and enhanced with magnificent
Baroque churches and palazzos. Nowadays the town is included in the UNESCO World
Heritage program. The image top left shows the church of Santa Maria La Nova, built in the
quarry of the same name; below, the church of San Matteo, the oldest in the town. The image
to the right shows the church of San Bartolomeo, set like a precious gem on the valley floor.

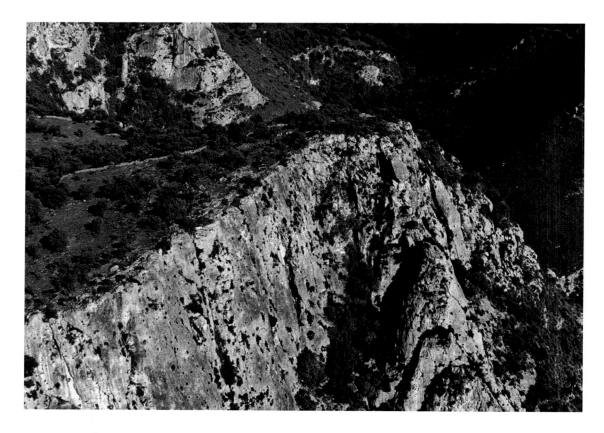

78 and 79 The Hyblean Plateau (seen here near Avola) is furrowed by deep ravines, the so-called "cave," carved out over the millennia by water courses. Several are protected by environmental and/or archeological restrictions that safeguard this untainted milieu and the precious traces of the island's first human settlements. precious traces of the island's first human settlements.

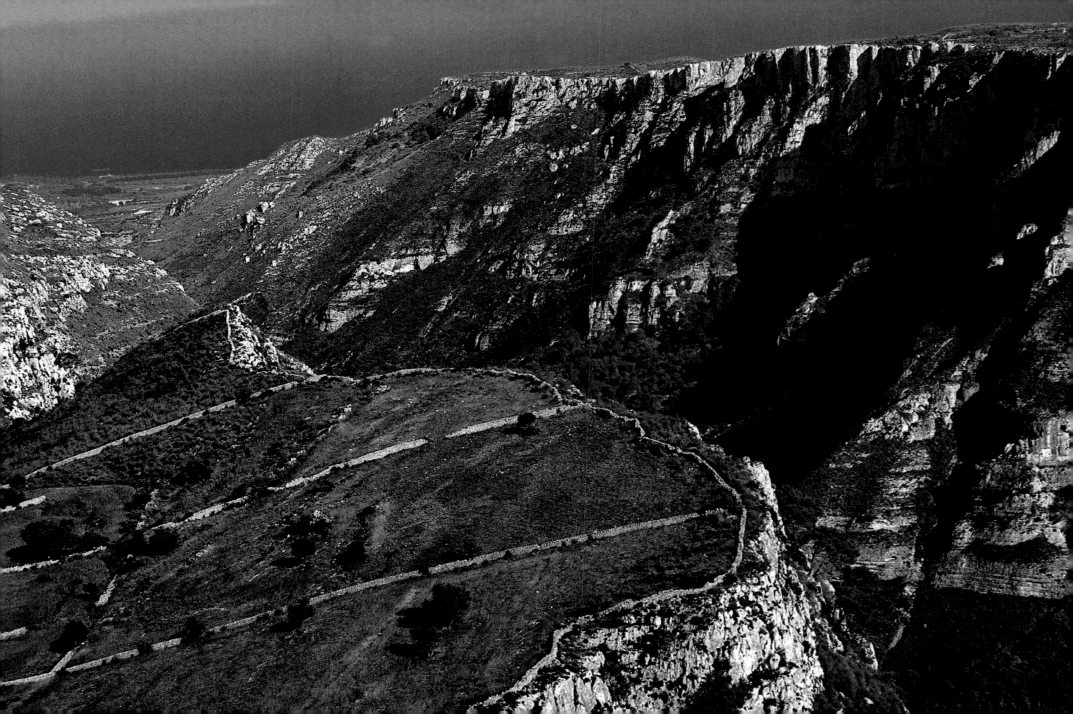

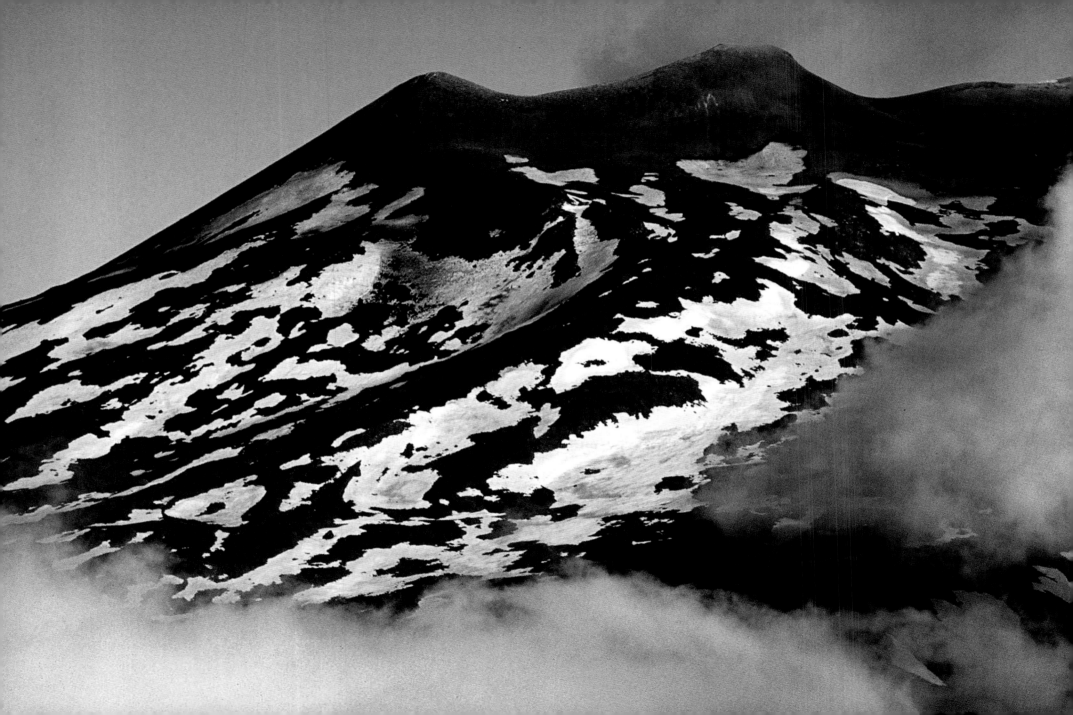

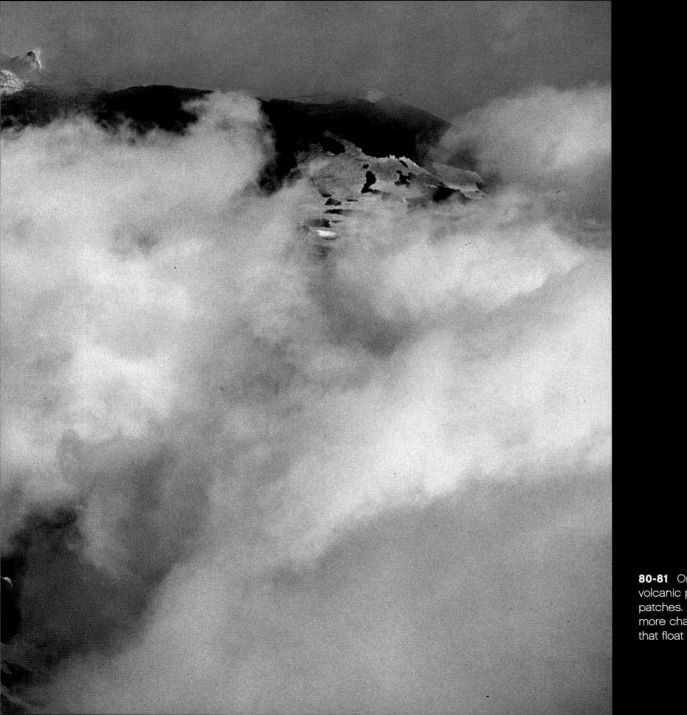

80-81 On the black ground near Etna's volcanic peaks, the snow forms large light patches. It's a magnificent scene rendered more charming still by the perennial vapors that float up from the living earth.

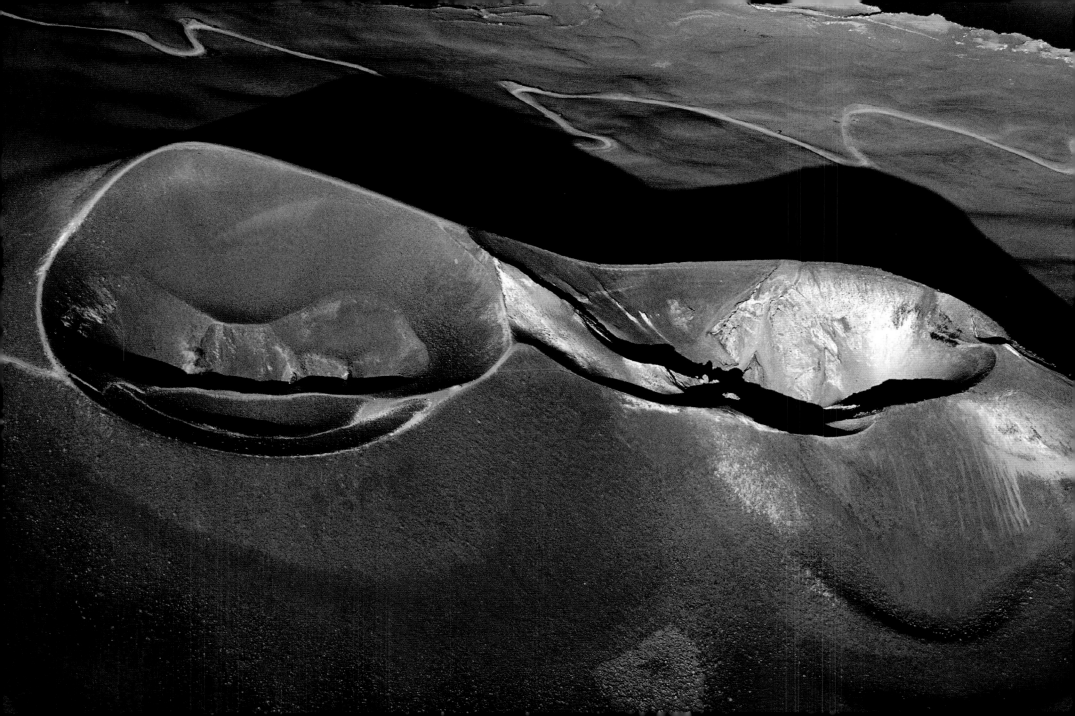

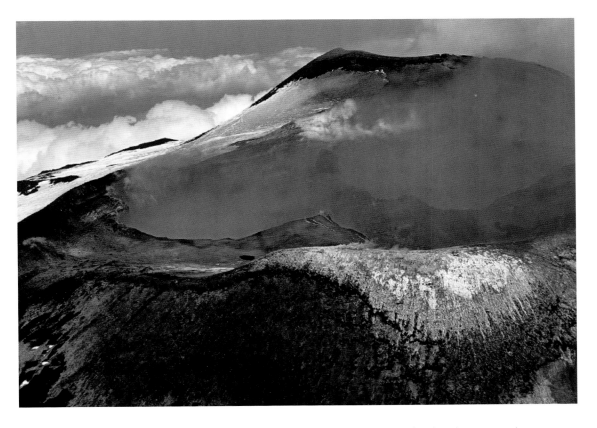

82 and 83 Flying over Etna, our gaze may plummet to the crater's depths, down towards unfathomable abysses, our imagination spurred to the impossible idea of a personal trip all the way to the bottom to see just what there is down there: the scientist Empedocles was unable to resist that temptation and hurled himself from the mouth of the volcano determined to understand and study; to reach the unreachable. The 3,330-meter volcanic peak has a perimeter of about 210 km.

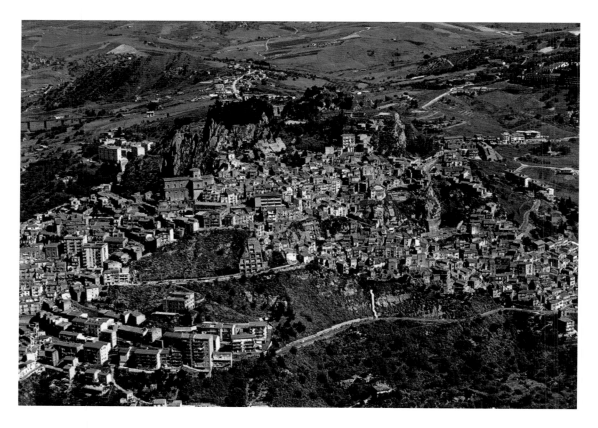

84 Nicosia (Enna) is set on a peak of the Erei, mountains between the Nebrodi chain and the lower territories of central southern Sicily. The town is of Byzantine origin and for many years the upper part of the settlement was in dispute with the lower part, each gathered around its own basilica.

85 The most distinctive part of Geraci Siculo (Palermo), deep in the Madonie Mountains, is the upper part of the settlement, which has lost none of its medieval look, with its picturesque labyrinth of narrow cobbled streets. At one time this was the residence of the Ventimiglia family, one of the most powerful in Sicily, originators of huge feuds in these mountains.

86-87 Many of the Madonie villages are surrounded by greenery typical of high-altitude settlements.

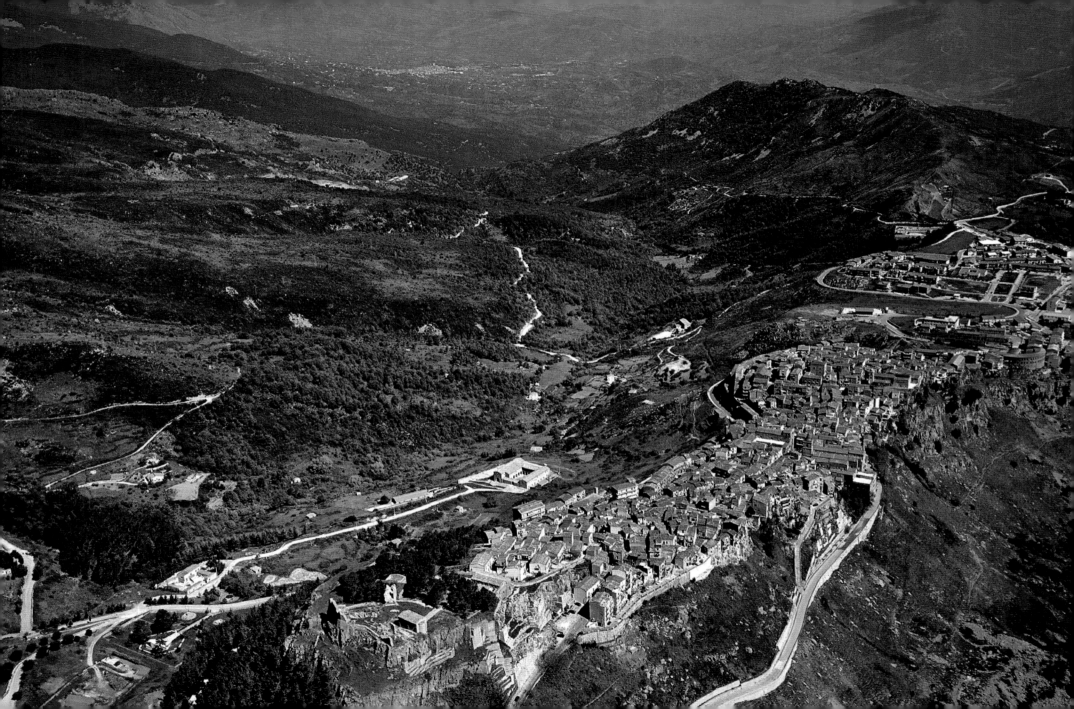

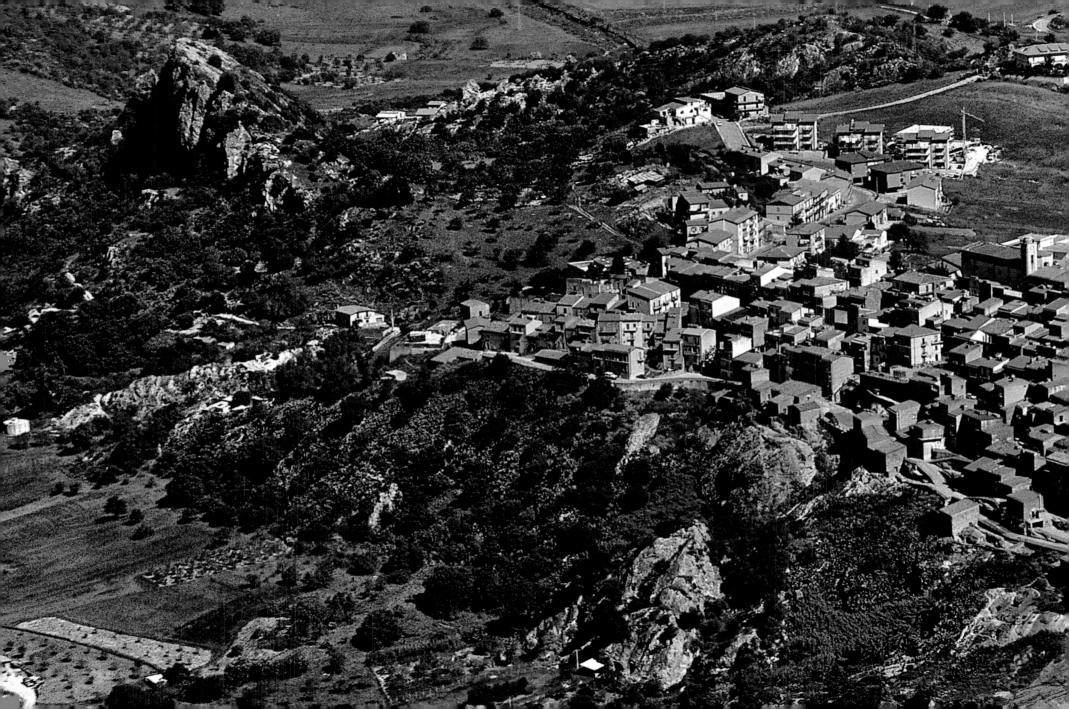

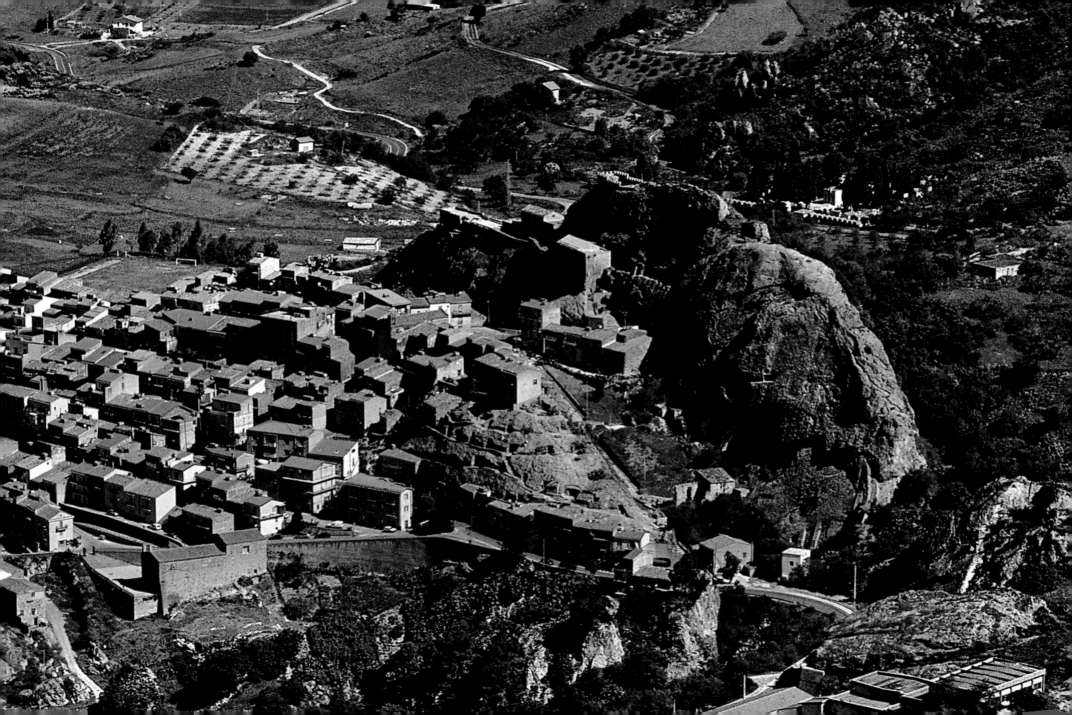

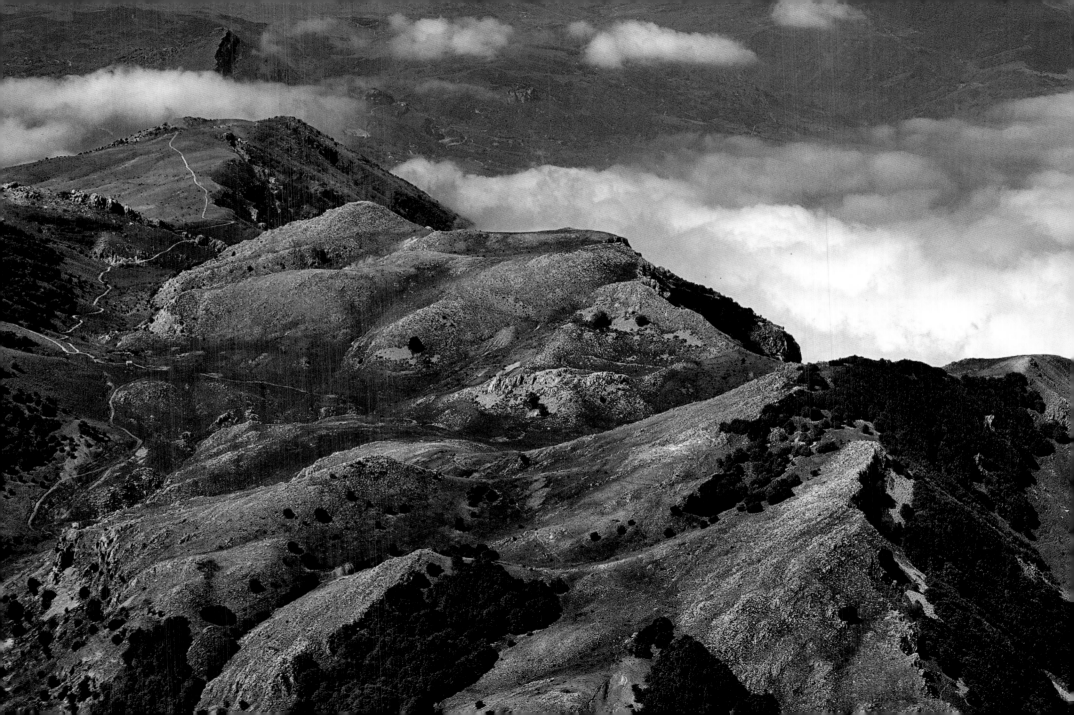

88 and 89 The Madonie are a real treasure house of geological, animal, landscape and botanical gems; for instance, the last 25 specimens of Abies nebrodensis, the Nebrodi fir, grow here, and at Piano Pomo, the park's central area, there are holly bushes that reach the incredible height of 14 meters, and have a circumference of four meters. Consequently the mountains are protected by the severe regulations of a nature park that was established in 1989, and which stretches south down the Tyrrhenian coast. The highest point is Pizzo Carbonara, a peak of over 2000 meters.

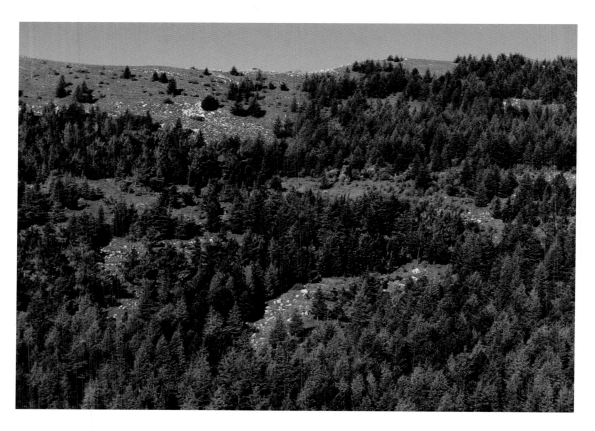

90 and 91 The scenery changes rapidly on the Madonie: arid, barren zones, characterized by karstic phenomena, alternate with considerable wooded areas with an abundance of water. Even the mountains, despite being just one chain, are quite diversified in appearance: on one hand gentle, green slopes cloaked in ilex, oak and beech, scattered with large valleys, used mainly as pastures; on the other, tall, rugged, almost dolomitic, peaks. Handy tracks give access to even the remotest nooks.

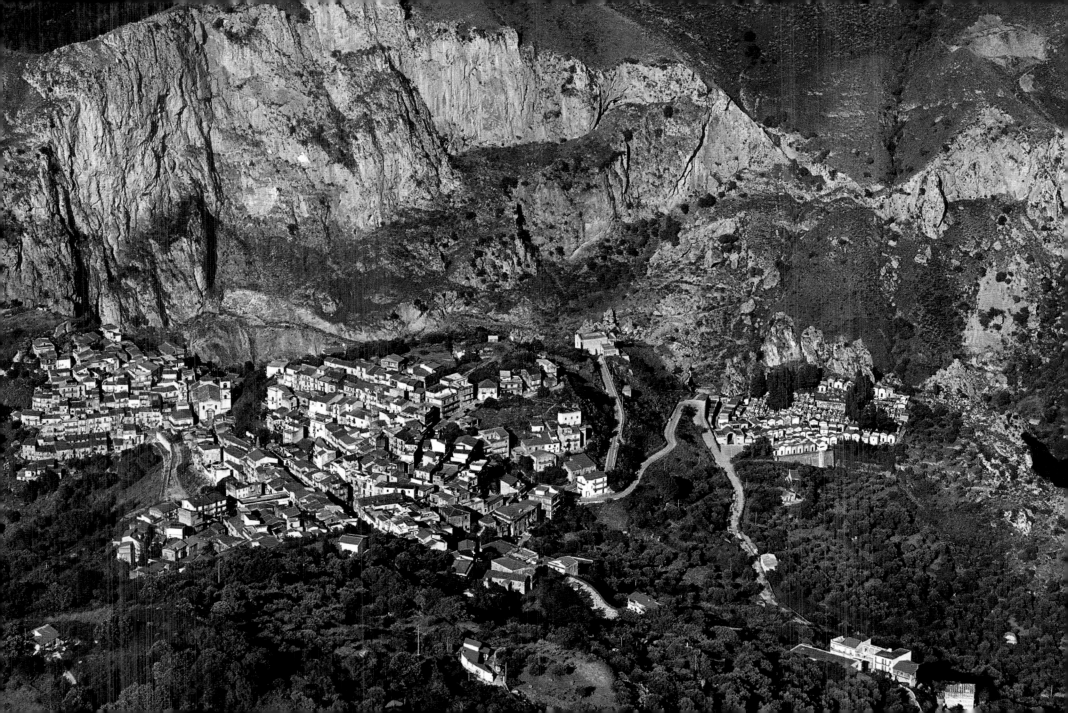

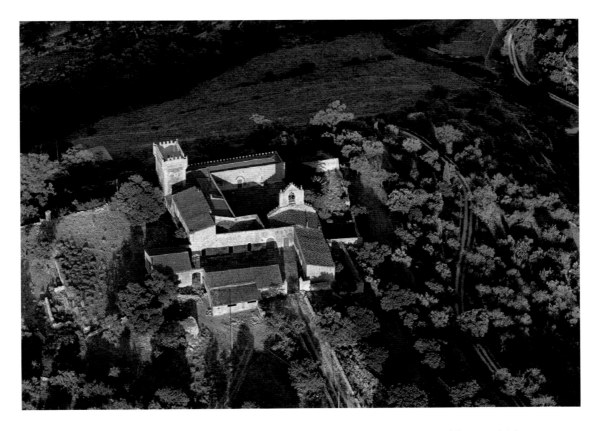

92 Gratteri, in the province of Palermo, takes its name from the Greek word krater, which means "basin." The town is famous worldwide for its chestnuts and almonds, which are collected on the surrounding hills.

93 Small, charming medieval settlements are to be discovered amongst the Madonie Mountains, retaining almost intact their old centers, with small houses huddled together along winding lanes, dominated by a church and a noble mansion – often even a castle – in varying states of decay.

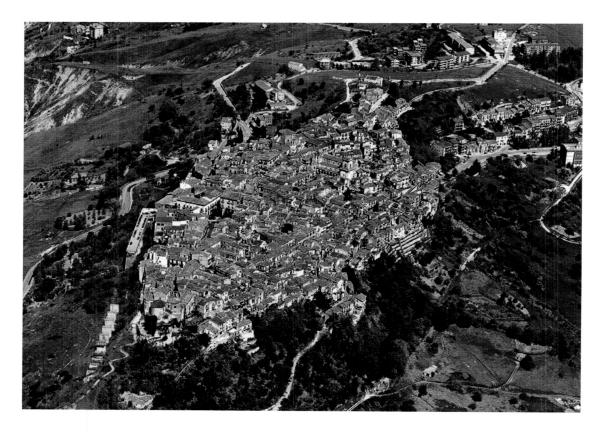

94 Petralia Soprana is the highest municipality in the province of Palermo. It is located in a lovely spot at an altitude of 1147 meters and though it is tiny it boasts quite an artistic and monumental heritage: the Mother Church and the Santa Maria di Loreto church are both noteworthy.

95 Caccamo's houses hug the hill slopes just east of Palermo. The town may actually have been founded by the Phoenicians and still retains a medieval layout, boasting not only its scenic central piazza dominated by the duomo, but also a magnificent castle, one of the best preserved in all of Sicily.

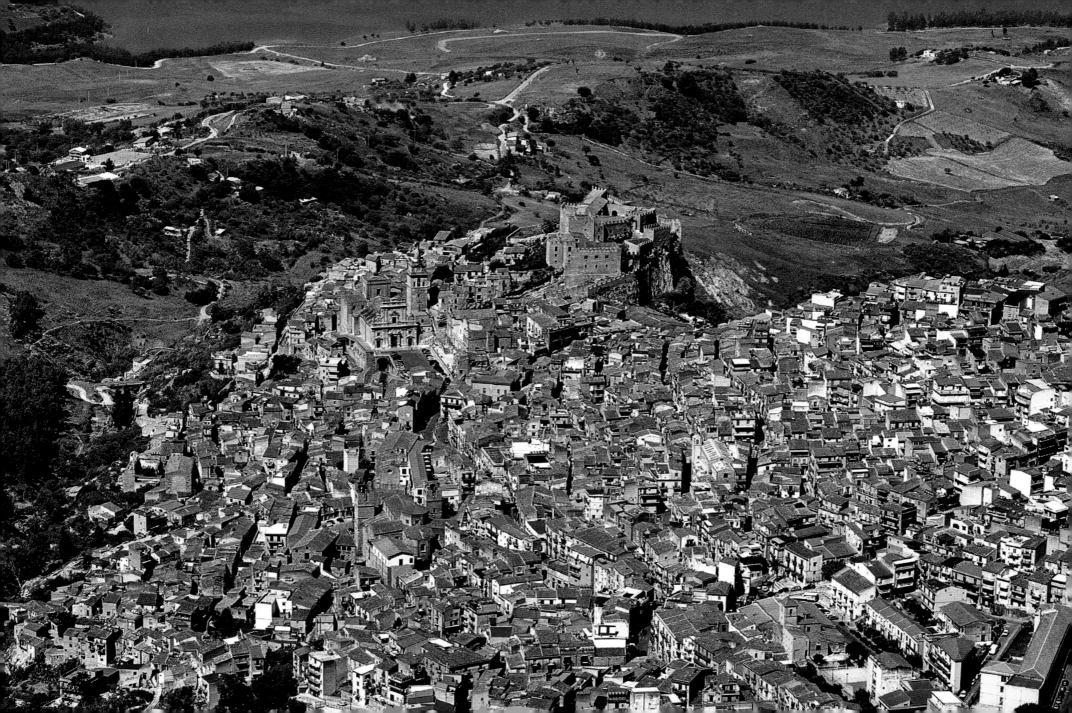

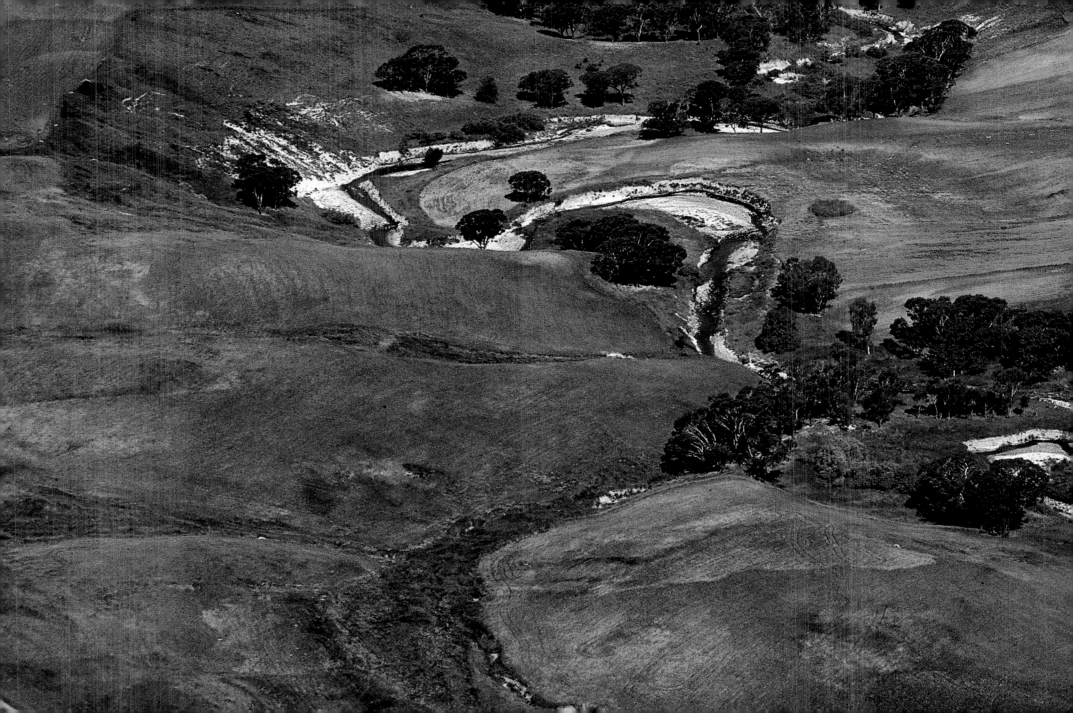

96-97 In spring the views on the Madonie Mountains might well deceive even an alpine expert: such green meadows and flowing water courses furrowing the rock are reminiscent of other latitudes.

98-99 Polizzi Generosa (a name given to the site by Frederick II of Swabia, charmed by the warm hospitality of the inhabitants) is built on a sort of natural terrace in a dominant position over the River Imera valley, in the province of Palermo. The town is well known for its handsome monuments, including the church of San Girolamo, and for its exquisite cuisine.

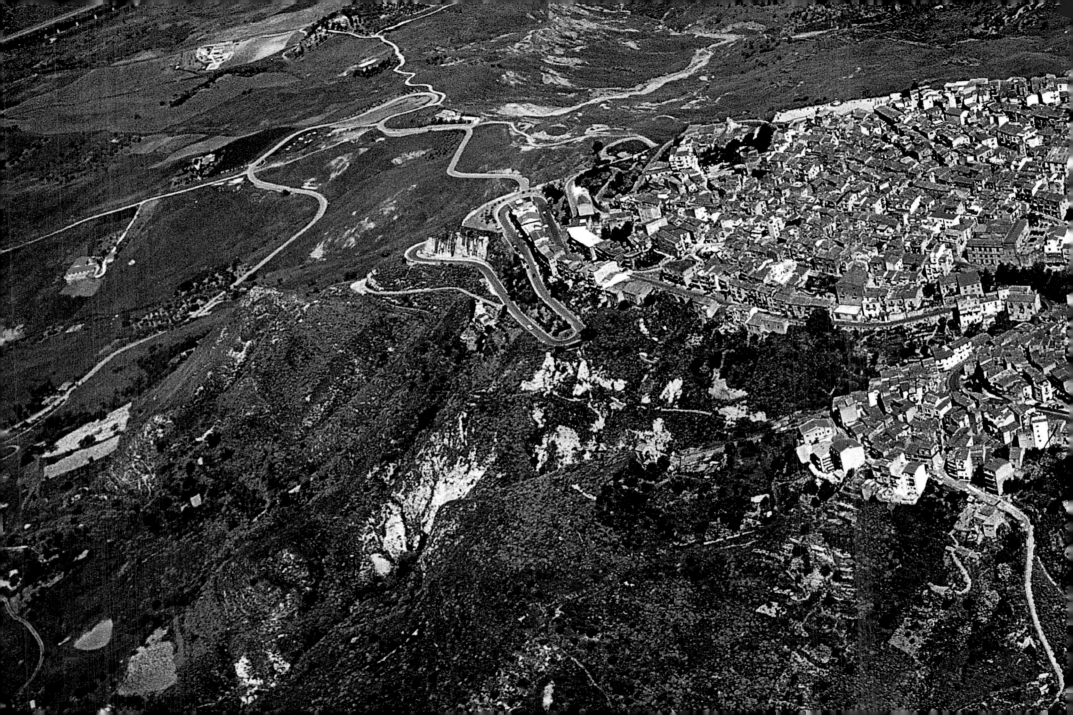

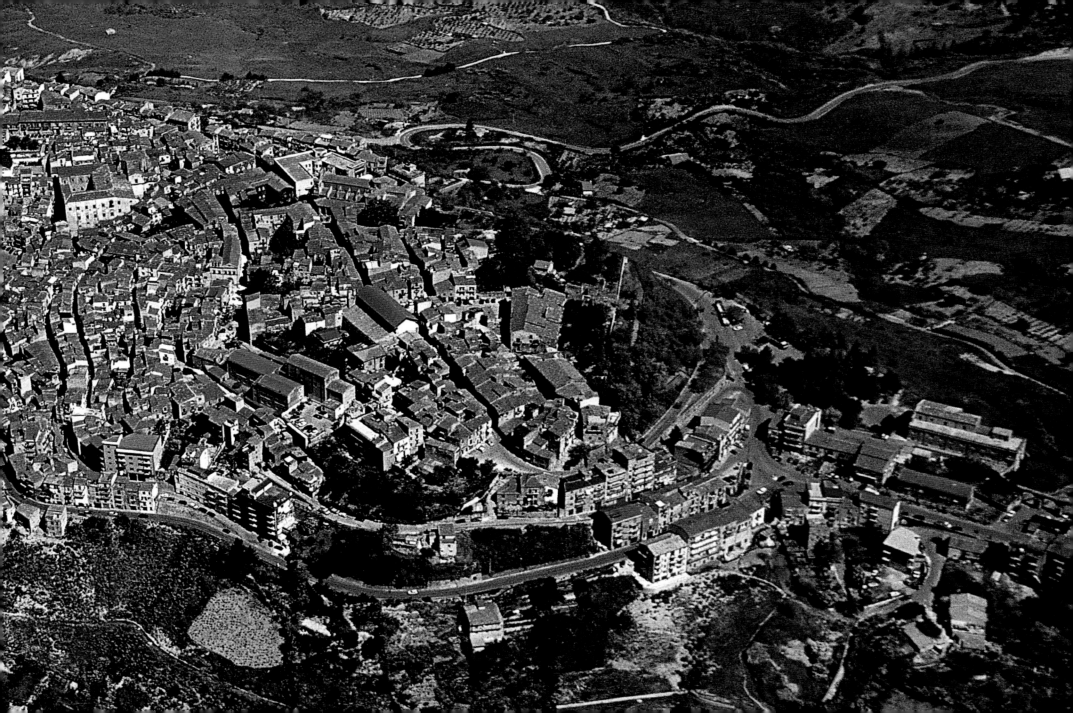

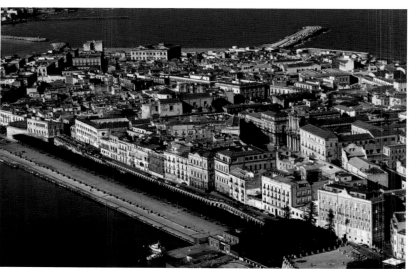

THE TOWNS

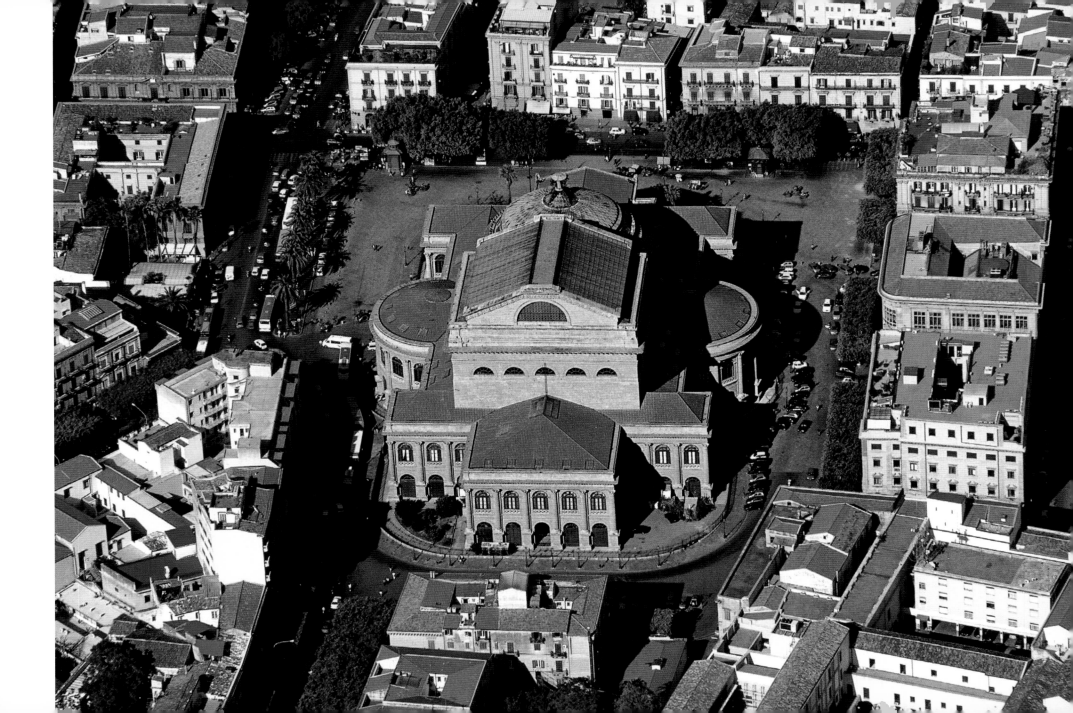

One summer morning – the exact year lost to the mists of time – a lone man on a small boat landed on the north coast of Sicily. He was spellbound, taken in by the luxurious vegetation, the coursing crystal-clear waters that sang as they plunged into the sea; the countless fish and wild animals to be found there; the range of sky-blue mountains encircling that magical place, the purest of skies. So he decided that this was where he would build a town, which slowly grew and, as the centuries past, became the city of Palermo. This is the legend narrated by the ethnologist Giuseppe Pitré, which says that from its foundation, Sicily's greatest city and capital (attributed by historians to the Phoenicians, in the eighth century BC) was constantly fought over and desired by all those who wanted to establish themselves on the island. The Greeks and Romans, the Arabs and the Normans, the French, the Spanish, the Bourbons – everyone wanted this city and as soon as they conquered it, they inevitably made it over to reflect their own culture. The Romans gave it mosaics, the Arabs added minarets, the Normans decorated buildings, set like "gems around the neck of a beautiful woman," the

Spaniards installed baroque volutes. This explains why Palermo today is the epitome of a city that combines sea and land, history and modernity, nobility, and proletarianism, wealth and poverty. Splendid palazzos soar over melancholy quarters, enormous cupolas pierce a turquoise sky and gaze down over narrow alleys, monolithic modern buildings encroaching on the orange and lemon groves that so enraptured Oscar Wilde. To admire Palermo at its best, we just need to find some high ground, like the top of Mount Pellegrino, which Goethe thought to be the "loveliest promontory in the world," or, on the opposite side, Mount Caputo and exquisite Monreale. The little town offers not only a view of the Conca d'Oro gulf and the entire shoreline, but is also the location of one of Sicily's most illustrious monuments: Monreale cathedral. The duomo was built by order of a Norman king, decorated with mosaics comprising millions of tiny gold tesseras, enhanced by a magical cloister, and from its vantage point dominates Palermo, like a noble animal keeping watch over the city. It's a similar effect to that of Etna, looming high beyond the city of Catania, which is often called volcanic. In many respects

100 left Ragusa, although one of Sicily's smaller provincial capitals, is famous for the significant number of Baroque monuments and is part of the UNESCO World Heritage program.

100 right Foro Vittorio Emanuele II is a wide tree-lined wharf, built in 1836, looking out over Siracusa's Porto Grande. On one hand the shimmering sea, on the other, elegant 1800-1900s buildings.

101 In the late 1800s an entire quarter of Palermo was razed to ground to allow construction of the Teatro Massimo, regardless of the priceless, mainly Baroque, architecture already present there.

103 Catania's bond with Etna is not just psychological, it is actually material, if we simply look at the lava stone used to construct small and large buildings, right from its foundation in the 8th century BC.

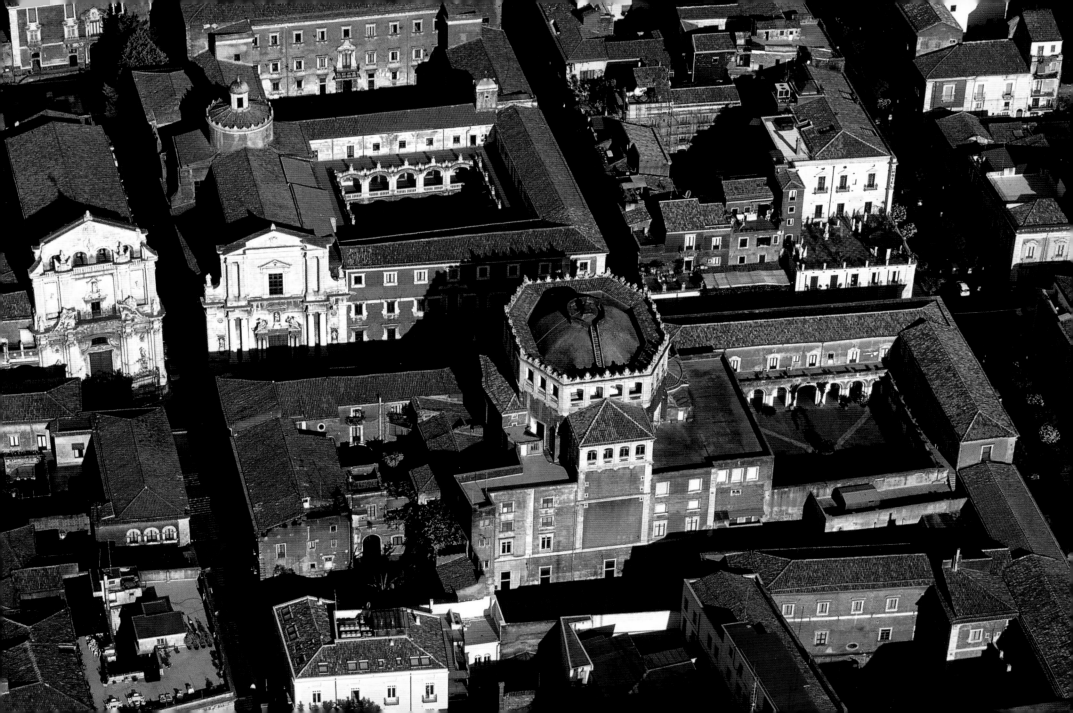

Catania really is the offspring of this great mountain, which over the years has given the stone for its construction and has forged the unruly, sunny nature of its citizens, people who have always distinguished themselves for their ability to knuckle down to work, even in the most difficult situations, building and rebuilding what the volcano is content to destroy. Nor is cost any object: the reconstruction following the 1693 earthquake, which destroyed the Val di Noto (the south-east tip of the island), furnished the city with strikingly lavish churches, piazzas, palazzos, and convents – a quantity of baroque monuments that just a few years ago led to Catania being included in the World Heritage program, alongside seven other small towns on the south-east cusp of Sicily. One of the towns was

Modica, with its characteristic "split-pomegranate appearance" (G. Bufalino), with half of the built-up area hugging a rocky spur and the other half scattered at its foot and the giddy San Giorgio defying the skies from the height of an endless staircase. Also included was Caltagirone, with blue, yellow, white, and green tiles winking from every balcony, each house number, each church and palazzo, and with its famous steep majolica stairway connecting the upper and the lower town. Then there is Noto, all golden stone, a convent, a church, a mansion, in quick succession, against an almost theatrical scenario of baroque volutes. And Ragusa, also clambering up and down the flanks of a quarry, with the skyline of Ibla that seems a miniature of huddled houses and lanes that suddenly widen on-

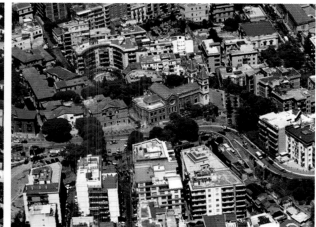

104 left Comiso (Ragusa), a large farming town on the south coast of Sicily, with countless 18th-century buildings, is famous as the birthplace of Gesualdo Bufalino, one of the island's greatest authors.

to small squares and terraces, as if to show us to best effect any of its countless views. The nobility that built here shrugged off the warnings of more earthquakes and ensuing damage in the future, and competed amongst themselves for the wildest creativity and spending to achieve endless types of decoration. Here a vine, there a grinning mask, putti here and horses there, pomegranates here and there scribes, innkeepers, angels, ladies

Siracusa has also been part of the UNESCO World Heritage program for some time, making Sicily the world leader in concentration of protected sites – an expected recognition, and in some ways appropriate, as it not only acknowledges history and art, but also the efforts made over the past few years to restore the city not to long-gone pomp, but at the very least to the beauty, dignity and amenity that are its due. So noe those who choose to visit Siracusa will discover not only the precious remains of its remote Greek past, but also lovely Ortigia, the quail-shaped island set in the center of the truly splendid gulf. The island's charming hodgepodge of Art Nouveau, Baroque, and Neo-classical buildings elbow their way through streets and courtyards towards one of Italy's most beautiful squares, under the watchful eye of the duomo's marble saints. On either side, the exquisite coastline stretches forth, interspersed with grottoes or with white beaches sloping down to the turquoise sea, furrowed by colorful typical fishing boats. Soaring high and allowing our gaze to follow the shoreline, we will see it rise and fall, becoming wild and dark as it gradually approaches Etna, with beaches of round, black pebbles, then lighten up again in the vicinity of Taormina. Even the most prolific writer runs the risk of being struck dumb when faced with this location, not least of all because it has a very long list of admirers: Wolfgang Goethe, Johannes Brahms, Oscar Wilde, Anatole France, to name but a few of the most famous names. It has been described in minute detail: its famous theatre, its vaunted atmosphere. To quote the words of Guy de Maupassant: "if anyone was allowed just one day in Sicily and asked: what should I see?, I would reply without hesitation: Taormina. It is just a landscape, but a landscape of everything that exists on earth for seducing eyes, mind and imagination." So the traveler who stands on the belvedere, intent on enjoying not just the panorama but also the grainy cold of a granita offset by a fluffy brioche, would be convinced that nothing better could be encountered.

Yet it is so easy to contradict this conviction: we simply continue on our imaginary flight, heading north for Messina and its Strait, skimming past the "Madonnina della Lettera" statue on her column,

104 center Modica (Ragusa) for many years the capital of a great feudal estate that covered what is now, more or less, the province of Ragusa. The town is considered a capital of Sicilian Baroque.

104 right Messina, "the gateway to Sicily", is an ancient port. Nonetheless, the 1908 earthquake and World War II bombings mean that the city now has a modern look, with few, although significant traces of its long history. The image shows the Sanctuary of Montalto.

watching over the port, the sixteenth-century fountains, the seafront and its pretty little houses. This is where we can enjoy the midday event of the cathedral's belfry clock, coming to life each day with saints and animals that strike out the time with roars, chants, and pirouettes, with the gentle slope of the Peloritani Mountains in the near distance and, at the far east tip of the coast, the small Ganzirri lakes and the Strait's unruly currents. This is where marine biologists set sail to track the movements of whales and dolphins; it is where migrating birds fly overhead. But it is not the only place where the tireless flocks can be seen in flight. Storks, flamingoes, herons, and ducks can be found everywhere, even on the other side of Sicily, where the coast crumbles into myriad cliffs and Trapani stands, "a city of little space and no great size, white as a dove" (Ibn Giubair). More precisely, they linger amidst the windmills and great salt pans, in an unpolluted environment of significant beauty, an endless checkerboard of glittering water at the gates of the capital. For those visiting Trapani, a walk around the salt pans is well-nigh compulsory, but there are other locations worth visiting: the seafront, the Ligny tower, the old center, and the city's splendid churches. The journey from Trapani to Erice takes the blink of an eye: up a winding road across the mountain slope that stands out against the seascape to the medieval town, one of the most spec-

tacular in Sicily, with its switchback streets, bare stone houses, and tiny squares and courtyards filled with geraniums, bougainvillea, jasmine, and wisteria; patisseries wafting the aroma of the typical almond pastries; the castle and its towers glimpsed amidst the pines that slope down the mountainside. Here we can cast our gaze in every direction: over the sea and the Aegadian Islands, across the undulating interior and down along the coast, the Stagnone islets, Marsala set amidst its vineyards, dense with churches and mansions, a devout custodian of the memory of Garibaldi.

Quite different, but equally extensive, is the panorama to be enjoyed from Enna, in the heart of Sicily, a town at such a high elevation that Arab geographers chose it to map out the virtual lines for dividing the newly-conquered island into "valli" (provinces). In remote times the ancient Sicilians built a temple here, in honor of Ceres, the goddess of fertility, knowing full well that from above she could more easily observe and safeguard the countryside, with its sun-kissed expanses of vineyards, olive groves, and fields of corn, the pastures dotted with herds of cattle and flocks of sheep. The same panorama unfolds before the eyes of the modern traveler, with hills seeming to overlap, sleepy farming villages, and mountain peaks in the distance, and Etna, omnipresent, watching over its territory, always.

107 Siracusa's long Piazza Duomo, in the heart of the island of Ortigia, the city's old center, dominated not only by the cathedral but by other churches and buildings. An architectural scenario of rare elegance, making this one of the loveliest in Italy.

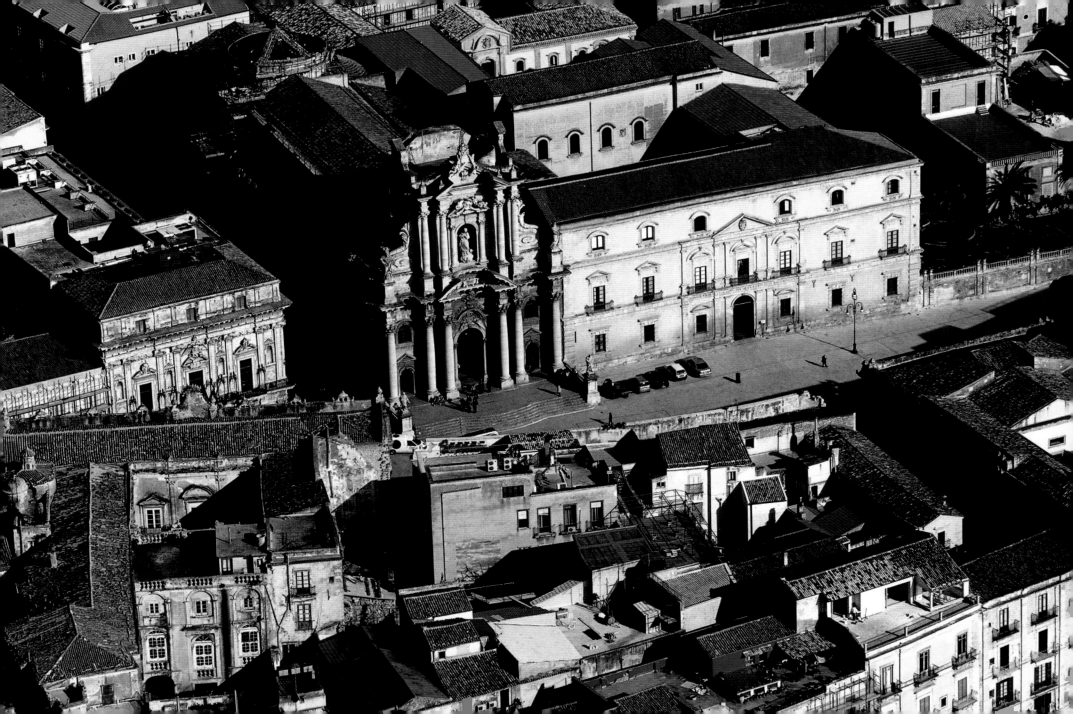

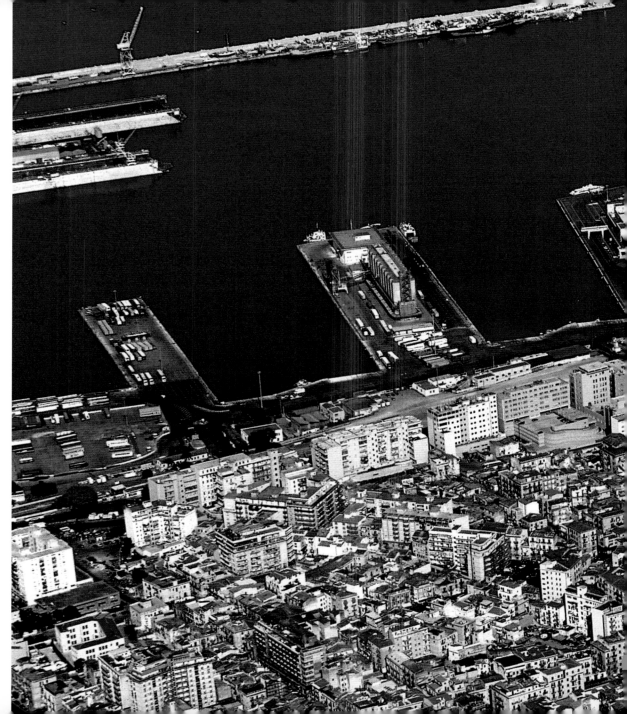

108-109 Palermo has always been a
seafaring city, on one hand modern and lively,
with elegant avenues and modern buildings,
but on the other, vigilant custodian of its
past memory: almost 3,000 years of history
have left so many priceless traces in its
massive old center.

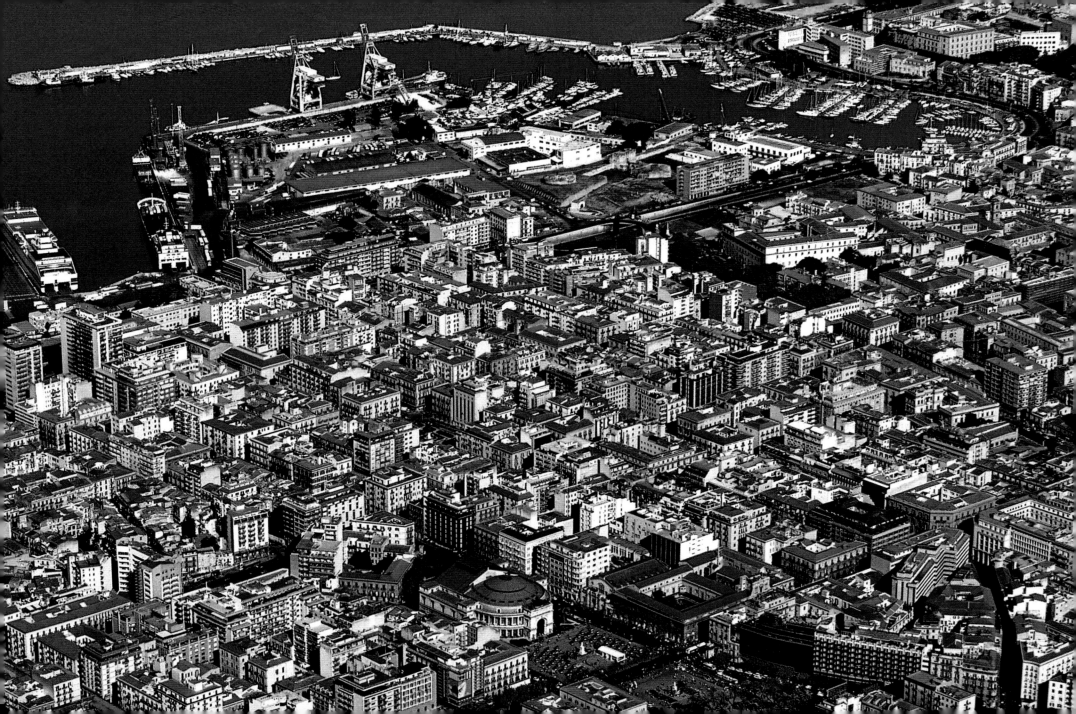

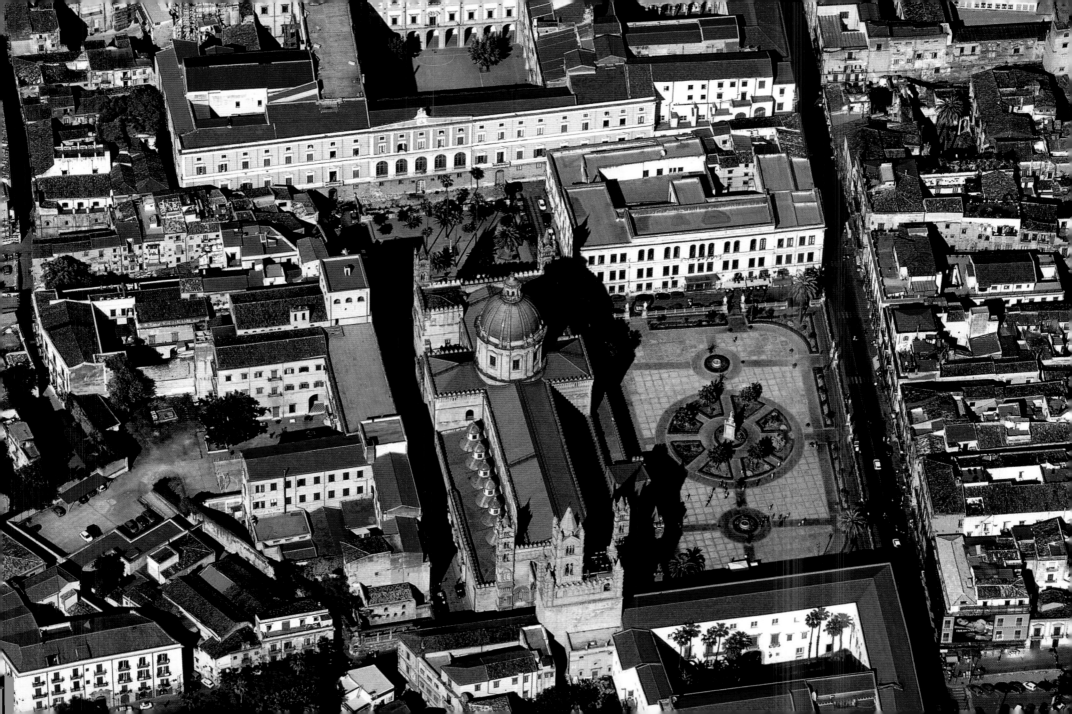

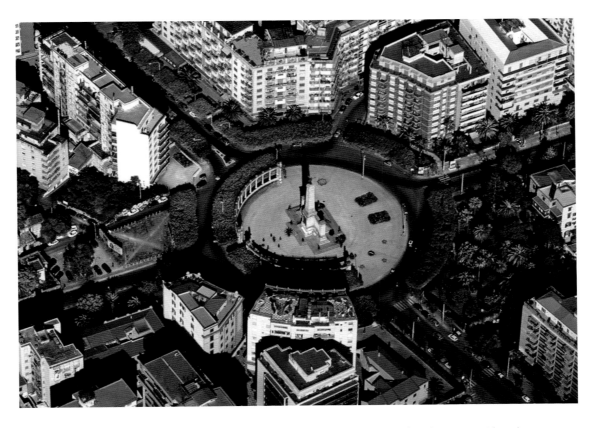

110 Palermo cathedral and the great parvis occupy a territory that has been considered sacred since the city was founded by Phoenician merchants. This is where the early temples were built, followed by the main mosque of the Arab city, then replaced by a Catholic church.

111 Superb Piazza Vittorio Veneto, Palermo, closes the northern side of Viale della Libertà, and is hallmarked by its semicircular colonnade with the lovely war memorial in the centre.

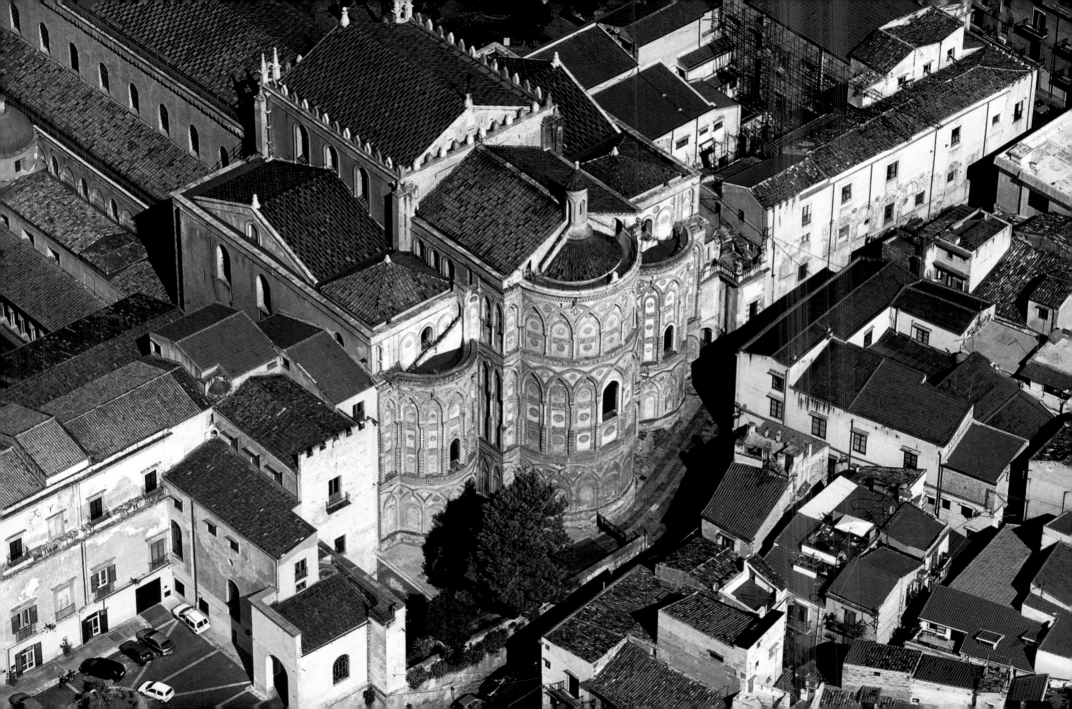

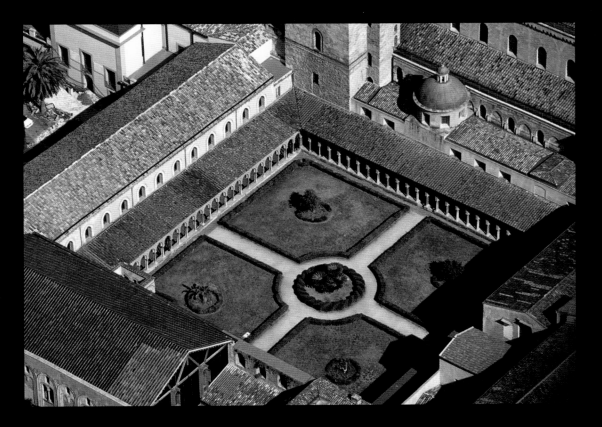

112 and 113 Monreale (Palermo) duomo, and the neighboring Benedictine abbey, with its magnificent cloister (image to the right), were built by order of the Norman monarch, William II, in the 12th century. The Norman stamp is evident in a number of details, including the false archlets that decorate the apses (left) and are actually to be seen repeated in other churches of that period. In other parts of the complex there is evident stylistic homage: fine gold mosaics inside, for example, in the best Byzantine tradition.

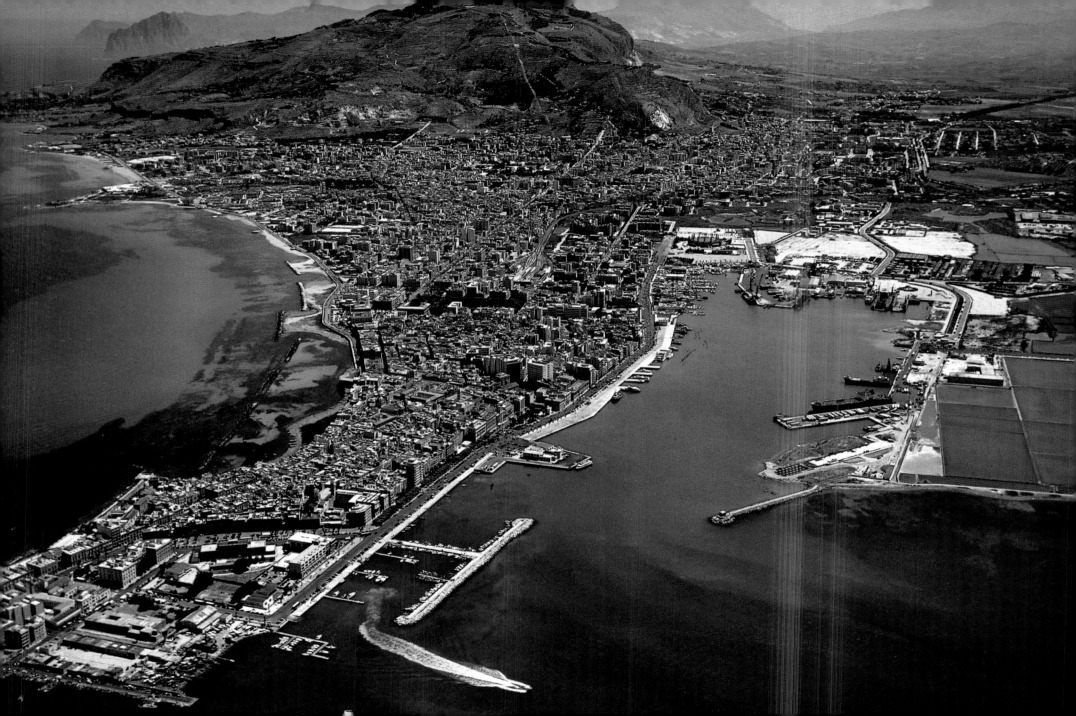

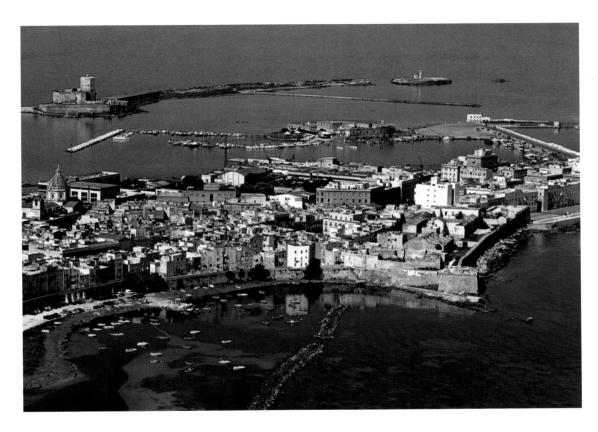

114 and 115 The sickle-shaped strip of land where Trapani is built inspired its historic name: Drepanon, which in Greek means, precisely "sickle". This is where the town's old center is now located, with lovely churches, aristocratic mansions, elegant streets. The entire area, especially near the seafront, has recently undergone meticulous restoration. The famous town of Erice hugs the crest of the mountain behind the city.

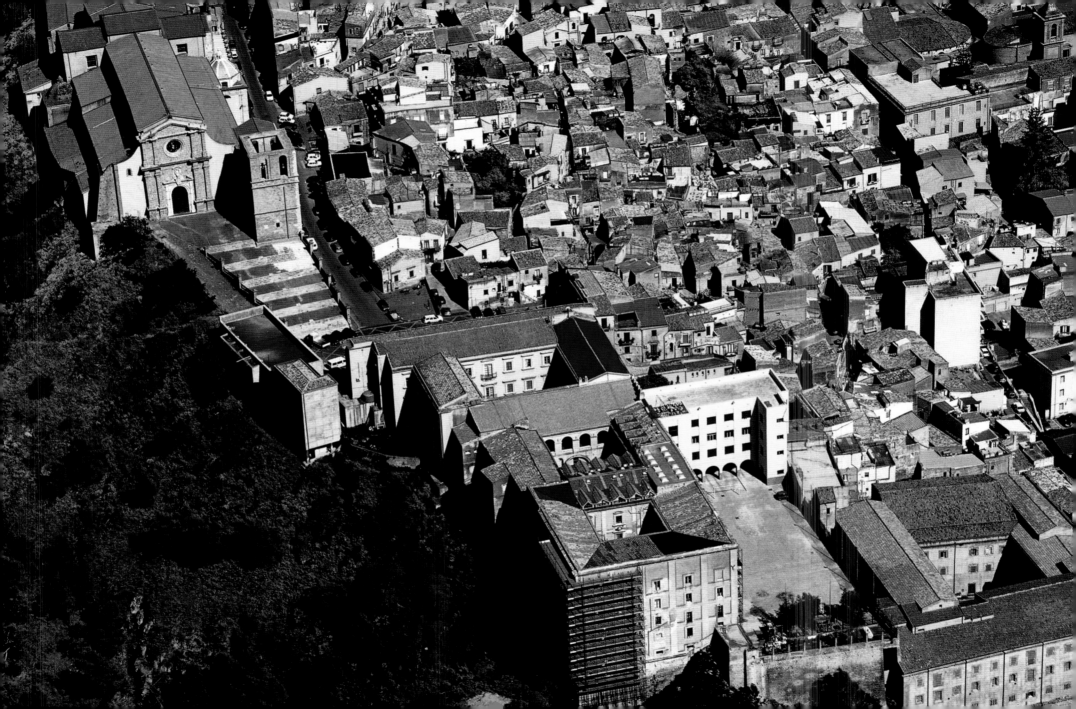

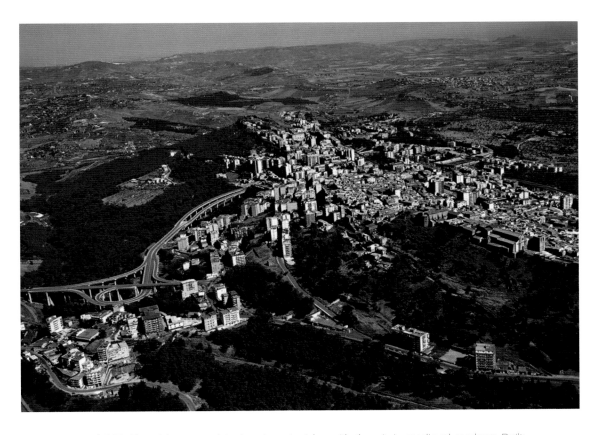

116 and 117 The old center of Agrigento coincides with the city's medieval nucleus. Built from the 7th century AD on a hillock behind the Valley of the Temples. Via Atenea is the sinuous backbone that cuts through the entire district, which has some interesting monuments, including the handsome cathedral of San Gerlando (left). Modern buildings, sadly not always attractive, and the main roads, are installed all down the sides of the hill.

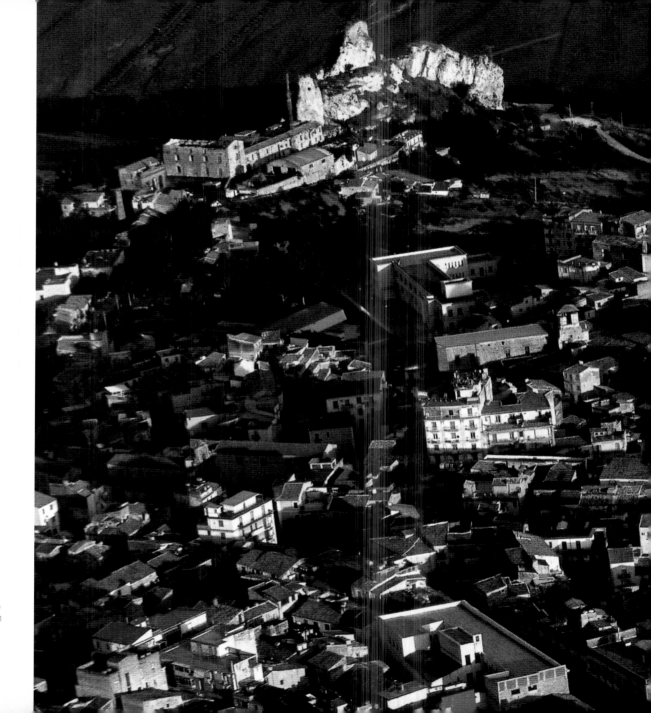

118-119 Caltanissetta cathedral, Santa Maria la Nova and San Michele, built from the 1500s to the 1600s, is the beating heart of a city that, in its own turn, is the heart of feudal Sicily, with its sulfur mines: reticent, secret, little known.

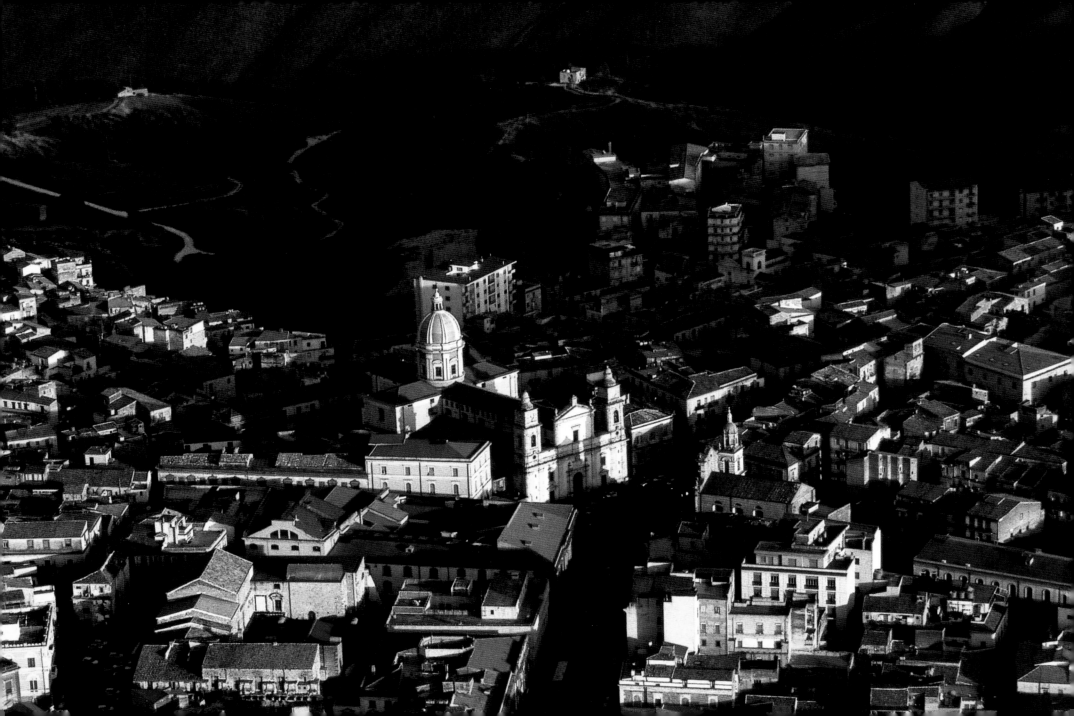

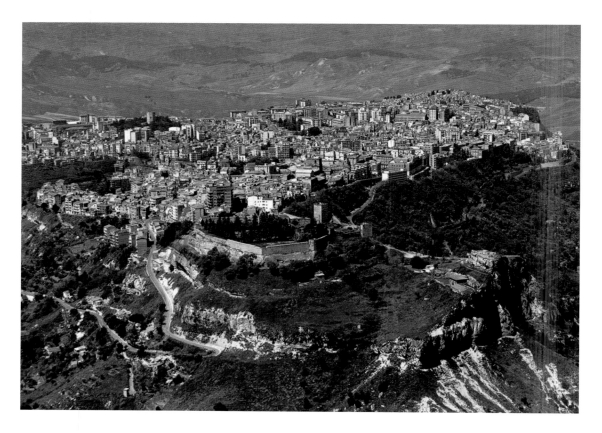

120 and 121 Enna is built on a wide terrace of rock (left), precisely in the center of Sicily, at 931 meters above sea level, and it is traditionally thought that from this vantage point Arab geographers mapped out the boundaries of the three "valleys" that were pinpointed to administer the island. Later its position was always significant, as it was easy to defend. Its castle, known as "Castello di Lombardia" (above), was only ever conquered by resorting to treachery. A mere six of the original 20 towers survive.

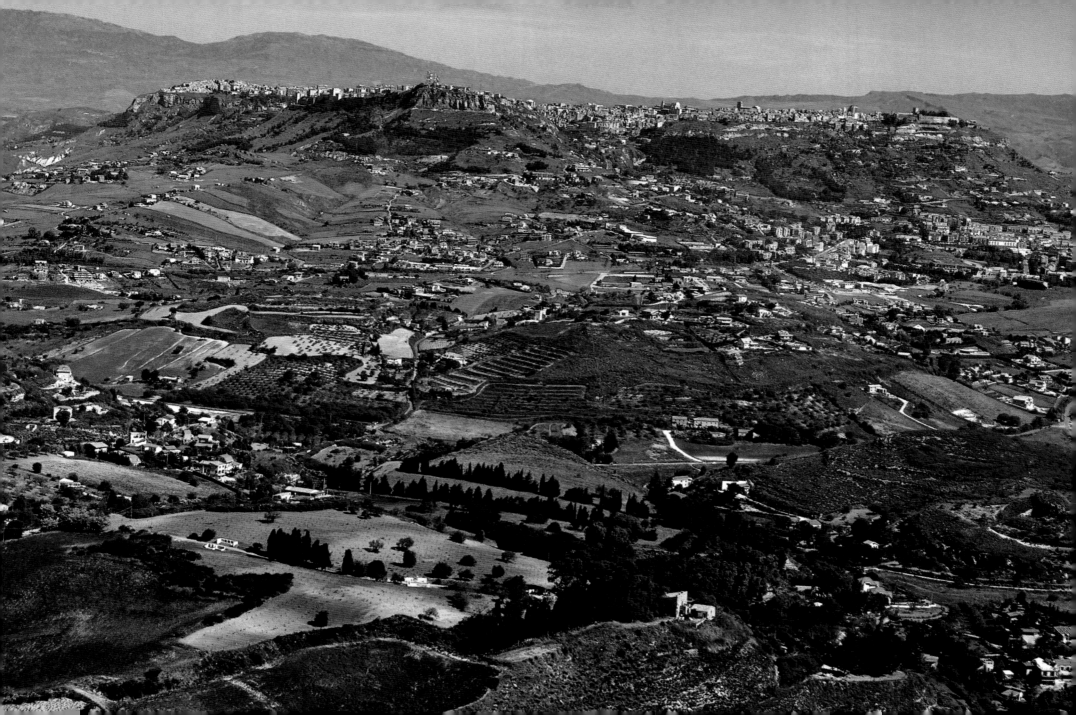

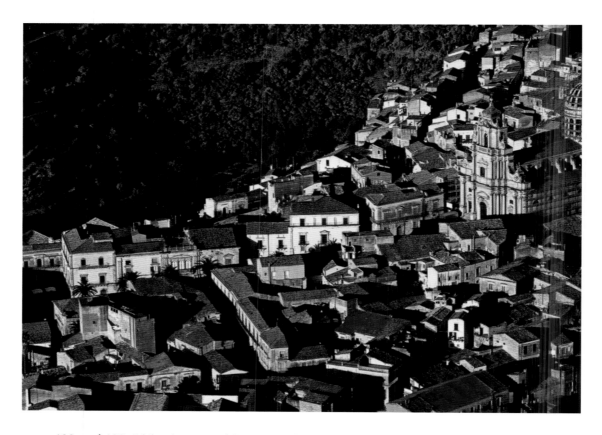

122 and 123 Whilst devotees of St George decided to rebuild their houses on the site of what is now Ibla, devotees of St John moved north. So Ragusa's dual nature had developed into rivalry amongst its residents and following the 1693 earthquake they underscored their difference, symbolized by this devotion to two saints, ever the more. The city was rebuilt, therefore, in different locations and each quarter has its own duomo: San Giorgio (see left) and San Giovanni (right). Today the rivalry between the two "belfries" has in no way abated.

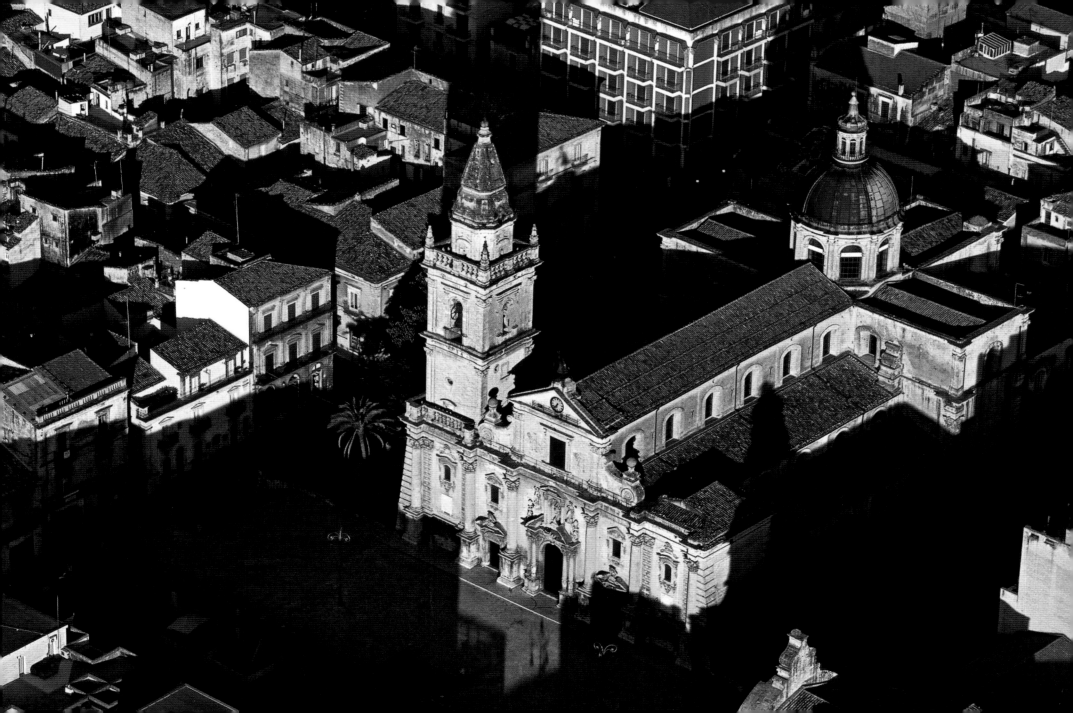

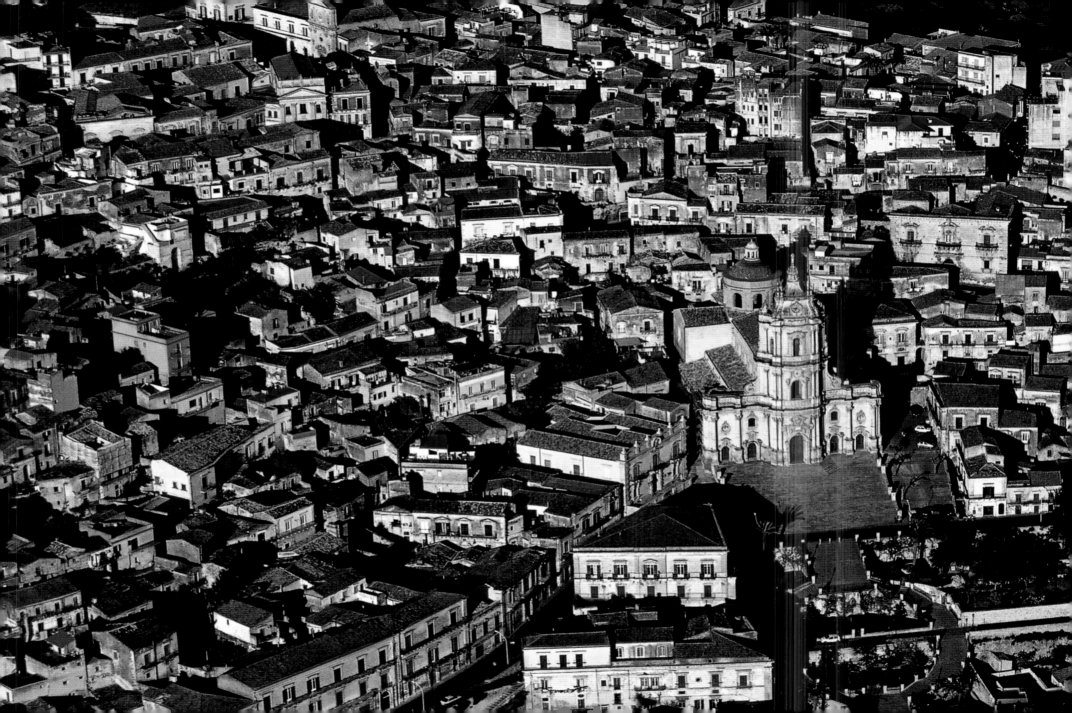

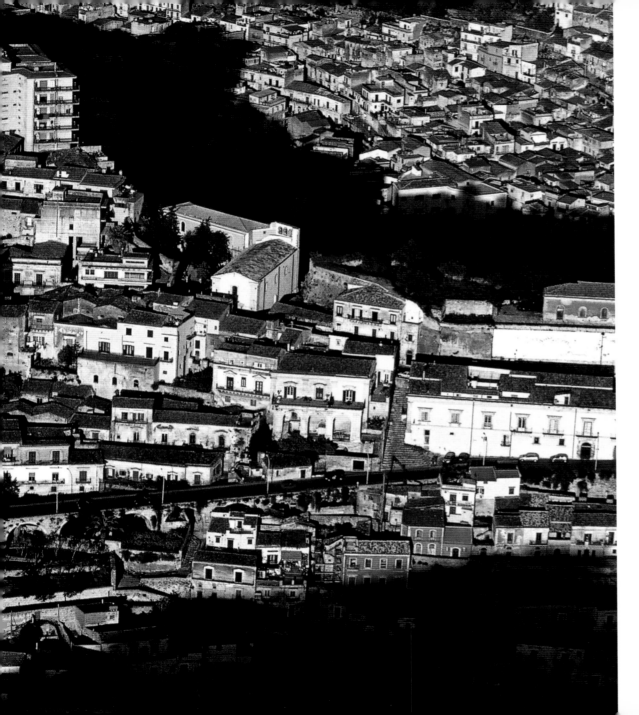

124-125 The very high façade of the church of San Giorgio, Modica (Ragusa), is a distinctive feature in many of the 1700s churches in the Ragusa area. The illusion of breathtaking height is accentuated by the preceding staircase, with 250 steps that lead the visitor's gaze even further skywards.

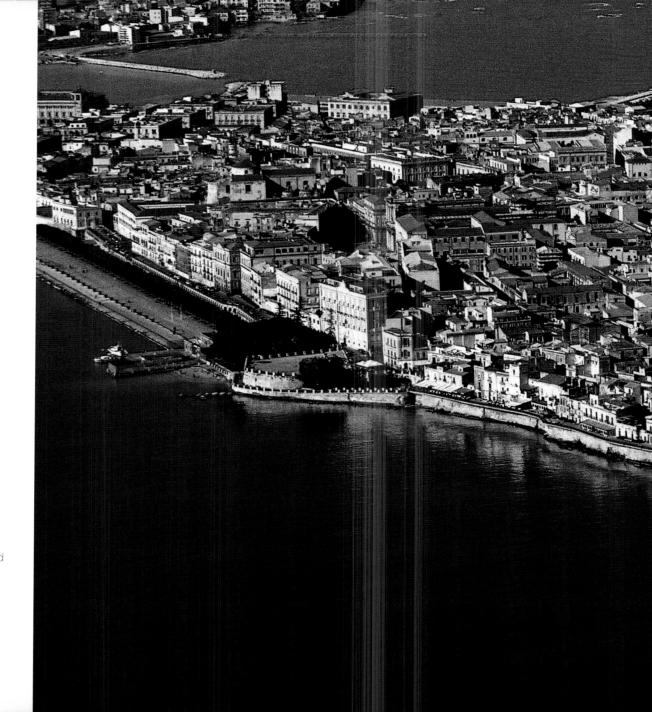

126-127 In 1239 Frederick II of Swabia ordered the construction of one of his loveliest fortresses. On the far tip of the island of Ortigia we find Castello Maniace, an impressive, perfectly square structure, with the classic corner towers.

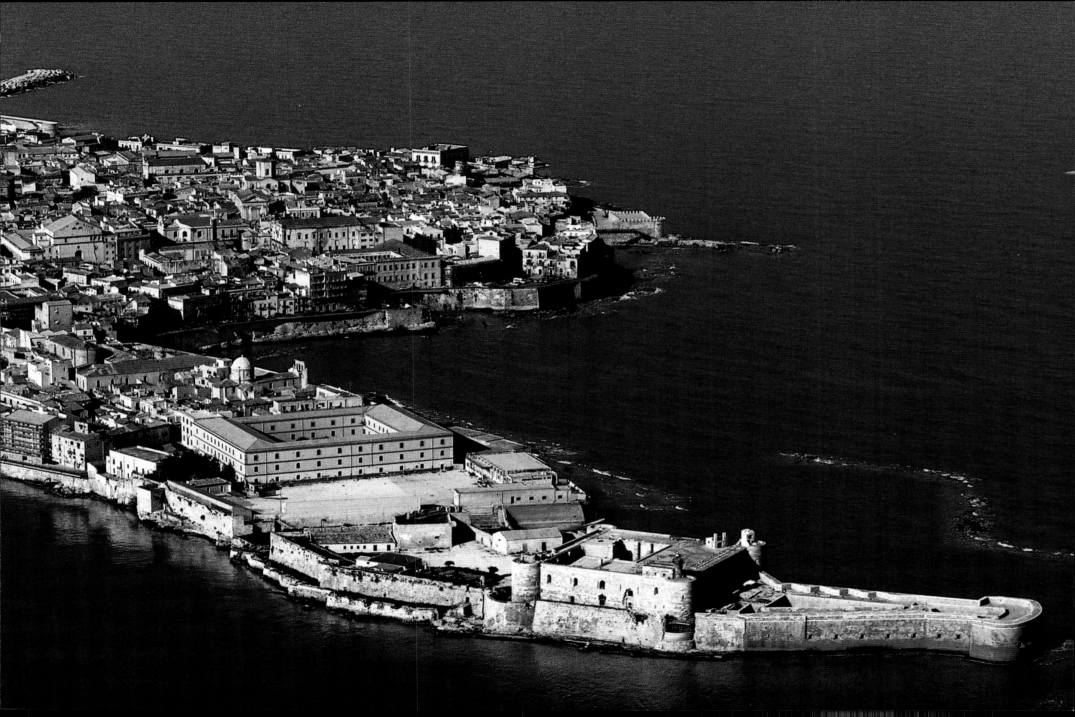

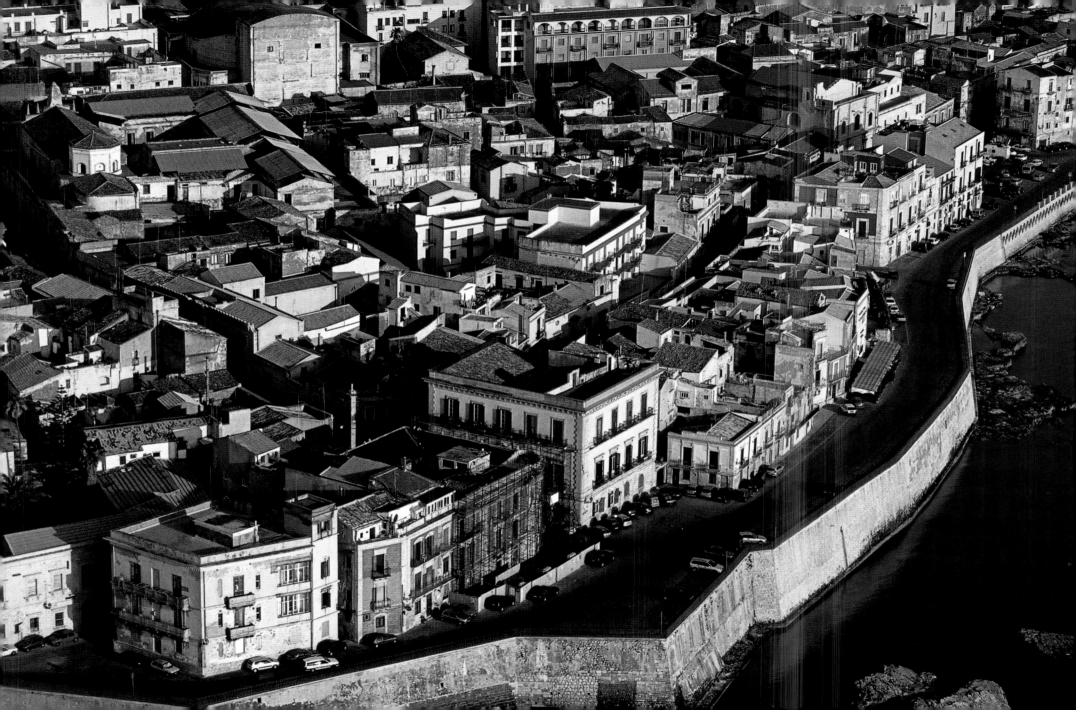

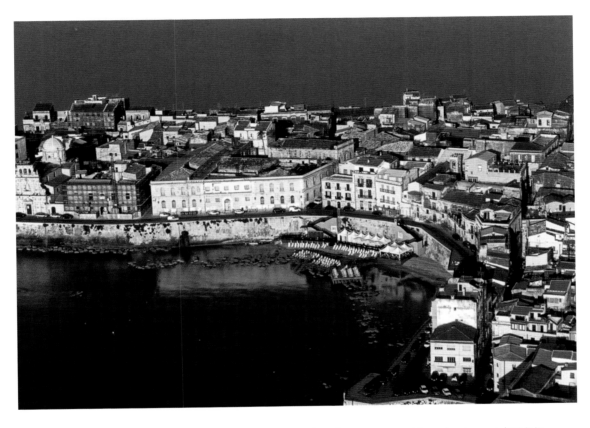

128 and 129 The islet of Ortigia is a lick of land, barely one square kilometer in area, but it is where the entire history of Siracusa is concentrated, from the Greek period to the 20th century. Its buildings speak of religions and wars, of love of beauty and power. Thanks to a series of public and private schemes an extensive recovery has been possible and today we see a magical location, lapped by a clear sea.

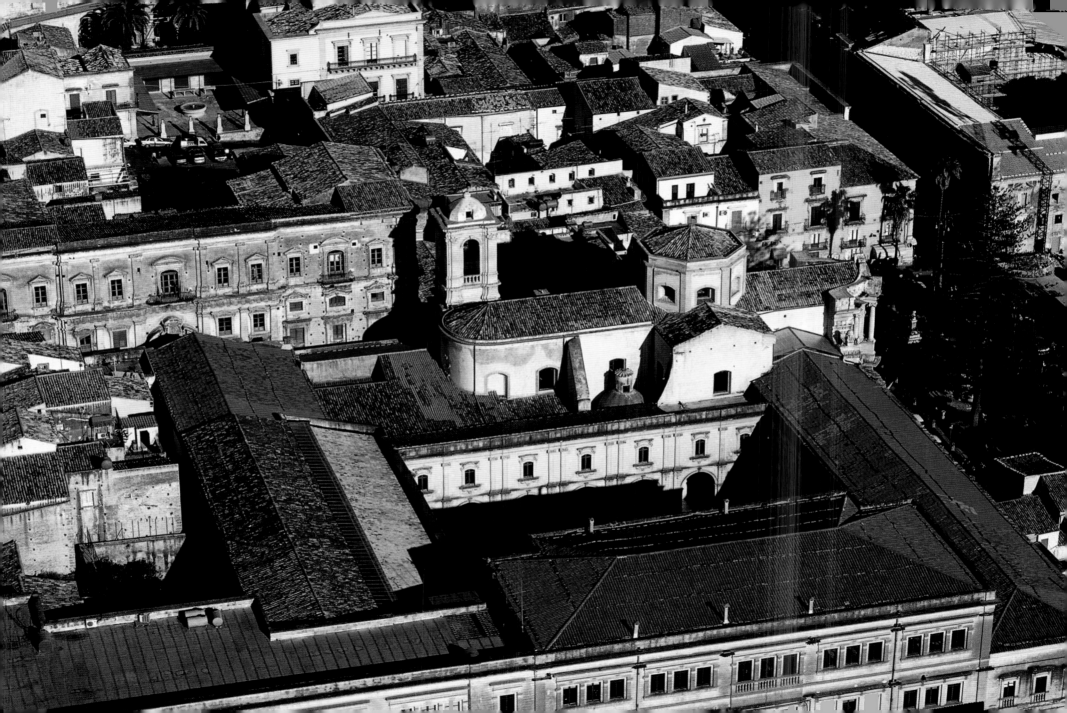

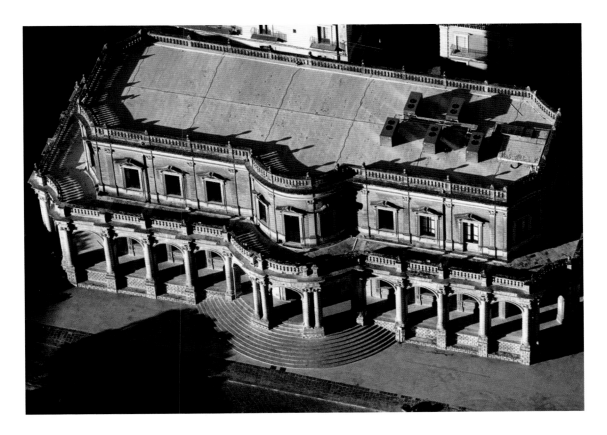

130 and 131 Noto, province of Siracusa, with its churches, convents and elegant palazzos, was entirely rebuilt during the 1700s, using the Baroque style, of which Sicily has long been considered the essence and this town its epitome. From the complex of San Domenico (left) to Palazzo Ducezio (right) now the town hall, designed by the architect Sinatra, and dated 1748.

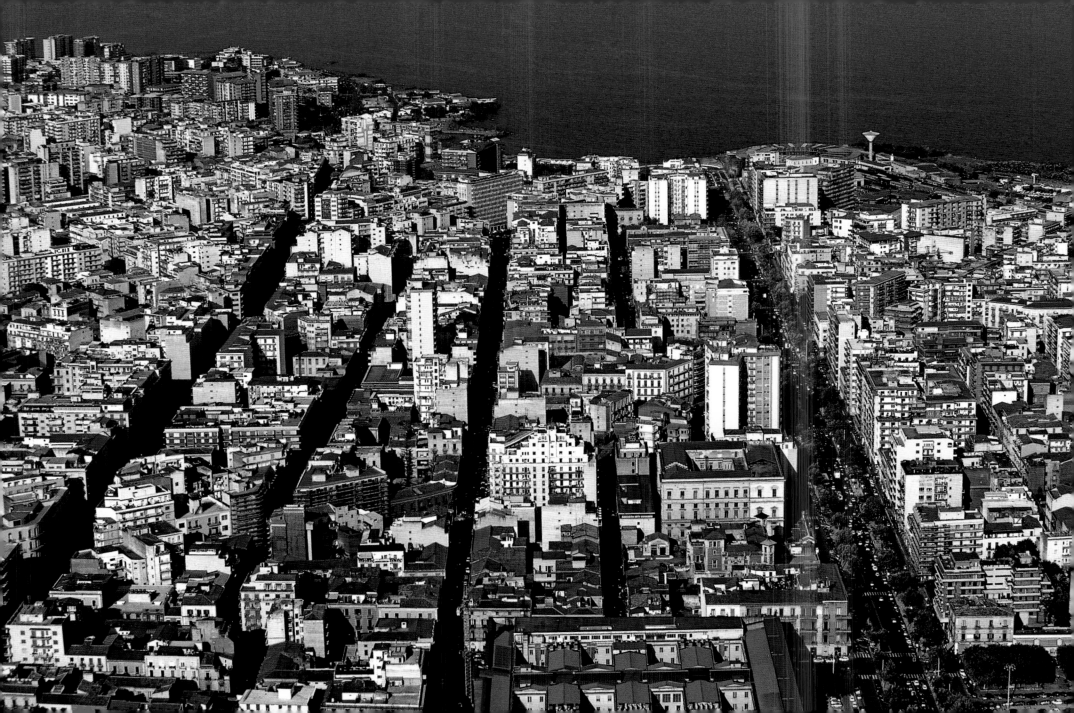

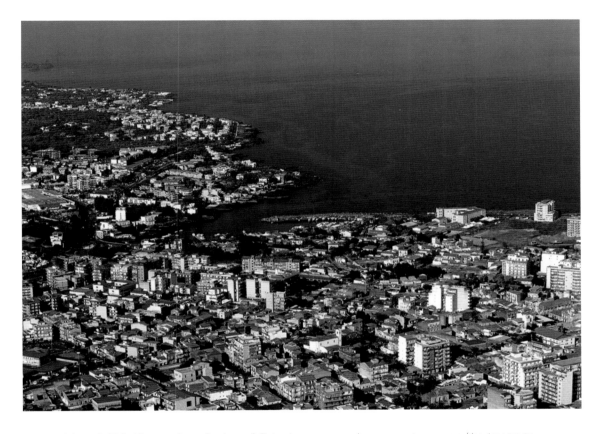

132 and 133 The modern districts of Catania appear as long, smart avenues (the image to the left shows Corso Italia, recognizable thanks to its trees) that lead down to the seafront, lined with buildings in pleasing architectural style. Catania has always been one of Sicily's most sparkling, lively cities, often in the forefront thanks to countless financial and cultural projects.

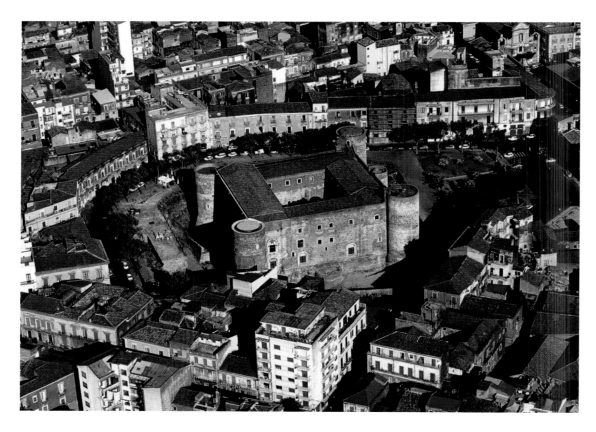

134

134 Ursino castle, a massive lava stone fortress of the period of Frederic II, was originally built on a promontory that pointed out to sea. In 1669, a terrifying lava coulee erupting from Etna reached Catania and surrounded it completely, thereby separating it forever from the sea.

135 Catania cathedral is dedicated to the patron saint, Agatha. It was originally a fortress church, built in the 11th century by order of Count Roger the Norman, over the preceding Roman structures, and converted to the Baroque style in the 1700s.

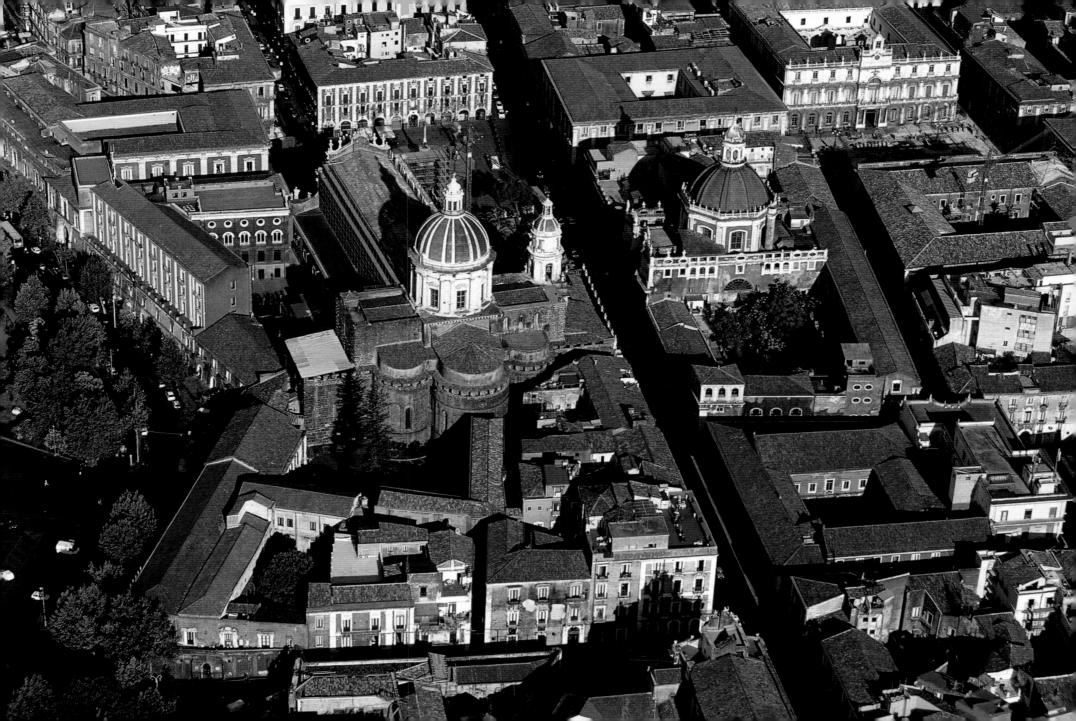

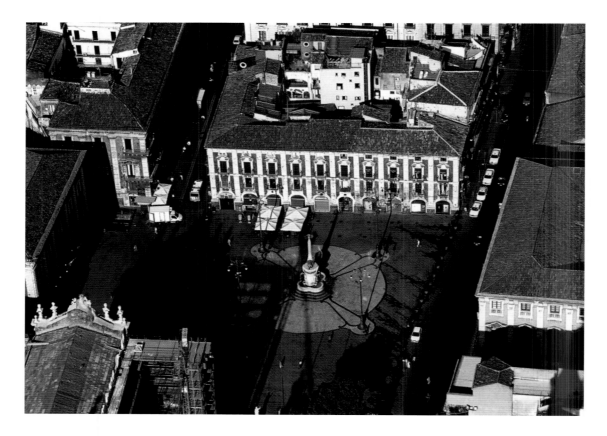

136 Catania city hall, also a Baroque building, is opposite the cathedral. Separating the two, at the center of the piazza, we find a fountain called "u liotru", the symbol of Catania, with a small lava stone elephant, supporting an obelisk and the insignia of the patron saint.

137 Catania's Teatro Massimo Bellini opera house was inaugurated in 1890, with a performance of "Norma", the masterpiece by the young local composer after whom the building is named. After recent restoration it now hosts a vast and prestigious annual calendar of opera and ballet, performed by some of the greatest names of the international scenario.

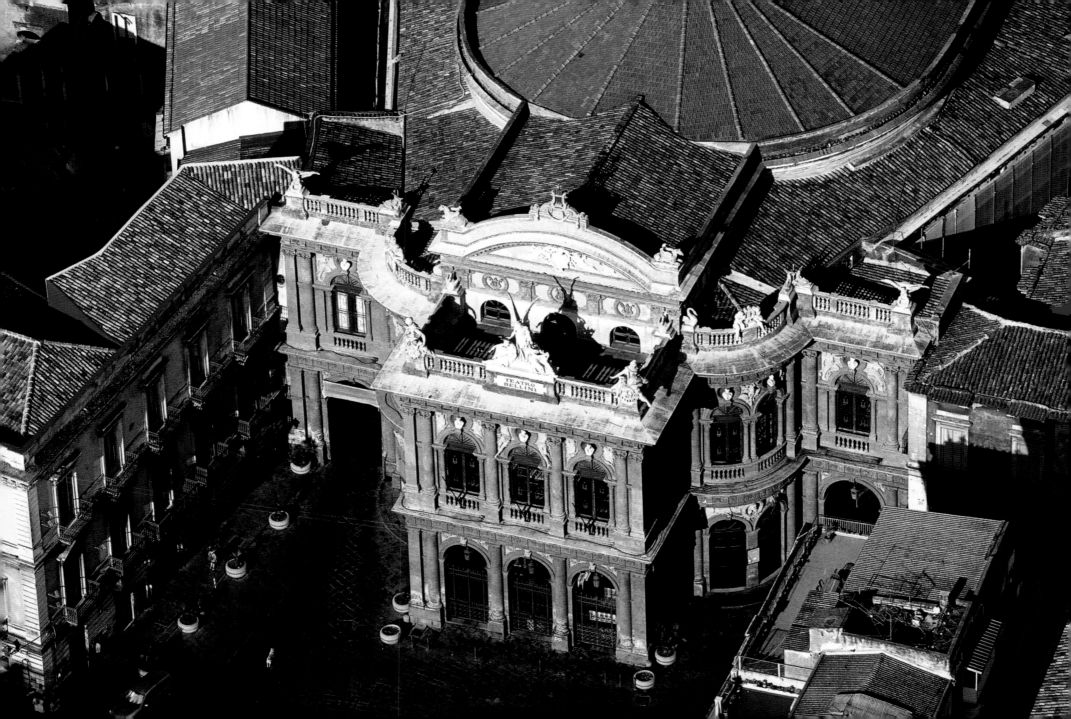

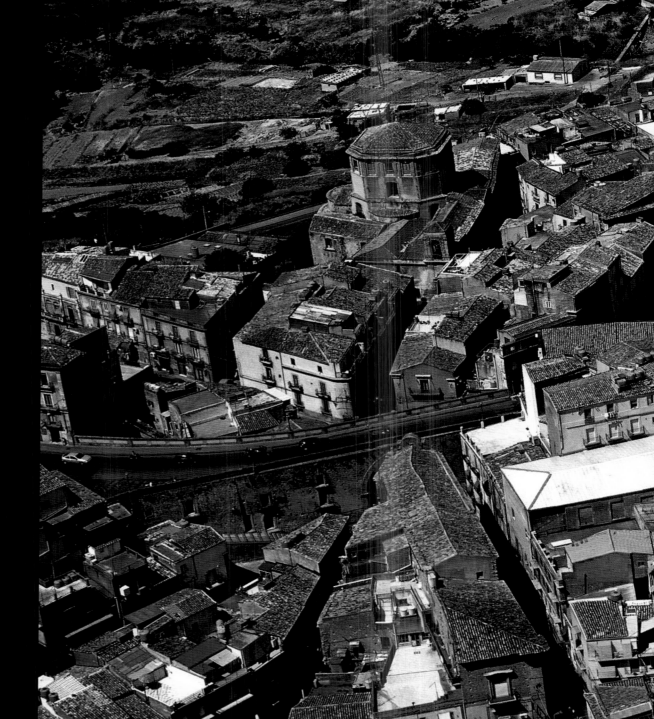

138-139 Caltagirone (Catania), an elegant town of Baroque form, is one of the island's capitals of pottery production. This craft is rooted deep in history and can even be traced back to prehistory, as documented by Italy's second most important ceramic museum, located here.

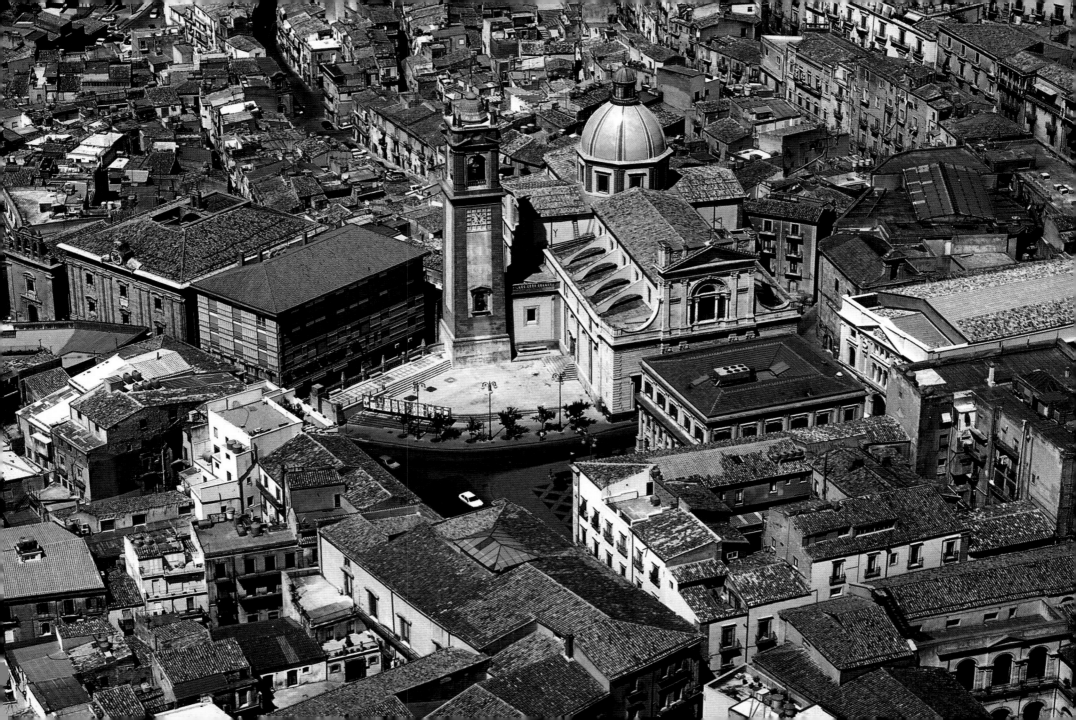

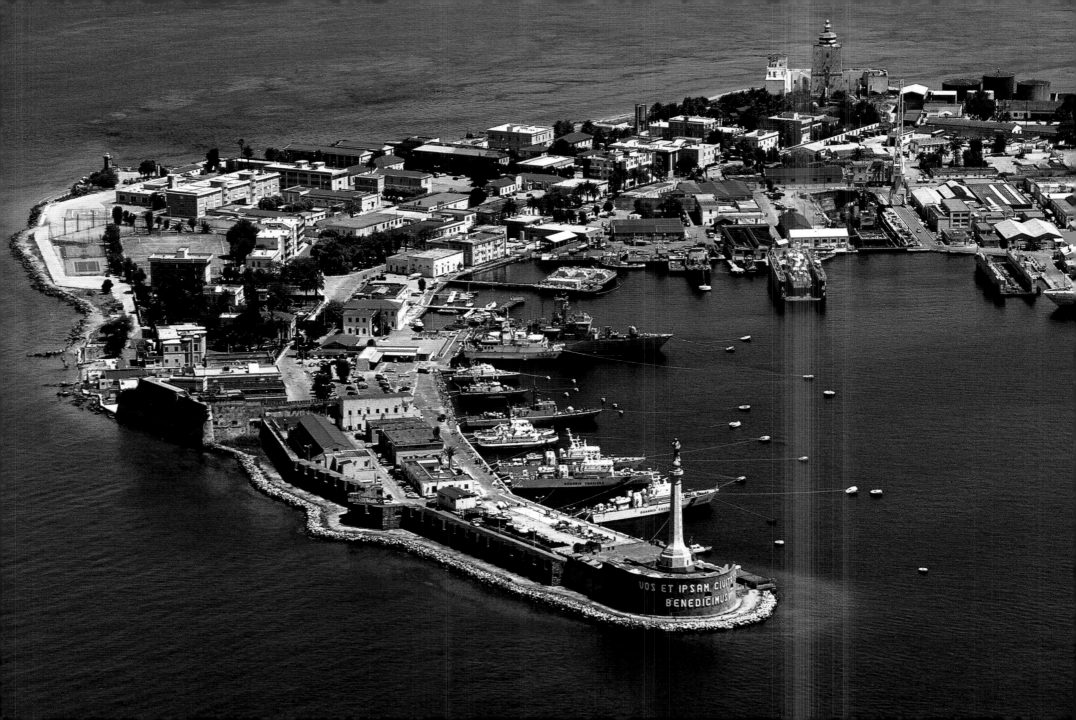

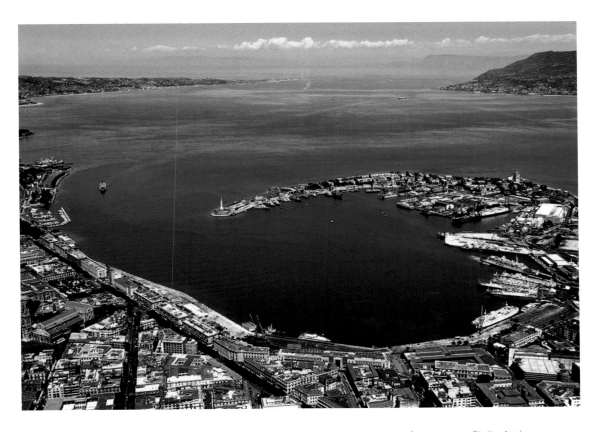

140 and 141 The port of Messina has always been a major point of access to Sicily. At the far end of the wharf, the first and last greeting for those arriving and those leaving, is a tall column bearing a gilt statue of the Madonna della Lettera, the patron of this city built on the Straits. This Madonna is legendary for a letter of blessing She is said to have written personally to the people of Messina.

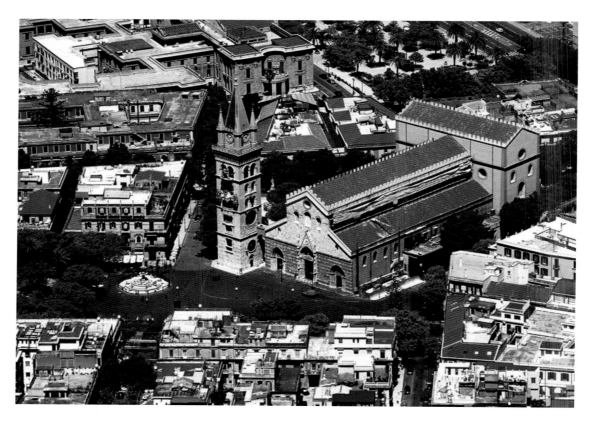

142 Messina's duomo is a sacred building founded by the Normans, refurbished and enhanced many times, damaged extensively by the 1908 earthquake and by shelling in WWII. The cathedral has been completely rebuilt with meticulous care and today appears in all its characteristic, scenographic assimilation of styles and decorations.

143 The church of Cristo Re was built in a dominant position over the city of Messina, in the mid-1930s. A war monument has been installed in its crypt and the church's adjacent bell tower contains a bell dedicated to the fallen of all wars (1935).

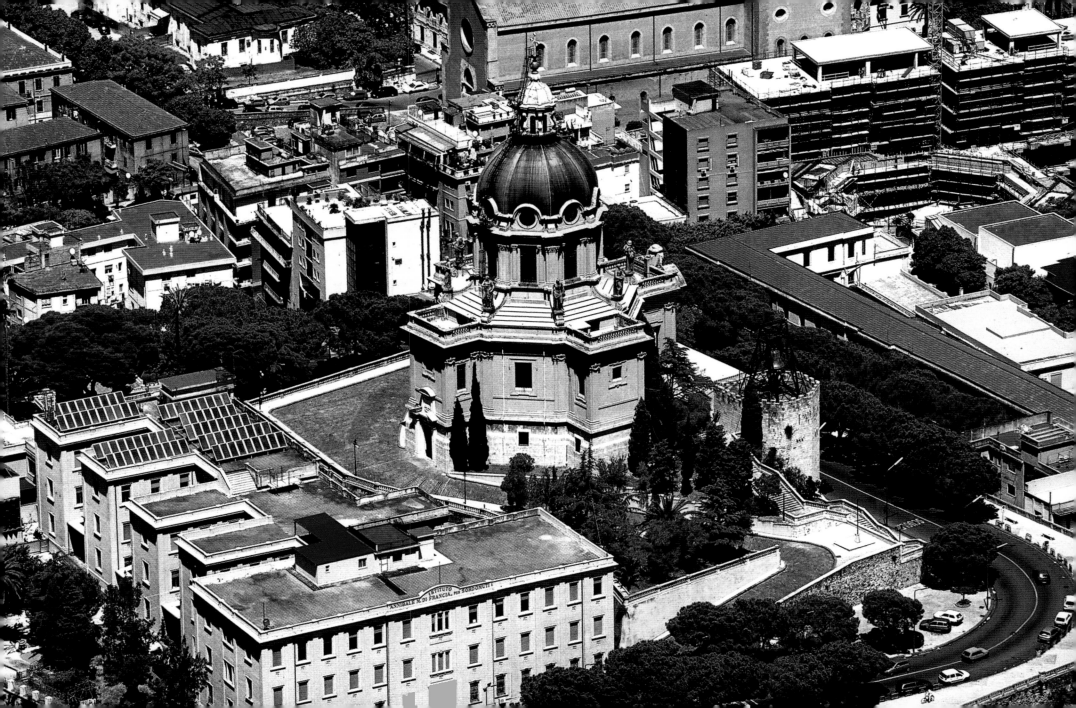

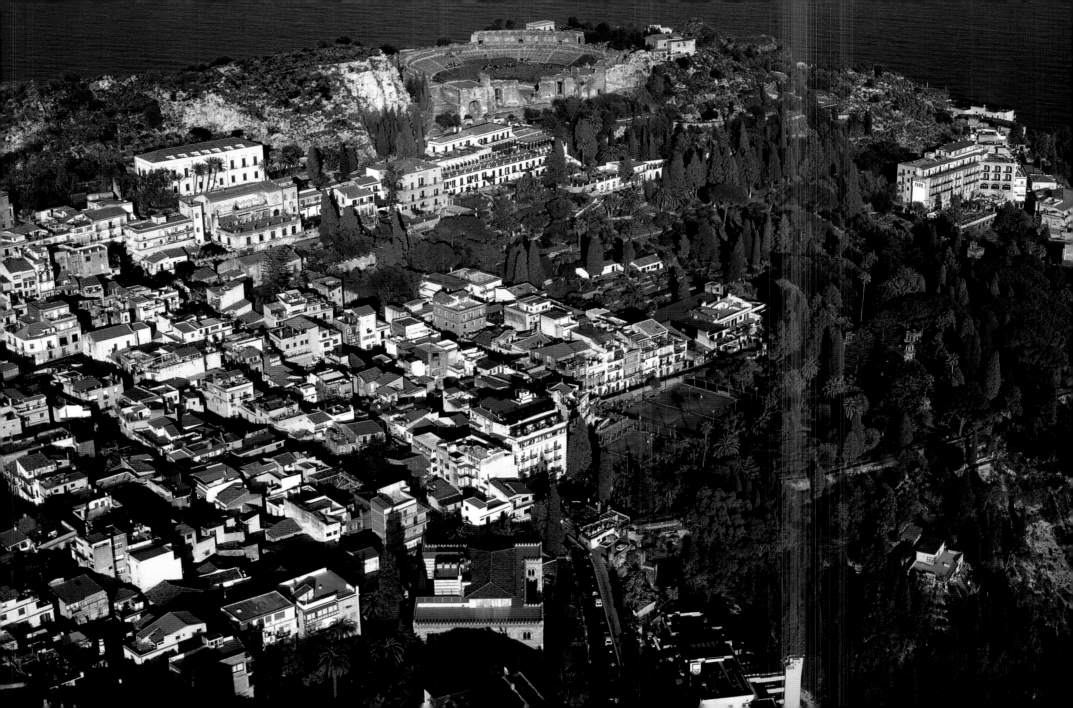

144 Taormina (Messina) was built on Mount Tauro, in the 4th century BC., by exiles from the nearby Greek colony of Naxos, who merged with the local populations living there. The town became famous in the late 1700s, when many young Europeans began to include it in their Grand Tour and it thus developed into a tourist destination of international renown.

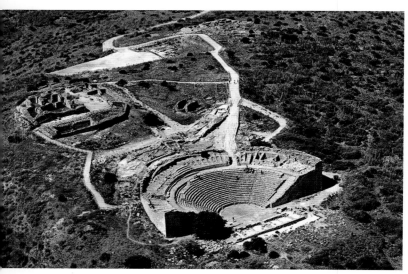

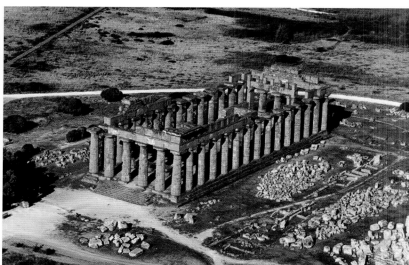

ARCHAEOLOGICAL
SICILY

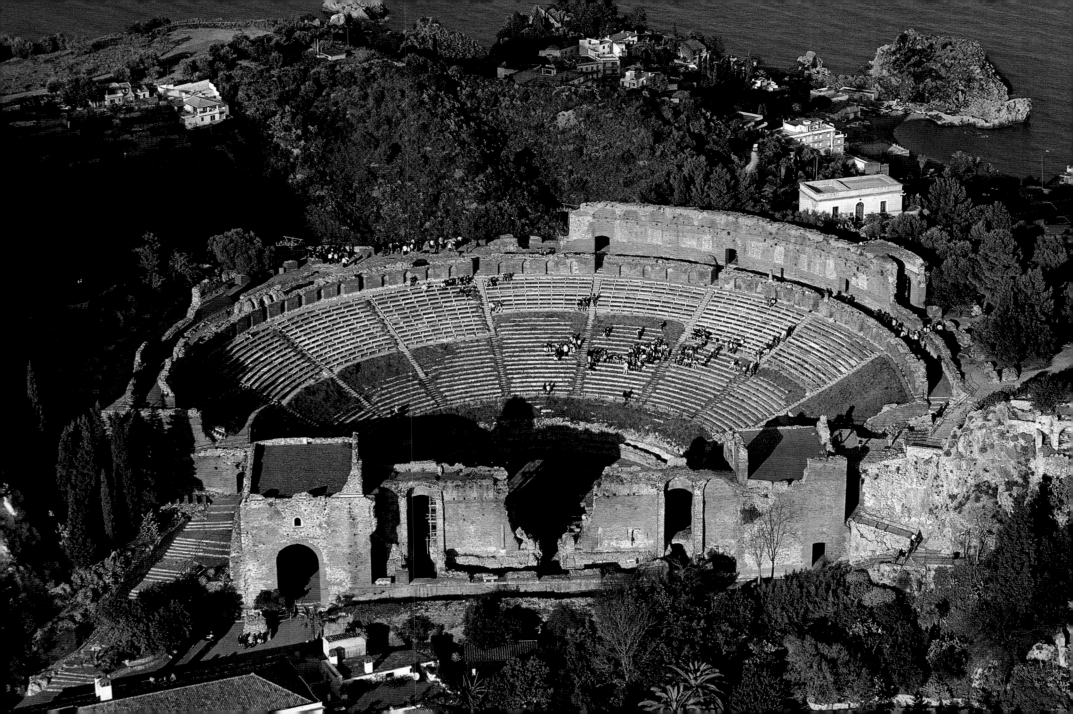

Little has changed since the end of the 1920s, when Leonard Woolf described seeing his future wife Virginia as something akin to unexpectedly glimpsing a masterpiece – as had been his experience in Sicily, where the temple of Segesta suddenly comes into view from behind a bend in the road. For today's travelers, the temple of Segesta, its sturdy Doric columns crowned by flights of crows, is an apparition, the sudden materialization of Ancient Greece amidst the prickly agaves and genista scrub, in the heart of a gentle hilly landscape of flourishing vines.

This is all that remains of the city founded by the Trojans, fleeing from their homeland after it was destroyed by the Greeks. It sits alongside the theater that opens onto this rampant panorama, and onto a practically unknown sanctuary partly concealed by Amazonian-type vegetation at the end of an awkward, insect-ridden path. The town is gone now, razed to the ground in the fourth century by Siracusa's enemy army, and even though the Romans rebuilt on the sparse ruins, so that until the Middle Ages the hilltop was always inhabited, the ravages of time finally took possession of everything and only a faint memory survives of the town, perpetuated by the mystical hill-peak temple dotted with oleasters and prickly pears.

At Selinunte, on the opposite side of the island, facing out over the African Sea, not even that much survived. In 409 BC, 100,000 Carthaginian soldiers systematically destroyed the city, leaving not one wall intact, and with unspeakable ferocity slaughtered almost 20,000 people. What a fate for this most western Greek colony, rich and powerful, a capital for trade with the entire Mediterranean, and its temples built so massive for the greater glory of the gods. If humanity began the destruction, it was certainly completed by earthquakes, and for a long time the place was the home only of ascetic hermits who had no interest in defending what little had survived of the statues, metopes, bas-reliefs, and mosaics.

Despite the systematic despoiling it suffered (it was actually used as a stone quarry for some time), Selinunte is still immense,

146 left The theater of Segesta (Trapani) is a perfect semicircle that opens onto a generous panorama, exactly as was dictated by ancient Greek theater architecture.

146 right The ancient town of Selinunte (Trapani) was totally destroyed by the Carthaginians. In 1957 one of the temples on the eastern hill (presumed to be dedicated to Hera and dated 5th century BC) was re-erected.

147 The ancient theater of Taormina (Messina) is one of the loveliest in Sicily, not only for its significance and relative completeness of the structure, but also for the breathtaking position: as we sit on the terraces we can admire the sickle-shaped Ionian coast and the cone of Etna.

149 The temple called "della Concordia," in Agrigento's Valley of the Temples, is one of the best-preserved of Greek antiquity. Oddly enough, this is because it was converted into a Christian church in the 6th century, and this new use safeguarded it from neglect and destruction.

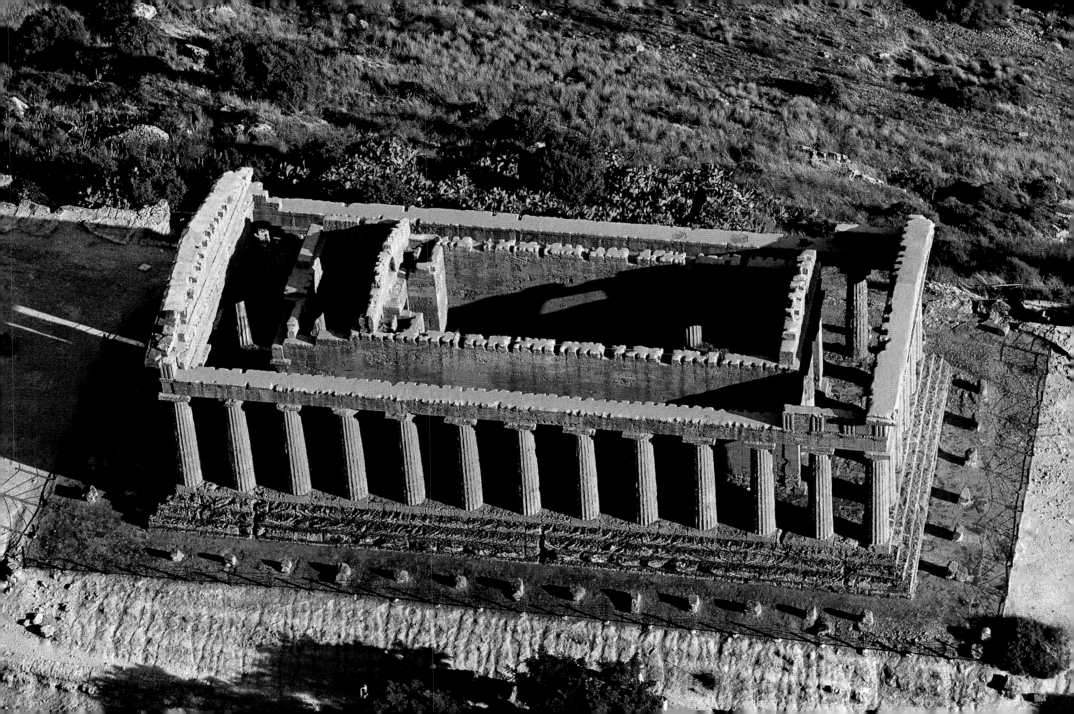

the Mediterranean's greatest archeological basin. A fascinating site, it has been the victim of unscrupulous marauders, but also loved, studied, and visited. As early as the 1700s, foreign visitors made their pilgrimages here to admire what remained. Englishman Henry Swinburne was one such traveler, and in 1777 he noted that in Selinunte, the smallest temple looked like the work of giants and that each column was a tower, each capital a rock: almost as if the intention was to intimidate the gods or frighten human beings. And in 1853 German historian Ferdinand Gregorovius, was moved at the sight of the sad, yet magnificent – almost apocalyptic – spectacle of the derelict temples. The colonnades are only standing these days thanks to the patient rebuilding carried out in the 1900s, by archeologists who dug, sought, reconstructed, and safeguarded this enormous heritage. Yet what we see is mainly an evocative mound of rubble: the armies of times past were no less cruel than those of times present. The soldiers of Carthage attacked the city with all the force of a destructive wind, forcing the entire population to flight, leaving everything behind. That is why, even now, in the nearby Cusa quarries, the column blocks for the Selinunte temples seem to be waiting for the workmen to return from a lengthy lunch break. Just a few years later, Agrigento suffered the same fate of destruction, and this was surely unpredictable. Agrigento, called Akragas at that time, was not merely a city, it was *the* city, the most lovely of those built by mortals. Its inhabitants "built as if they would

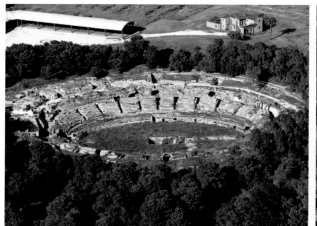
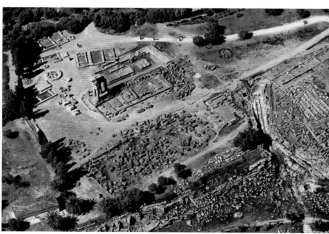
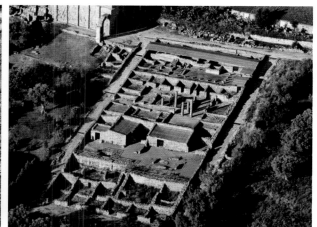

150 left Siracusa's Roman amphitheater was partly constructed by digging it directly into the rock. Although some of its upper section is missing (the stone blocks were removed in the 1500s and used to construct the bastions of Ortigia), it is nevertheless a fine spectacle.

never encounter death, and lived as if they might meet their deaths tomorrow" (Empedocles of Agrigento). There were incredible aqueducts, a huge population, and paved squares and roads where the most famous scientists, philosophers, and poets strolled: Aeschylus and Sophocles, Pindar and Bacchylides. Akragas boasted the temple of Zeus Olympios, a construction of such scale than a human being could comfortably stand in the column flutes. It was unique in Sicily, with its decoration of giant telamons, eight-meter statues supporting the crossbeams, 11 meters above the ground. Just gazing up at them was enough to cause attacks of vertigo. Not even Athens had such lavish houses, such great monuments, such rich towns. The legends of the wealth of the residents have been handed down: Gellias, who ordered his servants to stand at the might city gates and bring any visitor to him so he could offer them suitable hospitality, and who once provided food and shelter to at least 500 horsemen from Gela, caught in bad weather; and Antisthenes, who invited the entire city to his daughter's wedding breakfast, and had the bride escorted by 800 chariots, with hundreds of bonfires lighting up the route. There are tales of the tyrant Phalaris, who roasted his enemies in a bronze bull; and of Empedocles, who overcame the heat by cutting an entire valley into the hills behind the city, so cool air circulated.

It is also said that during the Carthaginian siege of the city, the people of Akragas continued their lives of luxury, eating and drinking, unmindful of the incumbent danger, totally convinced that help was would come from the gods who had been worshipped by the construction of these magnificent temples. The gods, whose airy colonnades still defy eternity, soaring upward against an African sky, on that spur of red, parched rock set in the heart of a valley, as if awaiting the faithful yet to arrive and prostrate themselves before the statues of Hercules, Juno, Zeus, Vulcan, the Dioscuri, and the others. Mozia worshipped other gods: El, the "creator of all things created", and his companion Asherah, lady of the seas; Mot, destructive drought, and the merciless Baal, lord of vegetation and storms. The people of Mozia dedicated exotic sanctuaries that mimicked the examples found in remote Phoenicia, the homeland of their ancestors; sanctuaries of which little or nothing has survived. Just as little remains of the tiny island: flat as a coin, with crenellated bastions, towers, and spinneries. Nevertheless, there is sufficient evidence for us to piece together the history: we know that there was a port packed with ships from all over the Mediterranean, loaded with purple-dyed fabrics, glass,

150 center A vast sacred area in the southeast corner of the Valley of the Temples is the site of four columns of the small Dioscuri temple. We will also find here the remains of the sanctuary dedicated to Demetra, goddess of fertility, and Kore, her daughter and queen of Hades.

150 right Tindari (Messina), was founded in the 4th century BC by the Greeks, on the Tyrrhenian coast, one of the loveliest in Sicily. Sadly, its splendid position on a promontory, was also its undoing, as part of it has been lost to the sea due to landslides.

scented essences, gold and ivory jewelry. We know the homes had mosaic flooring, fountains and colonnades, and that they were full of works of art that came from Greece, Carthage, and Phoenicia, like the deeply lovely marble opus of a young, tunic-clad charioteer, which is the undisputed masterpiece of the small Mozia museum. A treasure of vases, weapons, coins, trinkets, ceramics, the museum was founded in the 1800s by a keen English collector and amateur archeologist, Joseph Whitaker. When Whitaker bought the island, not even the name of ancient Mozia had survived, swallowed by the passage of time, but all the place required was someone who knew where to look. With rare passion and great expertise, the Englishman brought to light most of what is now to be observed on the islet (the archeological research is actually still under way, and regularly enhance our knowledge of the city).

Thanks to Joseph Whitaker, who dedicated his life to excavations and study of the island, Mozia is now a small paradise where botanical treasures (the Englishman also loved to collect rare and exotic plants) blend in perfect harmony with archeological finds. Set in the center of a lagoon, with gentle wafting breezes, Mozia also charms with its lovely landscapes, the scent of mastic, rosemary, and myrtle that accompany strolls, for

the all-embracing views that take in sea and coast from its paths, all just a short distance away, separated by a habitat filled with herons and flamingoes. It was Dionysius I who ordered Mozia's destruction in the fourth century BC. The tyrant of Siracusa certainly could not stand the idea of sharing *his* land with another rich, powerful city. Only Siracusa could enjoy that star role and boast that it was "in no way less than Athens." Siracusa's walls were the longest and mightiest, the Eurialo castle was impregnable, the city was full of mammoth sacrificial altars, and the temple of Athena had massive gold and ivory doors. There were five very elegant districts; one of them home to Magana Graecia's biggest theaters, where the greatest poets and playwrights of the time performed before a committed, competent audience.

The city was favored by the gods and by humanity, and was deemed "ideal" by Plato, the cradle of legends and perpetual genius, like that of Archimedes, who succeeded, amongst other things, in setting enemy ships alight with a sophisticated system of mirrors. (A typical scatterbrained scientist, Archimedes neglected to flee from Siracusa after the Romans landed, and he was murdered by a soldier.) With the advent of these new rulers, a chapter of Sicily's history closed and a new era began.

153 On the eastern hill of Selinunte, in the province of Trapani, there are three temples: one has been rebuilt, the others are little more than heaps of rubble. Several columns of temple "C," the most impressive, have been set back upright, to convey the idea of the massive dimensions.

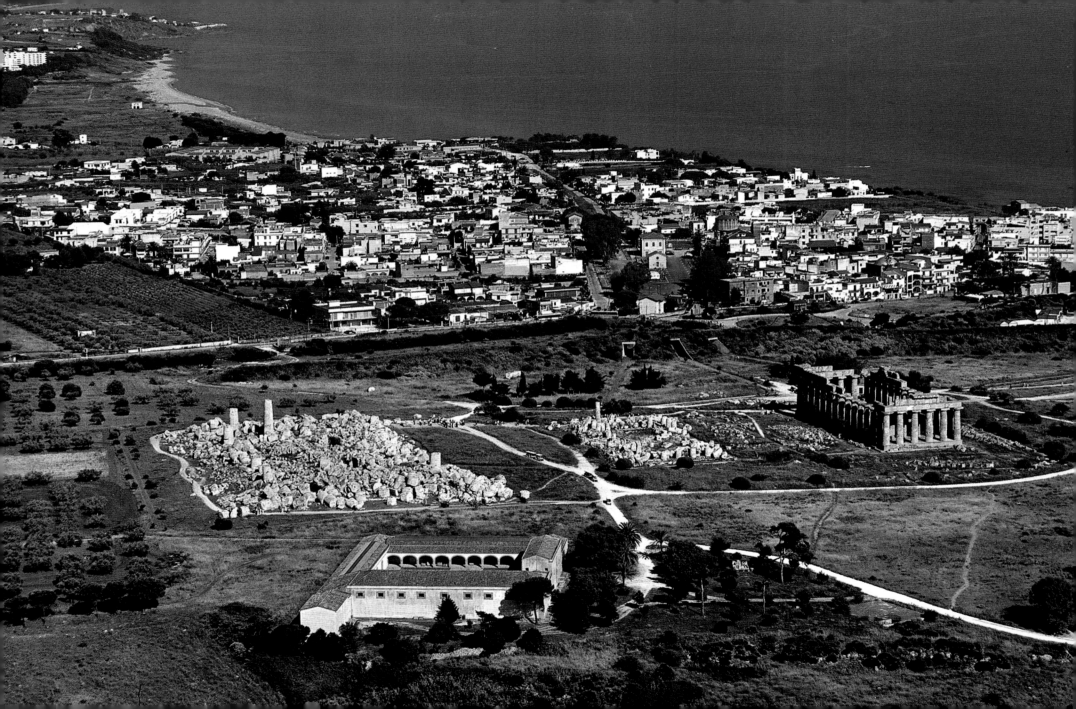

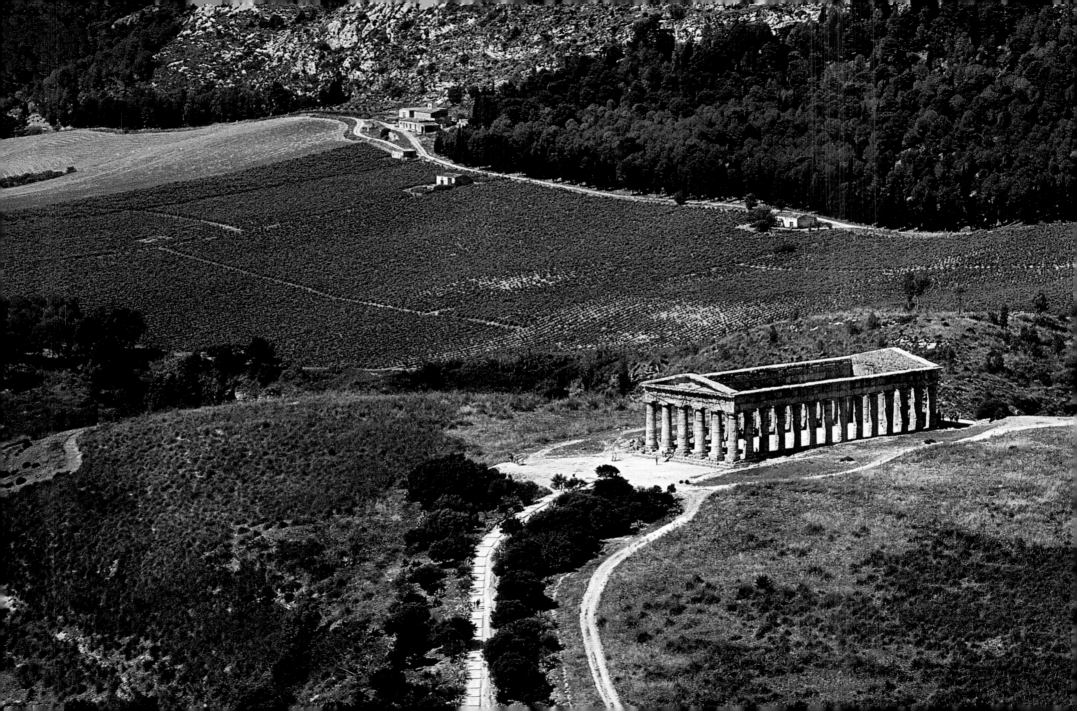

154-155 The town of Segesta is more or less totally destroyed, while its temple has survived practically intact, although it was never completed. Nowadays it stands isolated on a hillock, of such beauty as to appear unreal.

156-157 For almost a century now, the Greek theater of Siracusa has been restored to its original function. Each year, during May and June, the plays of Sophocles, Aeschylus, and many other authors of antiquity are performed here for the public.

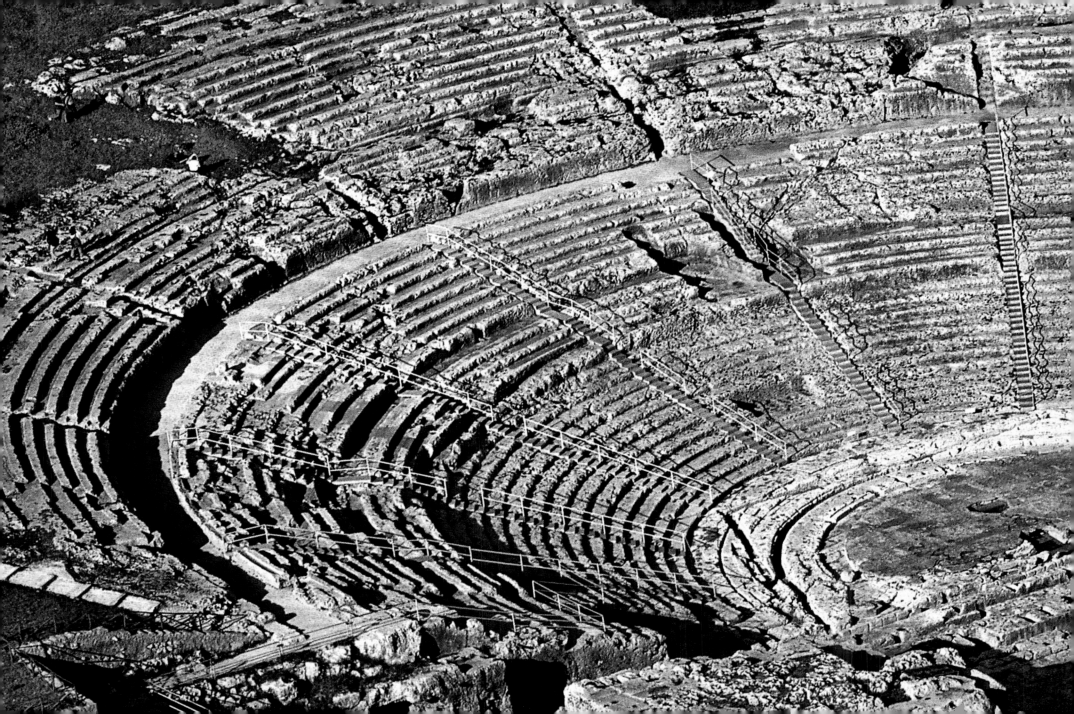

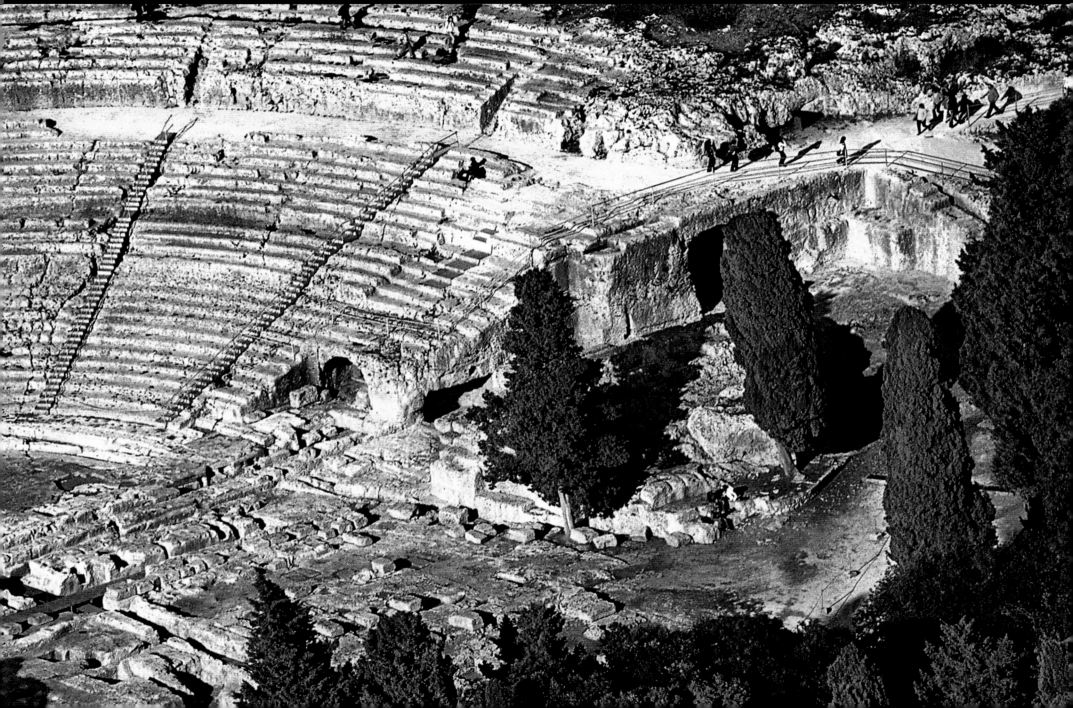

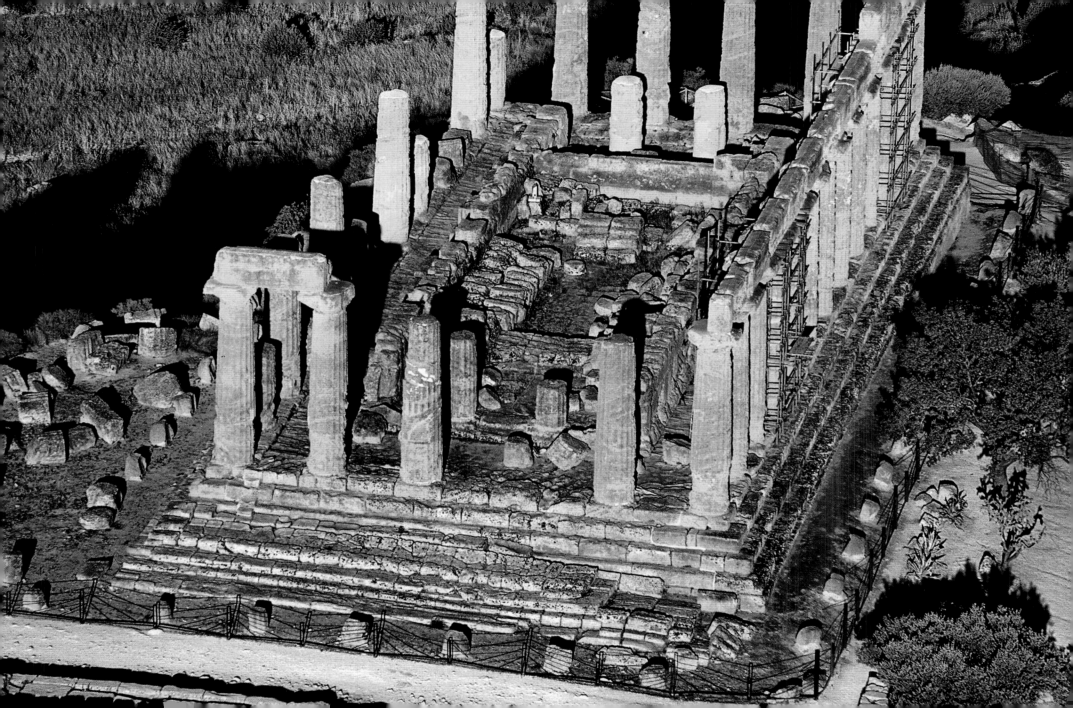

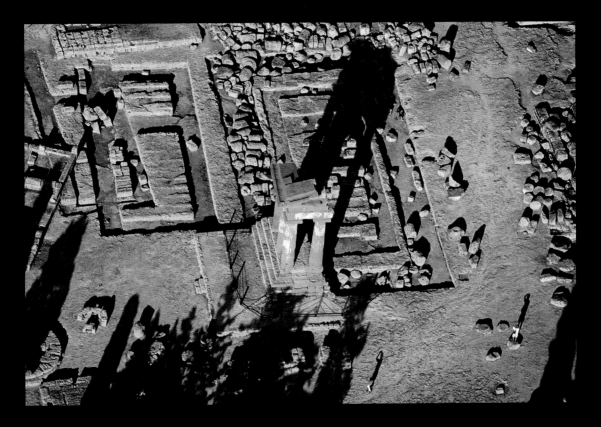

158 At the far western edge of the Agrigento's Valley of the Temples, we can observe the partially re-erected columns of the temple of Hera or Juno. It was built in the 5th century BC, burned down by the Carthaginians, and traces of the fire are still evident on the cell walls.

159 The small colonnade of the Dioscuri temple, often used as the symbol of Agrigento, is actually the result of a 19th-century reconstruction achieved with fragments recovered in the vicinity.

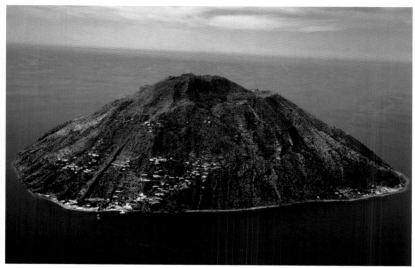

THE ISLANDS
AND THE COAST

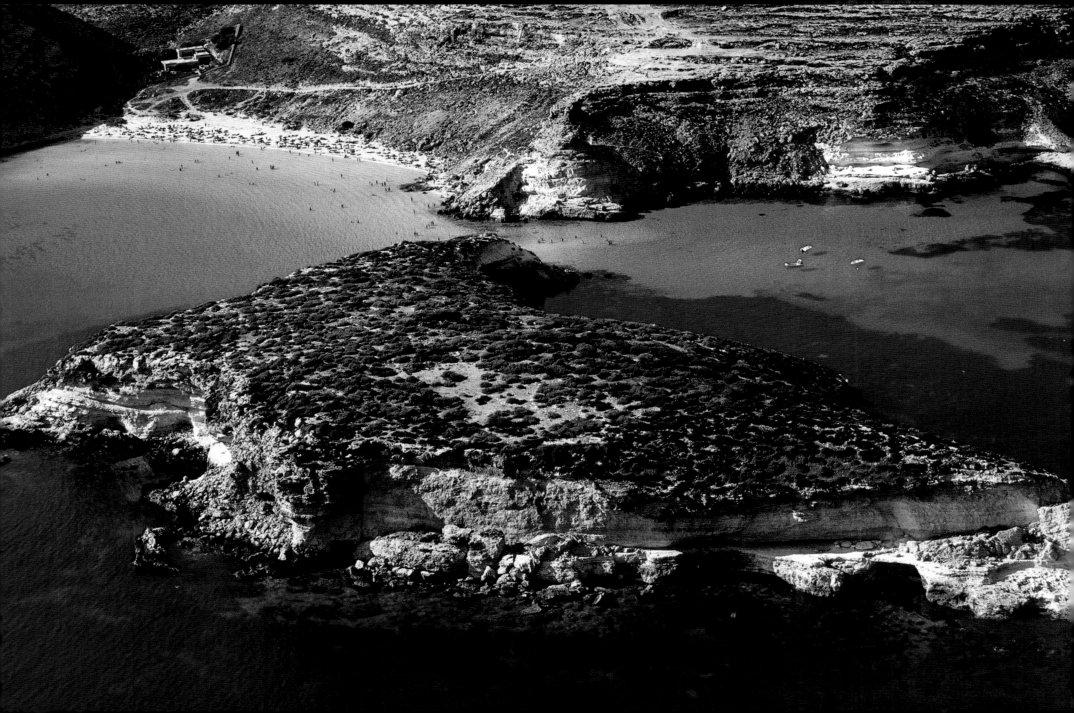

Novalis, the late 1700s Romantic poet and writer, once wrote that blue is not just a color; it is a totality of shades, an outright range of hues that darken endlessly from white until they fade at long last into black. Even those who have never read Novalis will "feel" the truth of that statement if they happen to be on the coast of Sicily, where the sea is certainly blue, but transparent and gleaming with sharp reflections, with golden or coral pink sparks. Gently becoming more intense, in a constant shimmer of bottle green, turquoise, cobalt ... then last of all, deep black that outlines the horizon. And more – the color changes with each stretch of coast: where the shore is jagged, crumbling into sullen reefs, the sea is a turbulent deep blue edged with foam; where the sand is soft and becomes white, ochre, or pink, turning joyful gold where it must roll over pebbles. If there is underlying lava, the sea is black. And the changes are not just of color, however, but of noise: the echoing storm arriving aboard the southeast wind, the gentle lapping of quiet, brilliant days, when the air is brimming with seagull cries.

Describing the Sicilian sea and its coast in a few words is no easy task. We might resort to figures and statistics, illustrating how much sea and how much coast is protected by marine reserves and parks; we could talk of flat landscapes and tiny marinas, listing beauty spots – and there are plenty of them.

The real beauty of this sea and its shores lies, however, in the spell they have succeeded in casting for thousands of years. Because the Sicilian sea is one of tales: stories of heroes like Ulysses, and monsters like the terrible Scylla and Charybdis; marvels like the magic apparitions of Morgan Le Fay and pirates; sirens like those of Ustica who enchanted sailors so they would be shipwrecked on the coast, and treasures like the recently-recovered Dancing Satyr, which is the pride of Mazara del Vallo, with a small museum dedicated just to him. It was a fishing boat that drew the Satyr up from its bed of age-old algae; just one of the many boats setting sail each day from Mazara, loaded with nets woven by fishermen wizened by sun and wind. The boats set forth as they have done for centuries, ever since the port was founded, with its canal for repairing boats and its churches to protect them.

160 left and right The island of Stromboli (Messina) is one of the most famous in the Aeolian archipelago because of its volcano's incessant activity. This has not discouraged humankind, who has always cohabited with it, and the white Aeolian houses stand out against the black earth. Today's Strombolicchio reef is a volcano that was active 200,000, years ago, before the island as we know it emerged from the sea.

161 Conigli reef or island is separated from Lampedusa (Agrigento) by a narrow stretch of sea that is so shallow it can be waded through. This is home to the island's only colony of lizards.

163 The island of Vulcano (Aeolian Islands) is the closest to the Sicilian coast, and characterized by its continuing vapor activity: the terrain exudes sulfur clouds that cause the formation of vast volcanic mud pools, which have therapeutic properties.

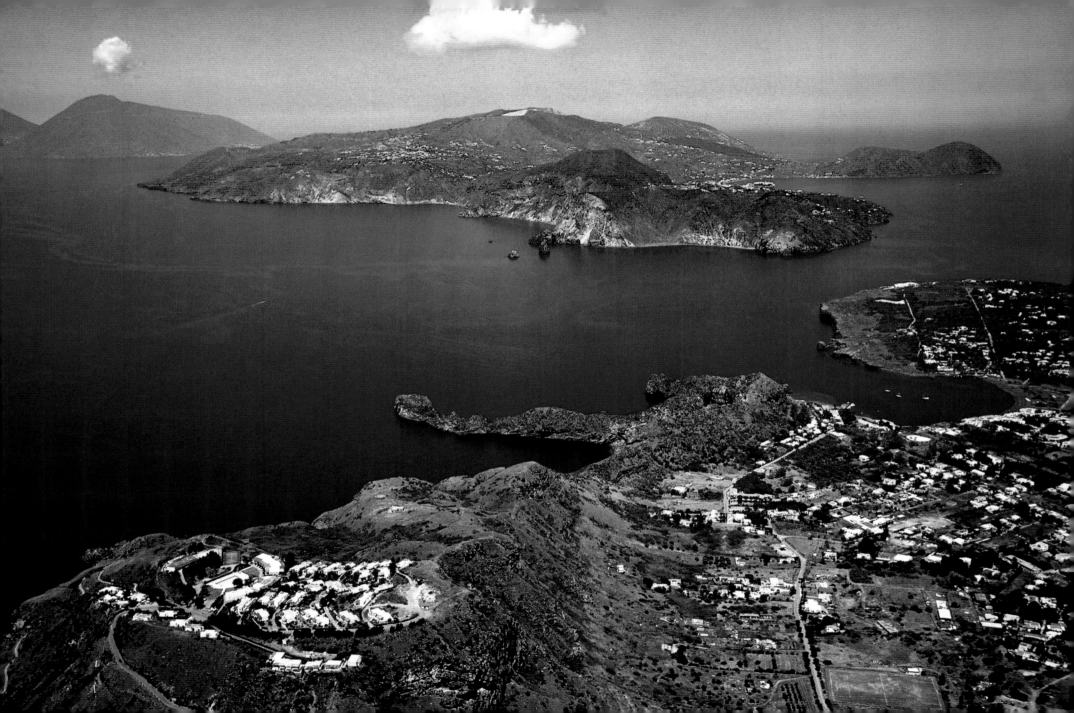

Yes, the sea can be dangerous – fishermen are well aware of that – and ships are wrecked by treacherous currents. So for protection, sailors rely on the intervention of God and the Madonna, promising penitence and vows. As did Roger II, on a remote medieval dawn: the Norman king was about to sink without trace, his sails ripped to shreds by the frightful winds, wood smashed by the terrifying waves. So he got down on his knees and promised to build a splendid cathedral on the site where the Virgin Mary allowed him to land safely. As if by enchantment, the storm lulled and Roger built a magnificent church, the Cefalù Duomo, at the foot of a cliff that looms high above the sea. Its twin belfries stand out against the small houses and pebbled lanes of

this fishing village, a triumph of faith and art – but then again, could a king have settled for less? Slightly to the west, another sea village has now turned into a lively tourist attraction: Mondello, officially part of the city of Palermo, but in reality with a soul of its own, at the tip of a gulf where the sea becomes that incredible turquoise hue. Anyone lucky enough to observe Mondello from a height will see it in the translucent splendor of its unpolluted sea, hemmed with a beach of coral fragments pushed up to the shoreline by the undertow to create rosy arabesques. Almost at the center of the crescent-shaped coast, the Art Nouveau resort architecture stretches like a delicate feminine quirk, embellishing the waves, just before reaching the town, a huddle

 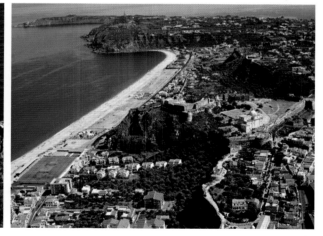

164 left The southern coast of the island, near Agrigento, is typified by long, sandy beaches to the east, but moving west we encounter taller, jagged sections with cliffs and promontories.

of houses under the rounded Capo Gallo promontory. It's a splendid view, like the one we will meet at Scopello if we push on to the west, but quite different if the truth be told. The coast here is narrow and pebbly, tamed by the jetties from which the tuna fishermen set sail in their boats. The tuna fishery, its warehouses, boatsheds, and dwellings intact, has been in disuse for some time, but is still part of the marvelous scene that meets the eye, alongside the rocky shore, the seagull-haunted stacks, the sixteenth-century tower that served as the lookout point for alerting fishermen of approaching pirates. There are countless sea panoramas: from Tindari, for those who lean out from the sanctuary of the miraculous Black Madonna, looking over the waves that dance across the pools of Marinello, Verde, and Mergolo, the seawater lakes on the coast that the sand remodels endlessly; another from Scala dei Turchi, the white chalk promontory, plunging gleaming into the sky-blue sea, just a few miles from Agrigento; and at Capo Bianco, the tall cliff, whose reflection glitters in the African sea, set against a backdrop of pine groves.

There is the Quattrocchi Belvedere, on Lipari, whose name suggests that it is called "four eyes" because two eyes are just not enough to drink in the sight of the coast dotted with stacks, and the breathtaking scenario of Vulcano just behind an arm of sea.

Nor is the Lipari panorama unique in the Aeolian Islands. These "shoreless mountains," in fact, are a constant source of delight for the eyes. Whether visitors seek the social whirl or deep silence, each island offers a "specialty." Vulcano, with its smoldering crater stained sulfur-yellow, the sea bubbling thanks to the hot underwater springs, and Stromboli, with its craggy slopes plunging seawards, are the islands for those who enjoy contact with a volcano's primordial nature, the continuous color contrast of black, red, yellow, the grey of the rocks, and the green of the Mediterranean scrub, clinging headstrong to each rock. Alicudi and Filicudi, the furthest to the west, are for those who seek solitude and silence – an escape from everyday routine. Salina offers its visitors the green of flourishing nature, to be explored on foot, along paths scented with ferns and capers, the fragrance of golden Malvasìa grapes, and the memory of Massimo Troisi, the actor who set his last film here. Sophisticated Panarea, the chic queen of summer nights, but also with a daytime activities: swimming at Cala Junco, perhaps the loveliest of the Aeolian coves, or boat trips out to the many reefs, a miniature archipelago crowning its coasts. Last of all there is Lipari, the "capital," with its citadel locked behind the bastions, the

164 center All around the coastline there are watchtowers (here an image of one in Scopello, province of Trapani), conceived and built to protect coastal settlements, warning inhabitants in good time that there were pirates on the way.

164 right Capo Milazzo (Messina) is a long cape stretching into the Tyrrhenian, and geographically connects with Tindari. It formed in remote history and its unique geological composition, unlike any other, has given a name to the period: the Milazzian.

panoramic streets, the evening stroll and jasmine ice cream. Ustica is ideally linked to the Aeolian Islands, just a few miles ahead, off the shore of Palermo. In fact, for the colonists who set off westwards from the Aeolian Islands in the eighteenth century, that black island was the first landing – just as it is today – for those flying in from the north, its characteristic tortoise outline Sicily's first greeting. A greeting of sloping shores, black with age-old lava (Ustica is the surfacing peak of a spent volcano), and clean sea, so transparent that from a boat we can lean out and see the polychrome beds where groupers, barracudas and lobsters live amidst reefs of algae and sea fans.

Plants and animals are protected by the marine reserve, just as they are in the three Aegadian Islands, which are surrounded by a handful of reefs that, seen from above, appear to be a small fleet, anchored just off Trapani. Again, each island has its own character: Favignana, the largest, is nearest the coast and the most "urban," with a lively little town, passable roads, and Sicily's biggest tuna fishery, still operational, as well as beach facilities. Levanzo is smaller and shyer, just a smattering of square white houses to form a village, and a single road. Marettimo is the furthest away, the wildest, a dolomitic peak furrowed by a network of

paths scented with myrtle, heather, cistus, and cineraria. All three islands have lovely coasts, with hidden coves flanked by soaring peaks, or rugged strips of rock. To the south of the most westerly tip of Sicily, lies Pantelleria, "the daughter of the wind." Its lakes and coves have been transformed into natural hot springs, constantly bubbling from the volcanic steam that issues from the depths of the earth. Pantelleria is such a special island: wide and unpredictable, it has a past described by Homer – it was said to be the home of the nymph, Calypso – and a present hallmarked by elite tourism and wine: precious passito, a raisin wine made from grapes that flourish at ground height, protected by stone walls.

Finally, just a few miles away, there are the Pelagian Islands, Lampedusa and Linosa, two "neighbors" on the high seas, but actually two quite different worlds: clayey Lampedusa, flat and dazzling; Linosa black, tall and rugged. Lampedusa looks seaward, with its low beaches and nooks of paradise, like Conigli Island; Linosa is landlocked, a harsh coastline where tasty lentils are grown. Lost at sea, more Africa than Italy, these are now islands for those who seek the silence brought by the wind, a sea inhabited by turtles, whales and dolphins, lazy Mediterranean days spent gazing out over the horizon.

167 Alicudi (Messina), one of the Aeolian Islands, the surfaced tip of a complex volcanic structure, explaining why the coast is so rugged and characterized by dark basalt rock.

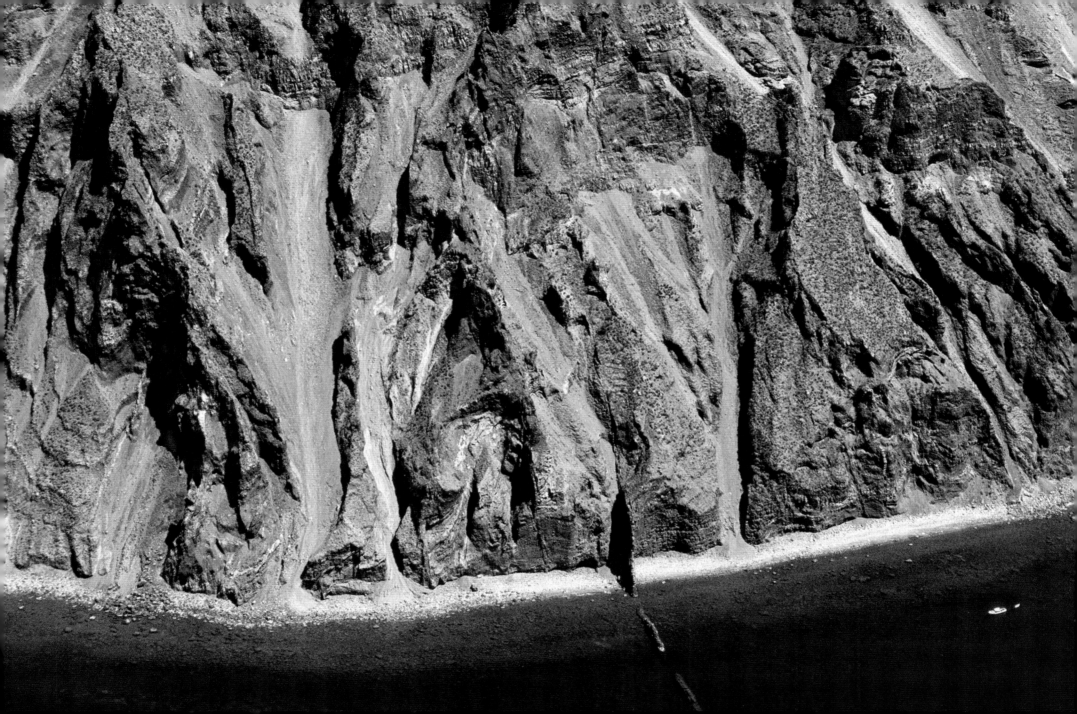

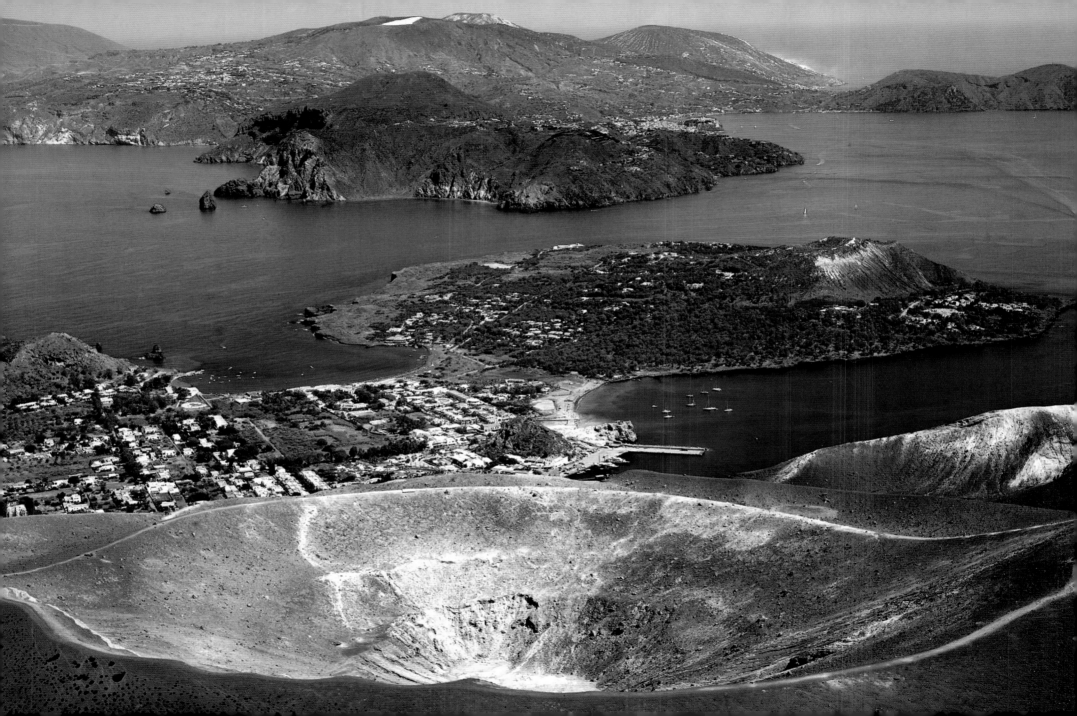

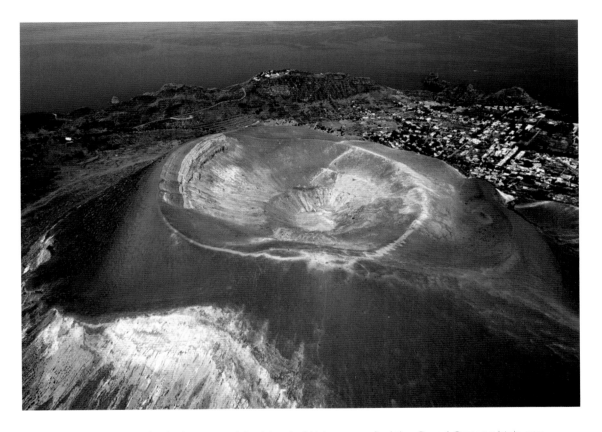

168 and 169 In the higher part of the island of Vulcano we find the Grand Crater, which can only be reached with great difficulty. The panorama expands as we climb, becoming ever more fascinating. The Fossa crater has a diameter of at least 500 meters. Large parches of yellow sulfur (due to its continuous exhalation from the terrain) crystals are dotted around the edge of the chasm.

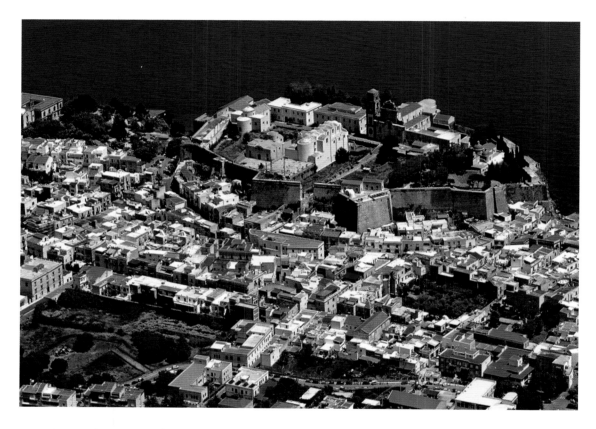

170 and 171 Lipari (Messina) is the biggest island of the Aeolian archipelago. The town is dominated by what is called a castle, but is actually a sort of natural citadel, subsequently fortified, where a series of settlements have been built since prehistoric times. Here there are archeological excavations, the cathedral of San Bartolomeo and an interesting multidisciplinary museum.

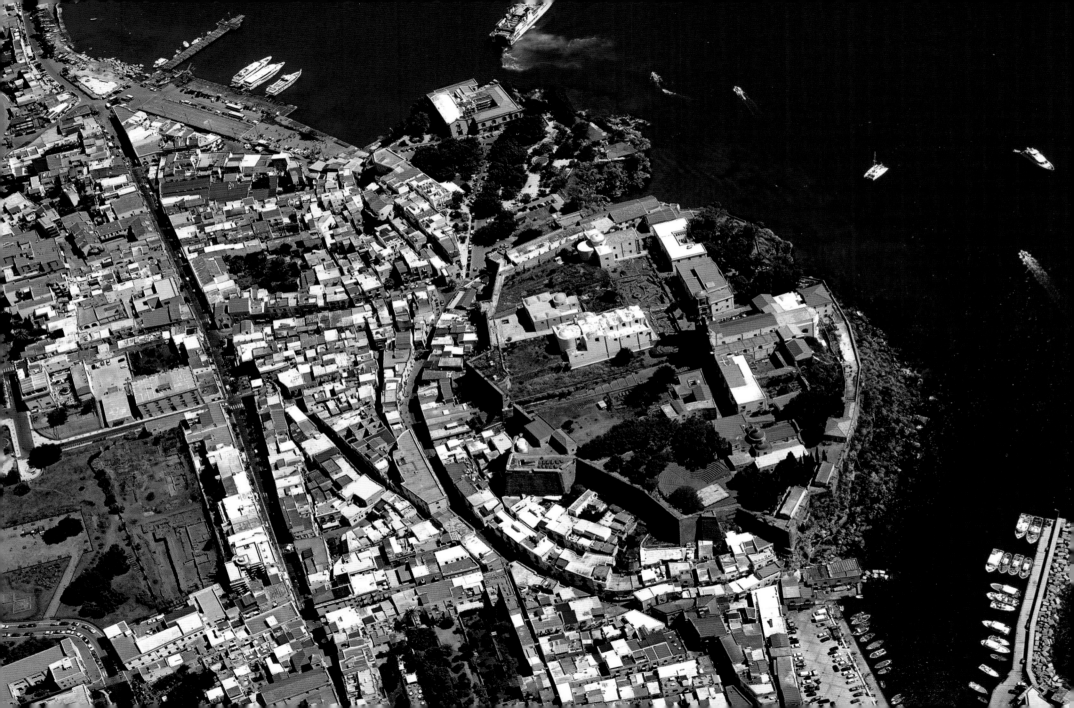

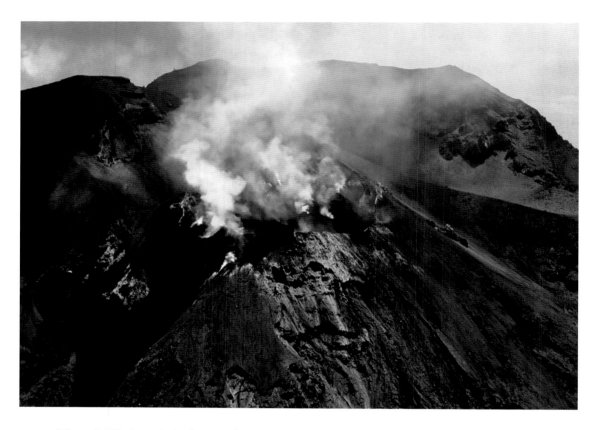

172 and 173 Stromboli's (Messina) iconic silhouette and its eternally smoking crater have always been a point of reference for sailors in the southern Tyrrhenian. At night, the intermittent explosions from the volcanic crater, which occur on average every 15 to 20 minutes, are a very effective lighthouse.

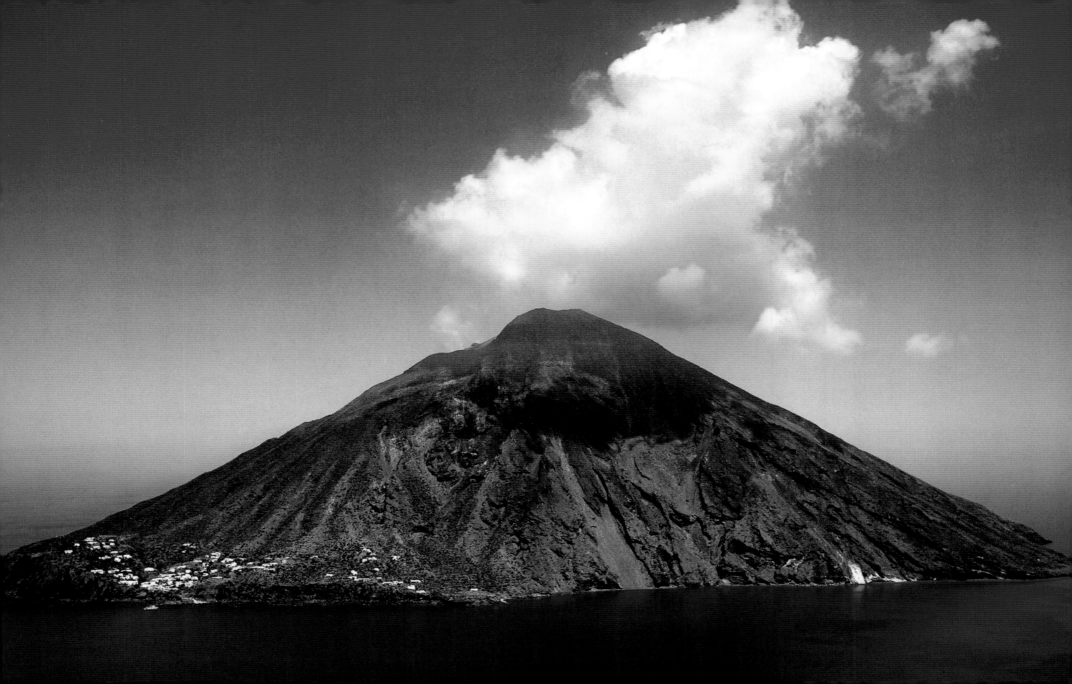

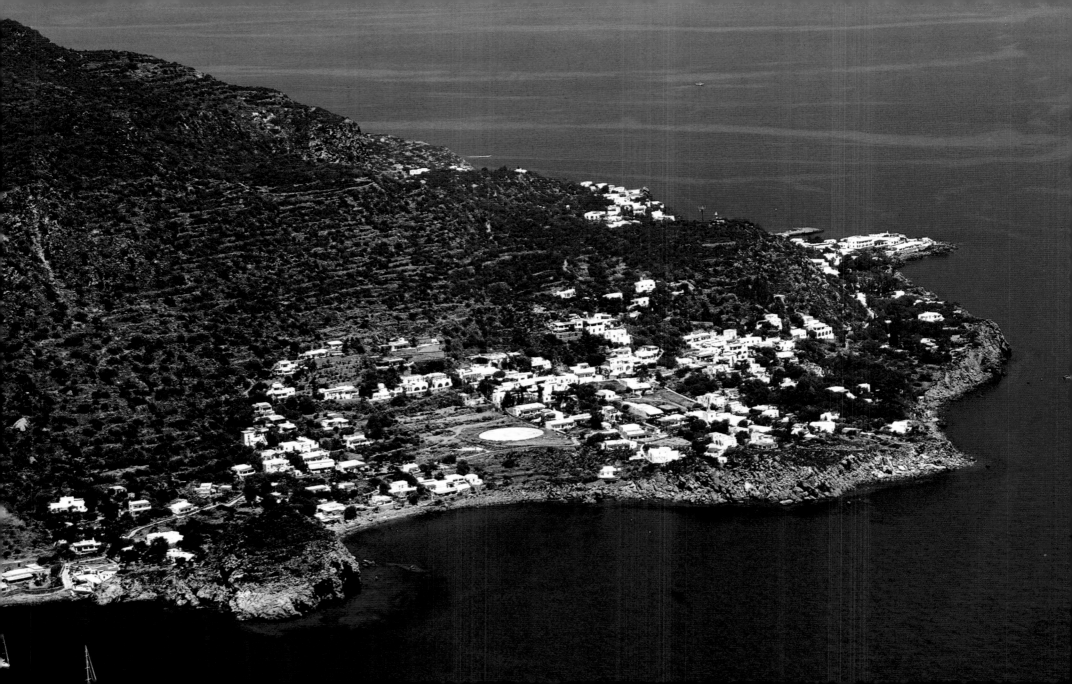

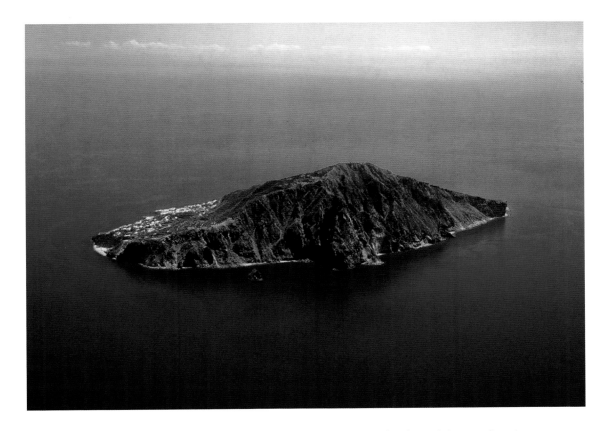

174 and 175 Panarea (Messina), the smallest of the Aeolian Islands, and the trendiest: in summer, young people from the other islands meet there to dance and dine in the various eateries and small squares. In any case, the island is worth seeing even in daylight, strolling along the network of paths that furrow the Mediterranean maquis, or maybe by sea, sailing close to the shore.

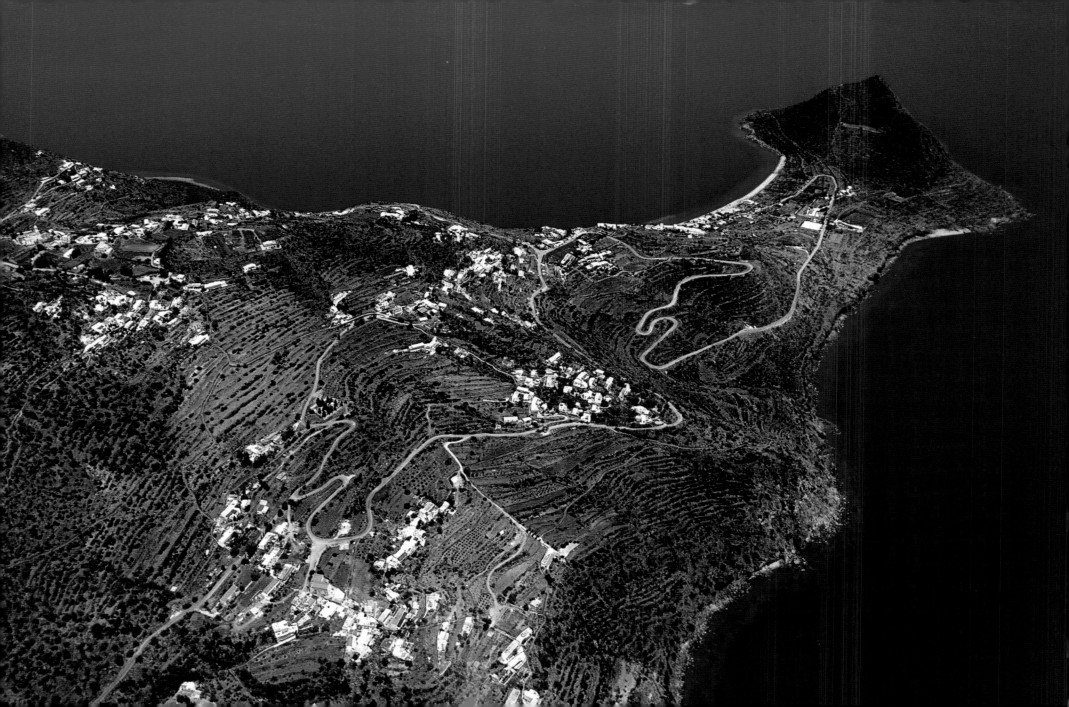

176 and 177 Filicudi (Messina), a smattering of white houses in simple Aeolian architecture along the shoreline, and scattered along the steep slopes. The isolated, almost inaccessible, rock is perfect for those who prefer silence, endless starlit skies, the scent of rosemary, lavender and thyme. The island has three villages connected by a single seven-kilometer stretch of asphalt.

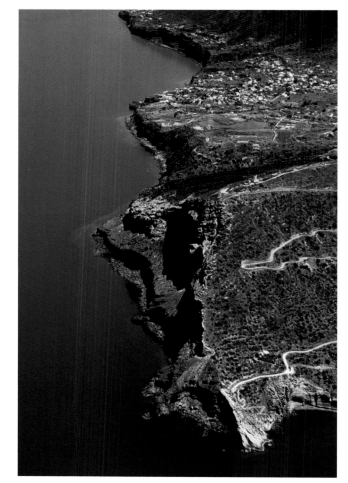

178 and 179 Salina, for the Greeks,
was Dydime (the twin), for the island's
two volcanoes. For the modern world,
Salina is "green." In actual fact, this is
the dominant color, thanks to the
island's spontaneous vegetation and
cultivations – especially vines, used to
make an exquisite Malvasia wine.
Alongside the blue of the sea, of
course, and the white of the typical
square houses, softened by their
bellied columns.

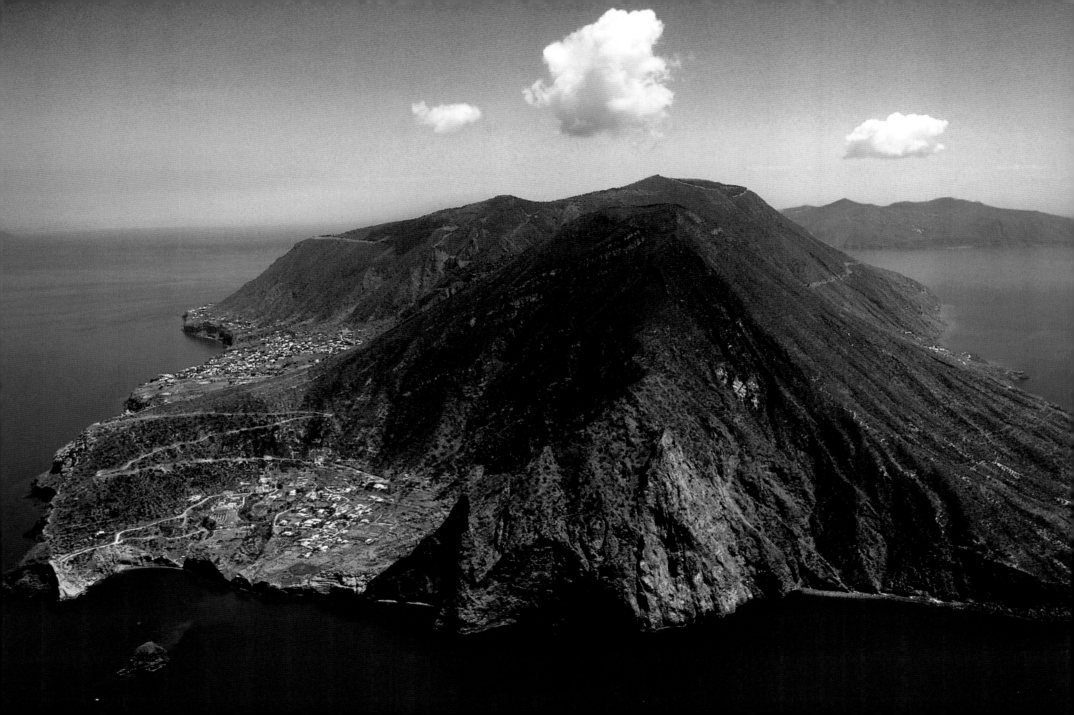

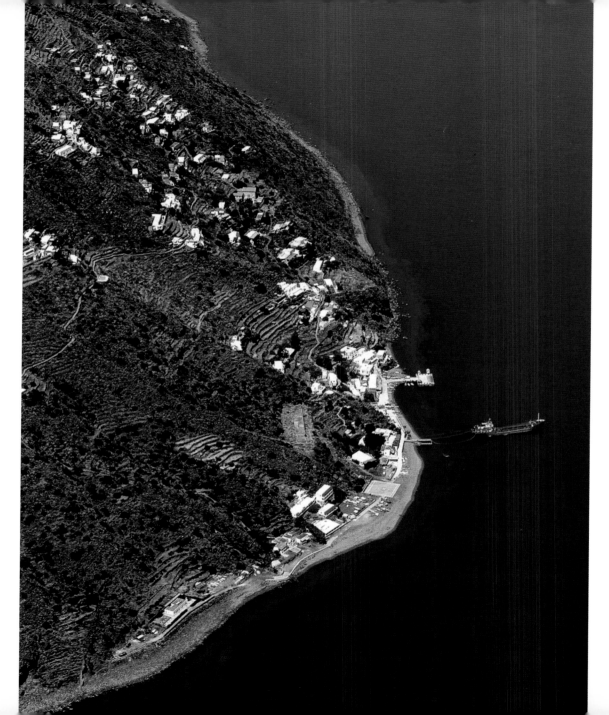

180 and 181 Alicudi (Messina) can only be described as a wild and solitary island, a millenary cone of black lavas emerging from the sea. Few inhabitants, no roads – just tracks called "trazzere" that are witness, along with the reckless terraces used for farming, of how stubborn a human being is when faced with the challenge of a difficult terrain.

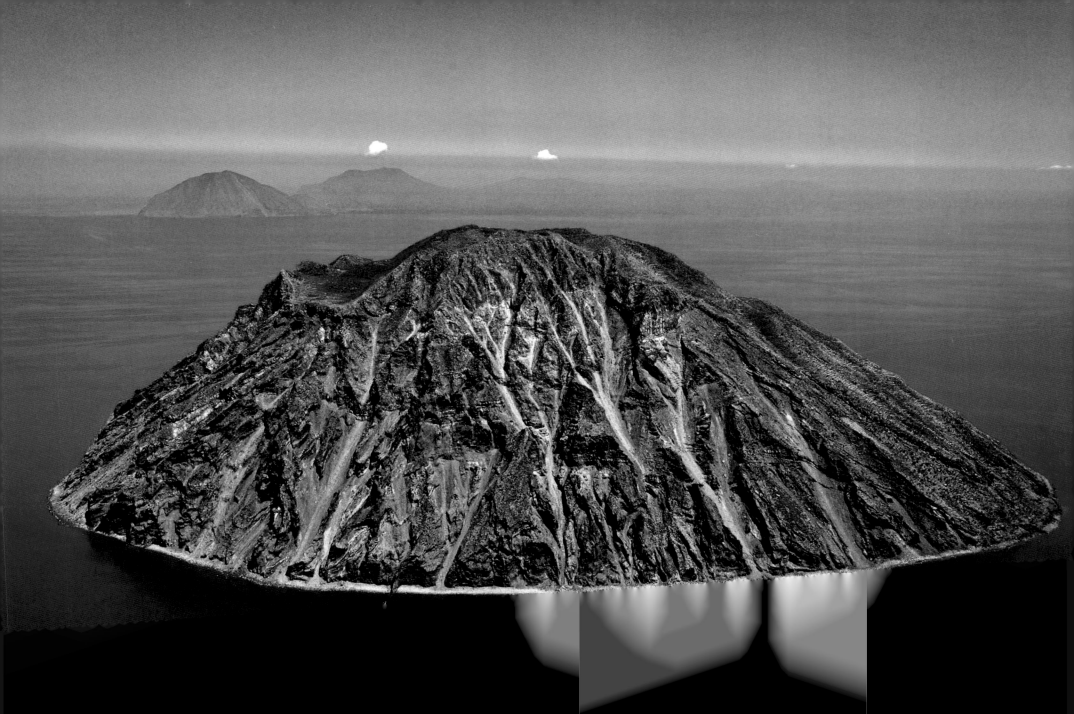

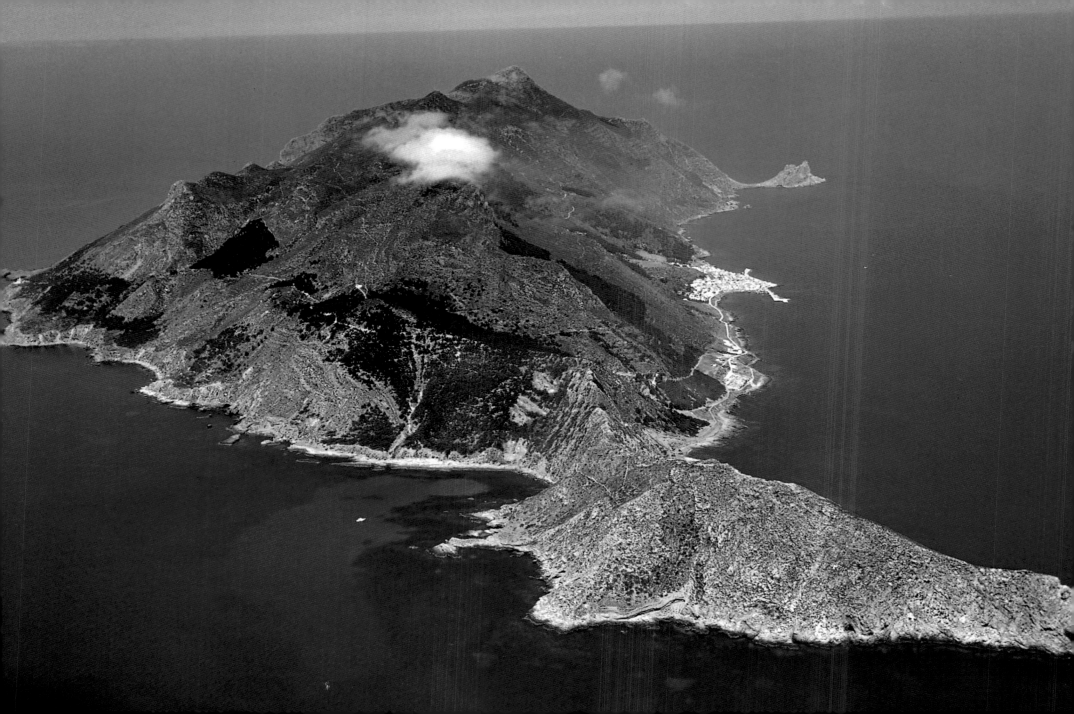

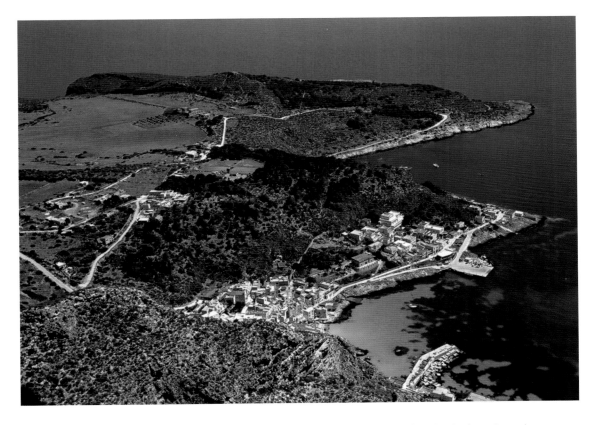

182 Of the islands that make up the Egadi archipelago Marettimo (Trapani) is the furthest from the mainland. It is also the most mountainous, with tall peaks that take on an almost dolomitic look.

183 When we reach Levanzo (Trapani), we may feel we have landed right in a painting where the colors have been skillfully put together: turquoise for the sea, white houses, the green of the oleasters.

184-185 The sea around the Egadi Islands is not only a wonderful color, it is also especially rich in flora and fauna. A protected marine park has been set up specifically to safeguard the integrity and biodiversity of the seabeds.

186-187 Formica (Trapani) is little more than a reef, encountered when sailing towards Levanzo. Despite its tiny size, it was the site of a tuna processing plant for many years, and the buildings have survived intact.

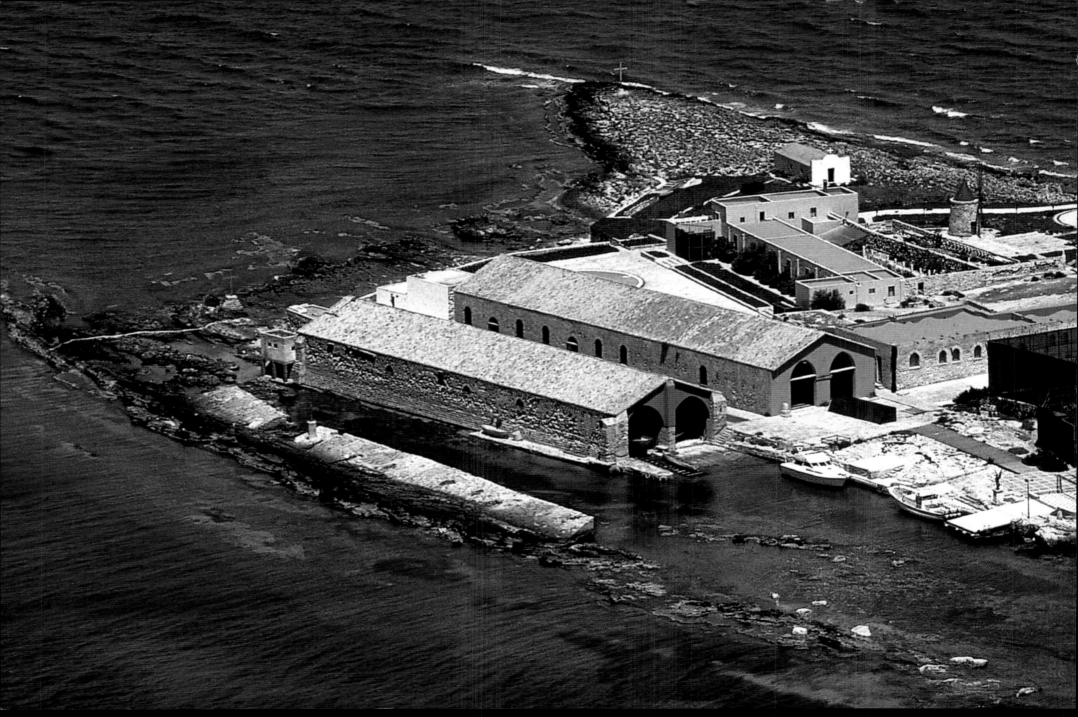

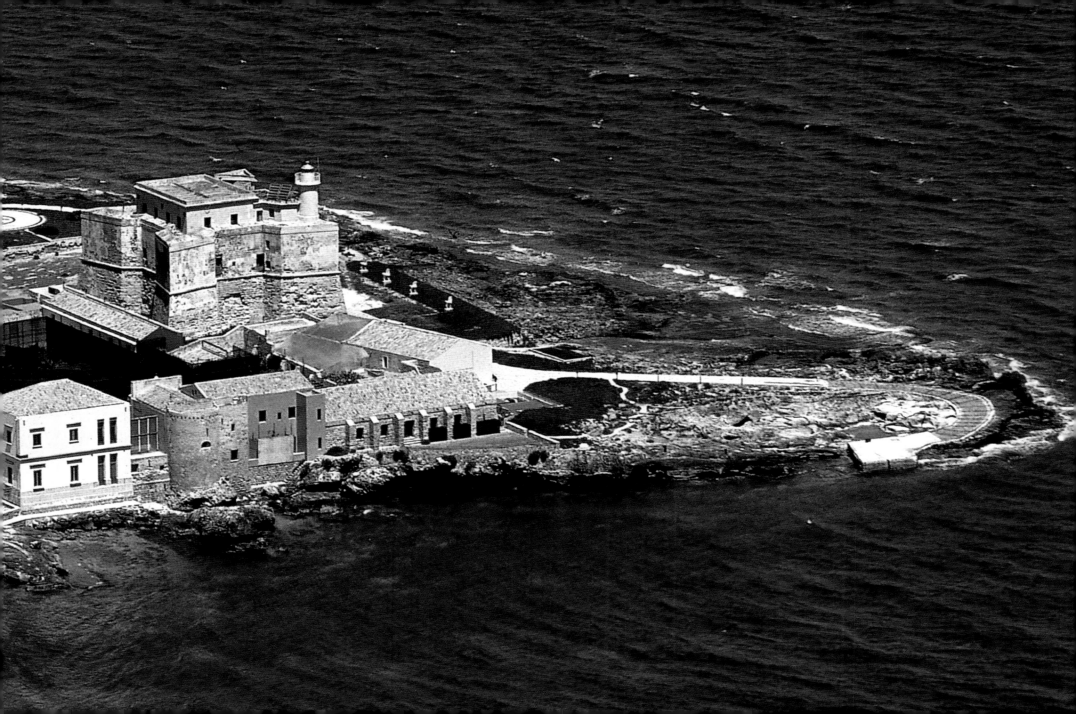

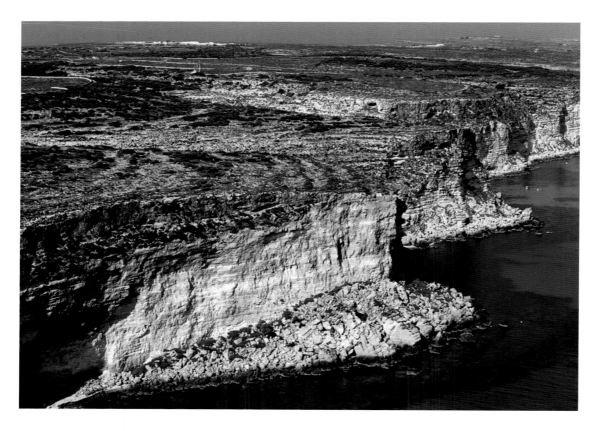

188 and 189 Lampedusa resembles a raft, a massive and windblown raft floating out in the sea. The sensation intensifies as we move inland, mainly barren, and we reach the island's northern tip, where the coast ends in a tall cliff that plunges sheer into the sea.

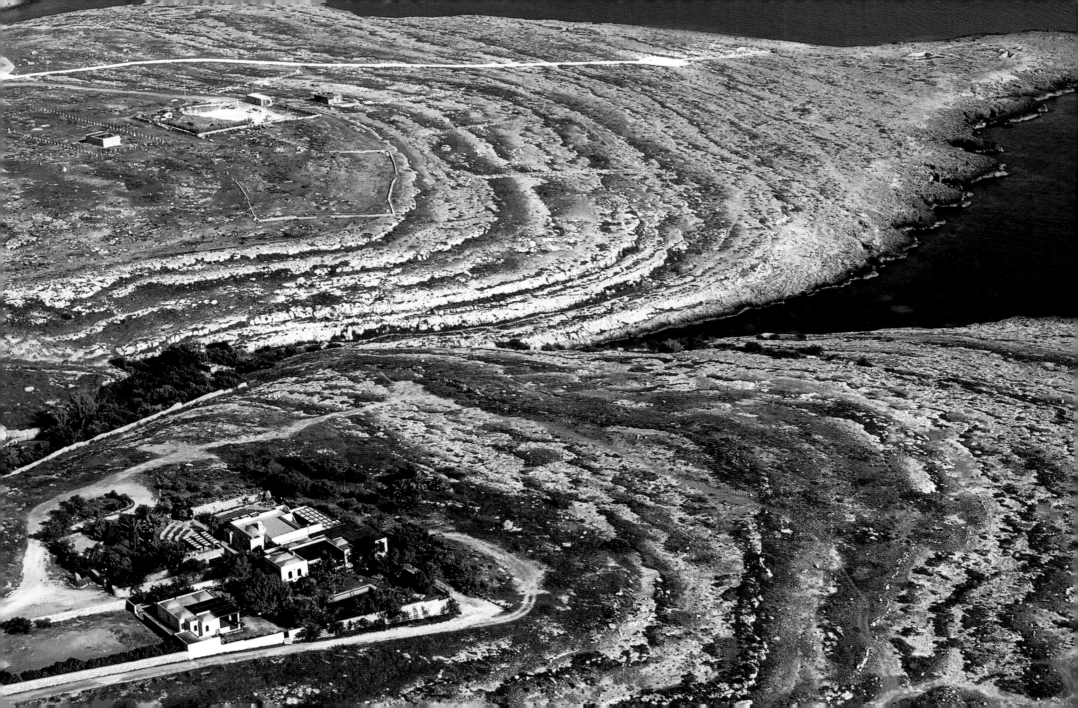

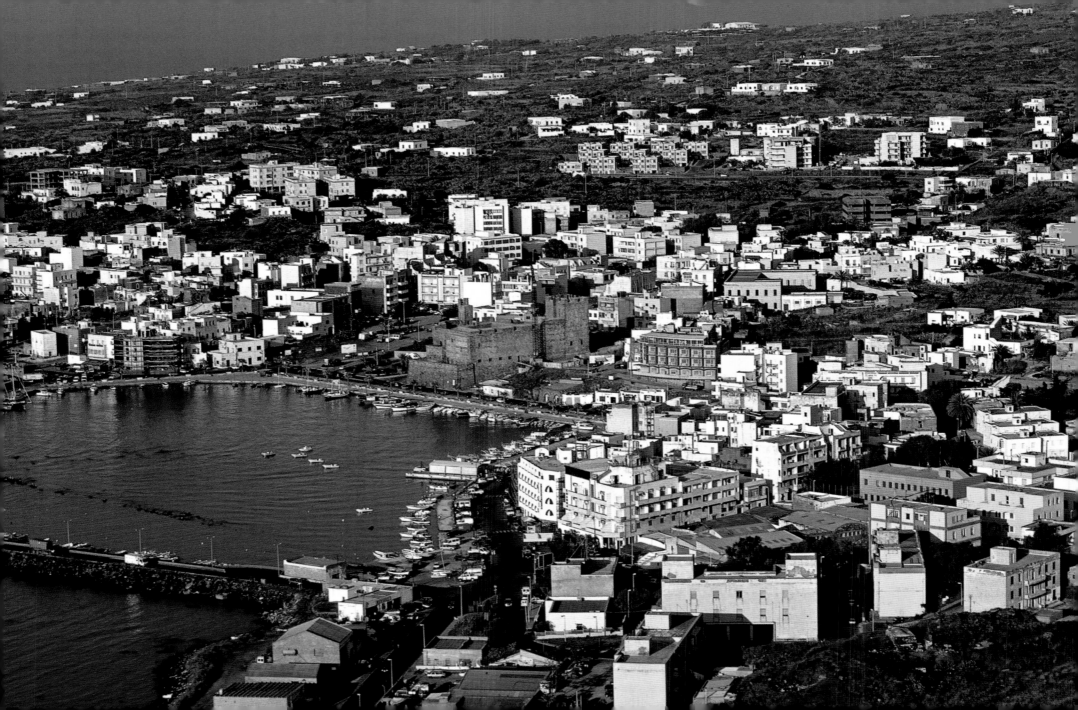

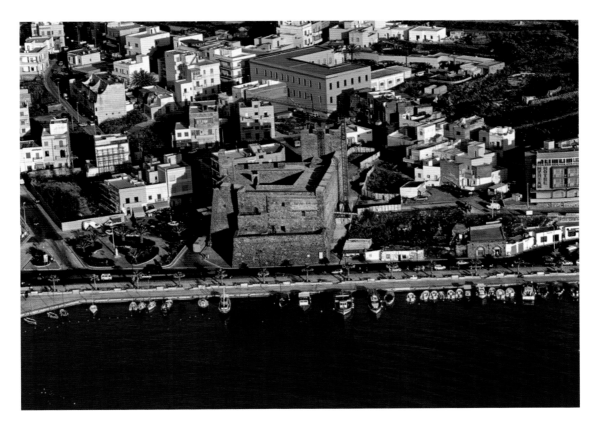

190 The island of Pantelleria (Trapani) is closer to Tunisia (70 kilometers) than it is to Sicily (110 kilometers), and after Malta it is the biggest island in the Channel of Sicily. It covers 83 square kilometers and its highest point is called "Montagna Grande", the big mountain, at 836 meters above sea level.

191 The main town in Pantelleria, called the "daughter of the wind" by the Arabs because it is particularly subject to strong air currents, is laid out around the port and the Barbacane castle. This fortress may well have been built in the Roman period, but has been demolished and rebuilt on many occasions. Today's structure is dated 13th century and built in lava stone, a material of which there is an abundance on this island, which is the visible tip of a great volcano.

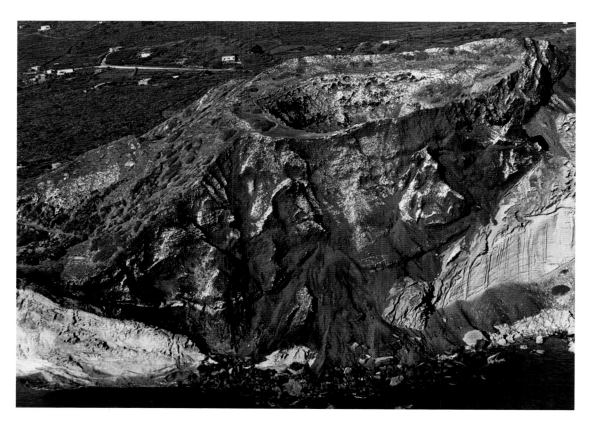

192 and 193 Just as Lampedusa is flat, Linosa (Agrigento), the other island in the Pelagic archipelago, is tall and steep. Even the colors are different: no longer the blinding whiteness that fades into yellow clay, but the strong contrasts of ochre, red brick and deep green. Even the small town features this multicolored look, each house painted a different gleaming pastel shade.

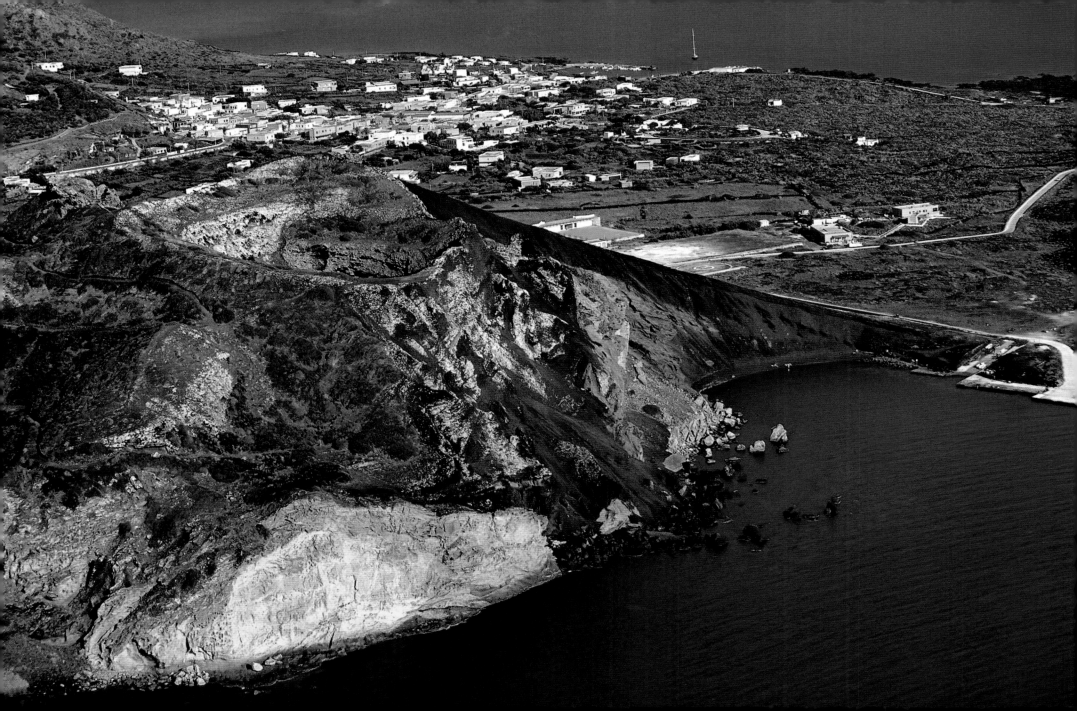

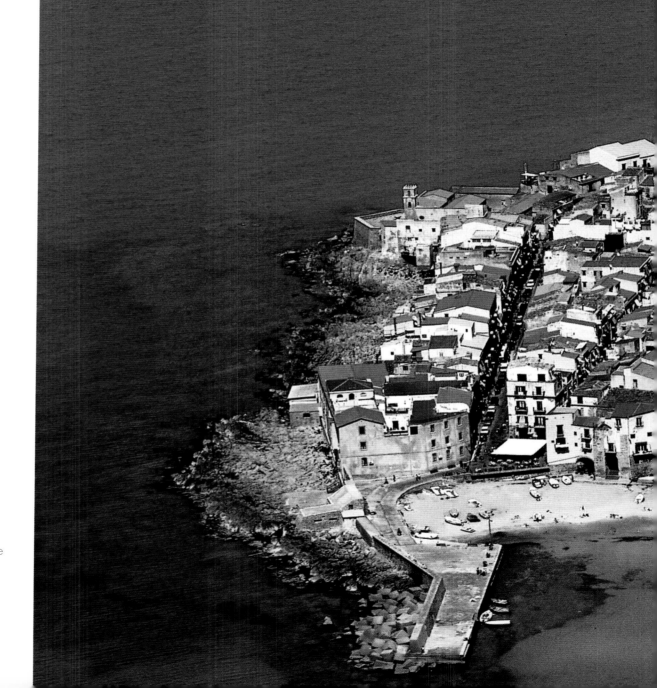

194-195 Cefalù, once an ancient fishing village, is now comfortable as a tourist attraction, valorizing its two major resources: the beauty of the sea, lapping two sides of the old center, and the sheer number of different monuments, starting with its lovely Norman cathedral, which has dominated the town for nigh on nine centuries.

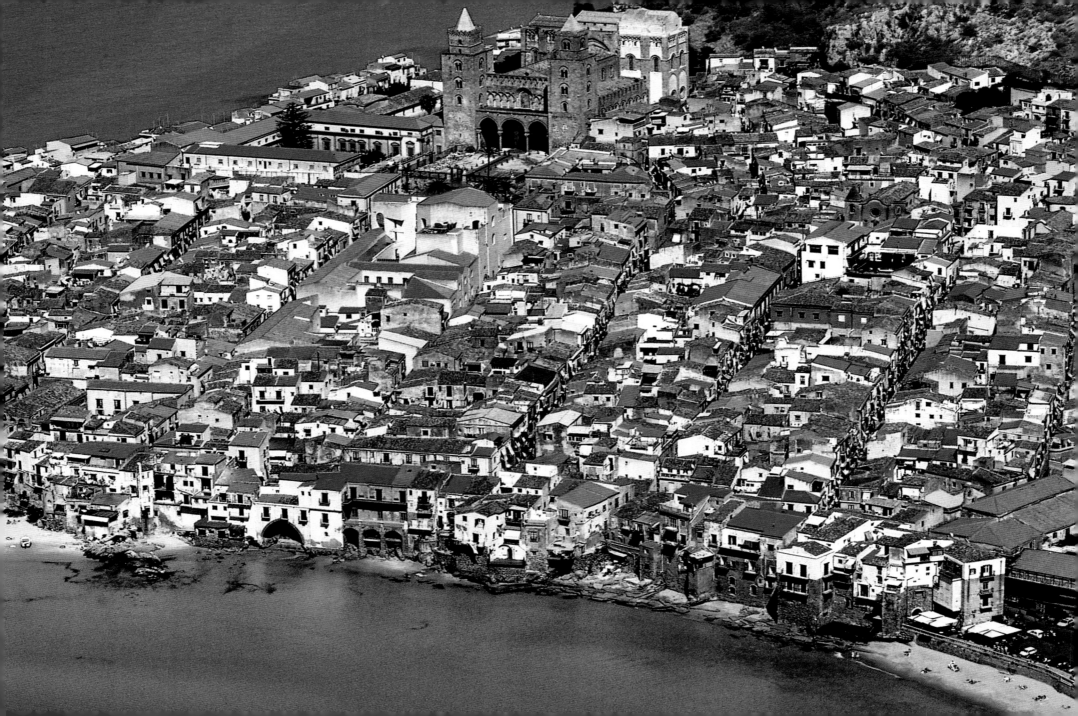

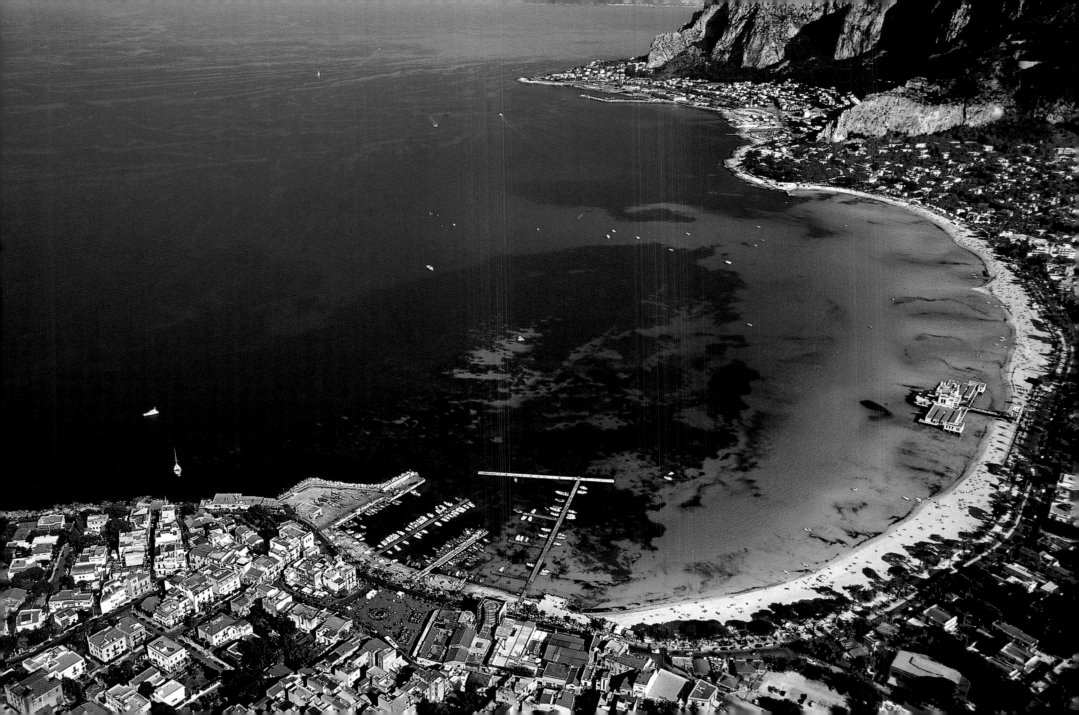

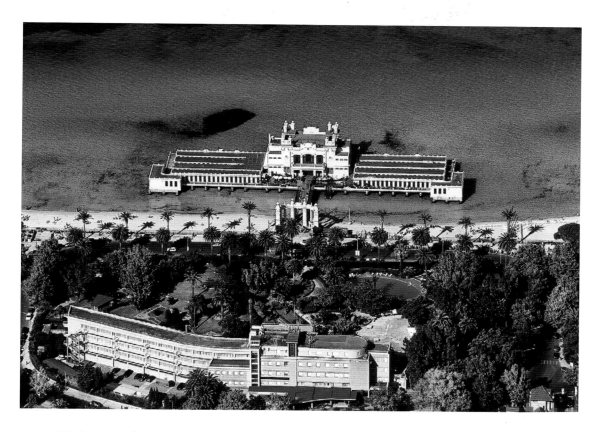

196 Mondello (Palermo), with its long, sandy beach, has been a firm favorite with generations of Palermo locals since its creation almost a century ago, achieved by a scheme undertaken by an Italo-Belgian company to reclaim a malaria-ridden area.

197 Mondello's lovely Stabilimento Balneare private beach, a fully-operational gem of Art Nouveau architecture, also dates back to the 1900s. Unlike all of the other bathing establishments opened at the time, this one was not built on stilts, but set on reinforced concrete, an innovative material for the period.

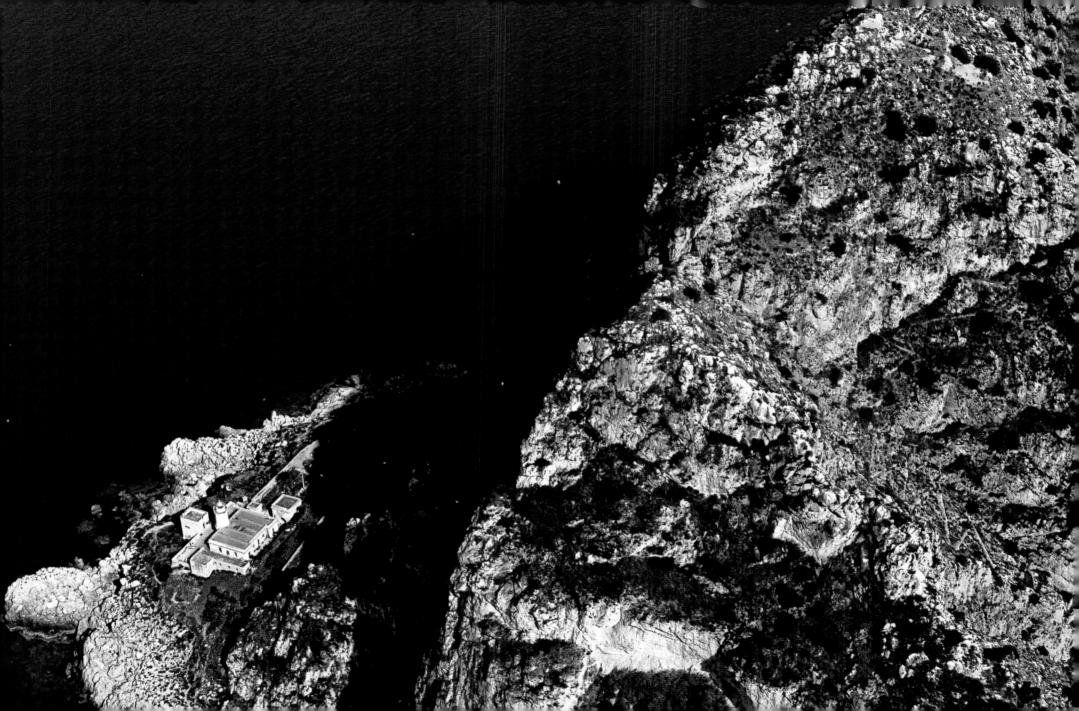

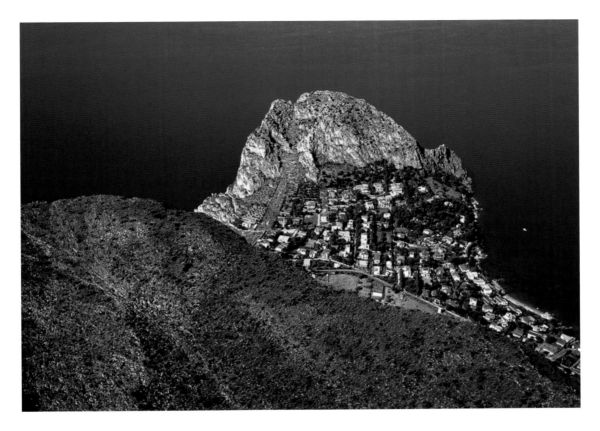

198 The lighthouse at Capo Zafferano, near Bagheria (Palermo), has a massive look to it, and is connected to the mainland by a strip of land. Above the cape there are the remains of a tower.

199 Sicily's Tyrrhenian coast is more jagged than the southern shore. While the southern coast comprises mainly long, low beaches of very fine sand, the northern coast is more rugged, with rapid promontories reaching out into the waters, like at Porticello (Palermo). Nonetheless, human presence is constant, as witnessed by the seafaring towns built here, some dating back to remote eras.

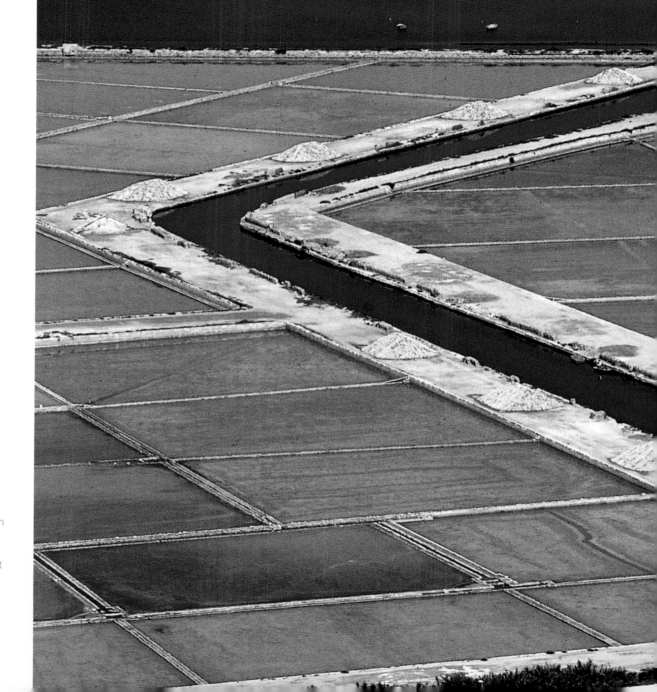

200-201 Extracting salt from seawater is a long and difficult operation, still performed with patience, mainly by hand, by the salt-pan workers. The pans stretch for tens of acres along the coast from Trapani to Marsala, and it is still possible to see the ancient windmills once used to perform some of the more intricate operations, like salt grinding.

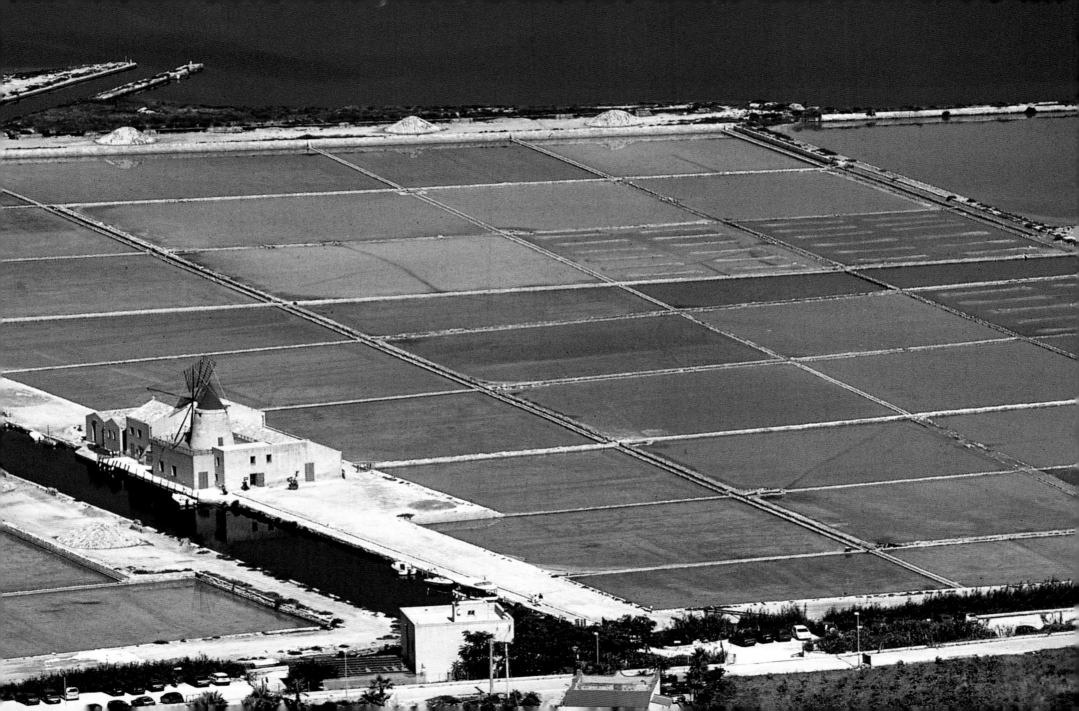

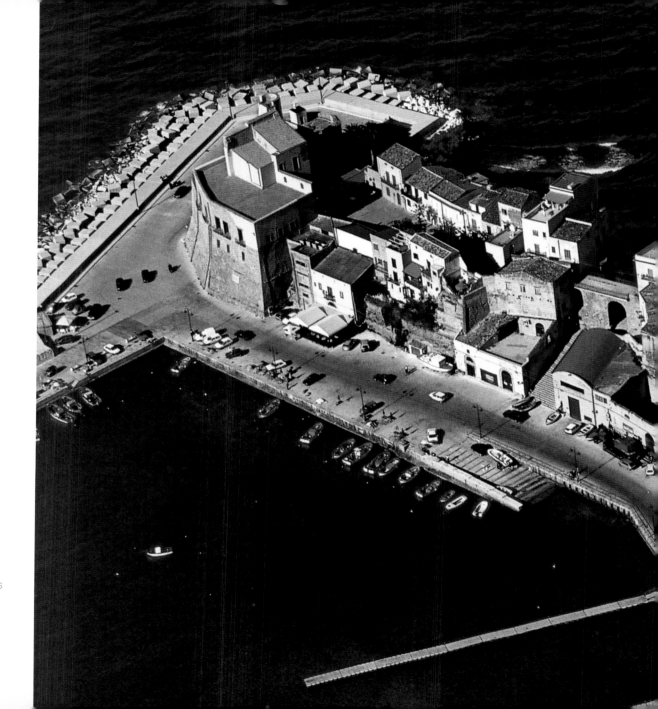

202-203 Castellammare del Golfo (Trapani) was built in the mists of time as a port for nearby Segesta. The fortification that gives it is name – and which can still be seen on a lick of land reaching out into the sea –was built precisely to protect the port activities.

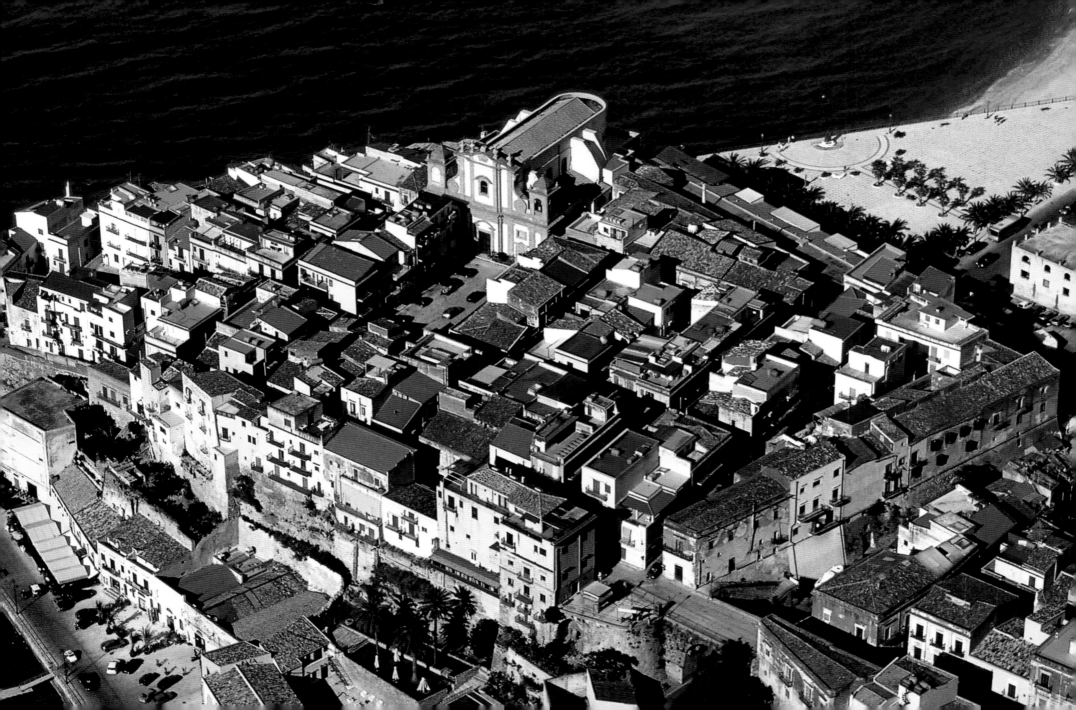

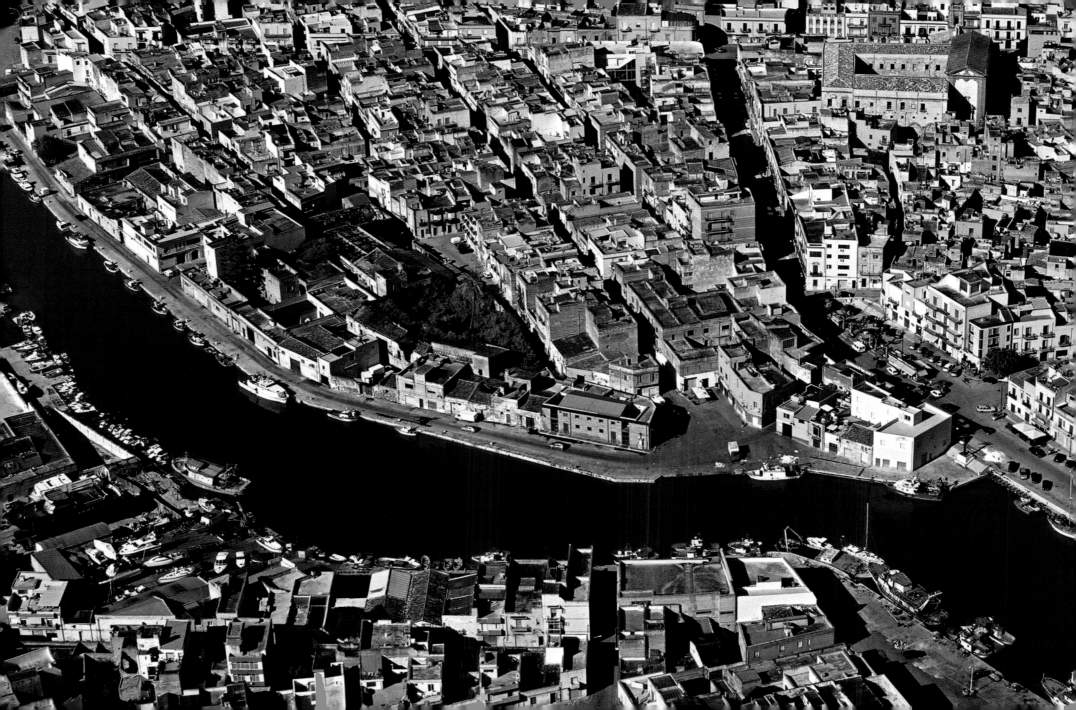

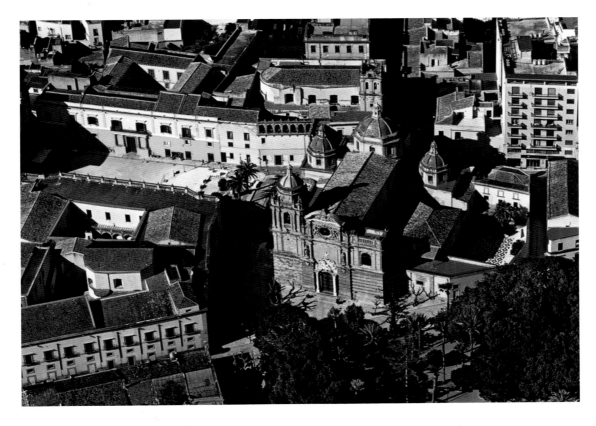

204 What is now Mazara del Vallo (Trapani) was, in the 9th century, a small village: its inhabitants were the first witnesses to the landing of the Saracen army that in just a few years went on to conquer Sicily. Mazara is now the island's most "Arab" town, with its own kasbah and a numerous Maghrebine community. It also boasts Italy's biggest fishing fleet. The canal harbor is a very busy place.

205 Mazara del Vallo cathedral was built in 1093 by Count Roger de Hauteville, to honor a vow he made during the 1072 battle against the Saracens, and rebuilt in 1600, when the bulky Baroque belfry was added. The façade was not completed until 1906.

206-207 Marsala (Trapani), an elegant town with a pleasing old center, is famous for its fortified wine, produced here since the late 1700s, and for the landing by Garibaldi and his Thousand Men. However, it also has many interesting monuments and museums, including the site that exhibits the only authentic Punic ship to have reached modern times virtually intact.

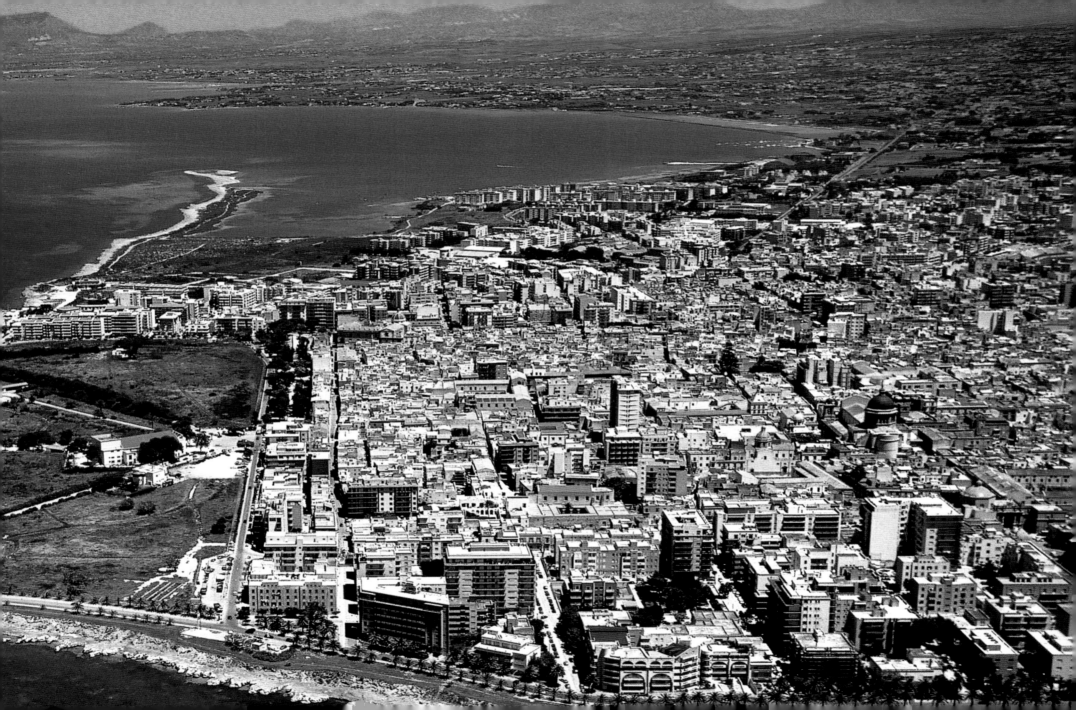

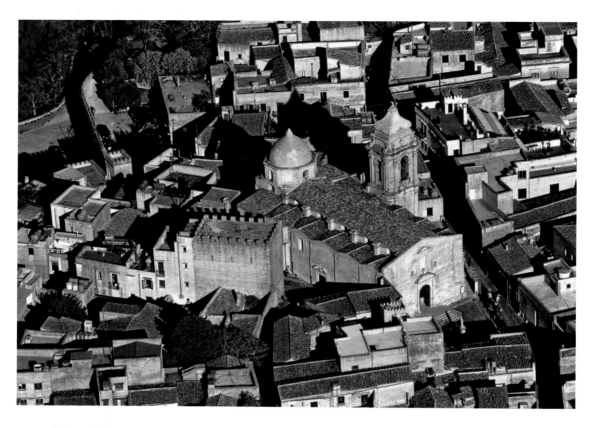

208 and 209 On the peak of a solitary mountain, on Sicily's western tip, the small town of Erice is the successor of a very ancient settlement, built around a pagan temple that was greatly venerated. It has always been a spiritual place, where nuns and monks took up the positions left vacant by pagan priestesses, and where today stands in the same garb it wore in Medieval times, with its tiny stone houses, its churches and convents, cobbled streets and flowering courtyards. The photograph to the left shows the church of San Giuliano, founded by the Normans and rebuilt in the 13th century.

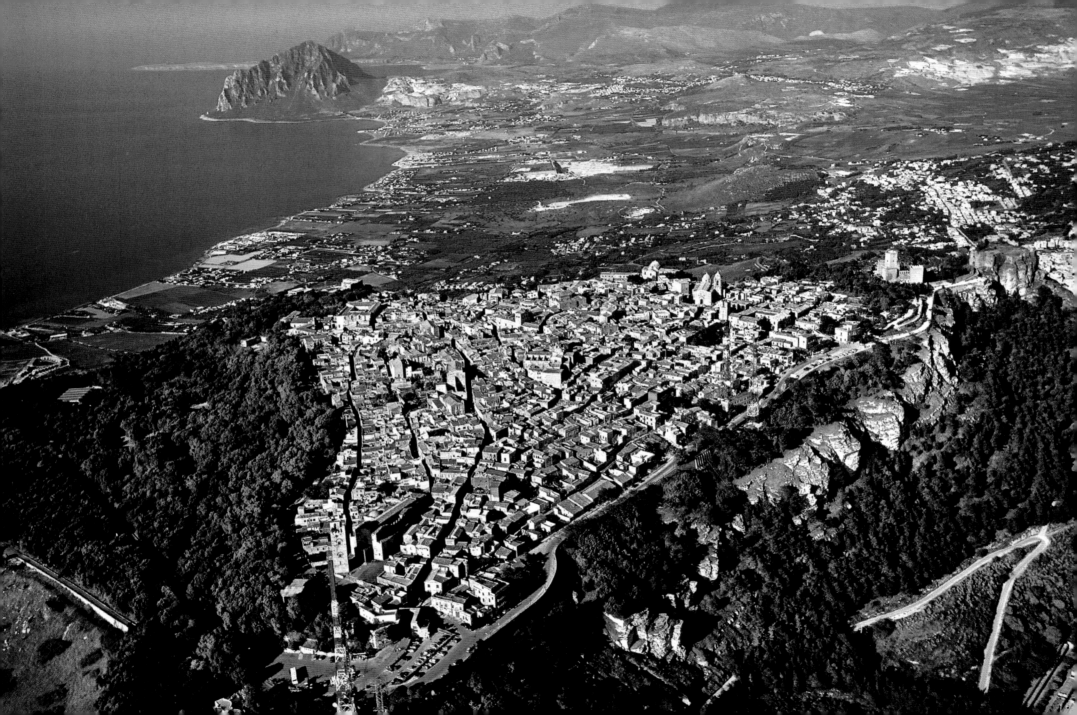

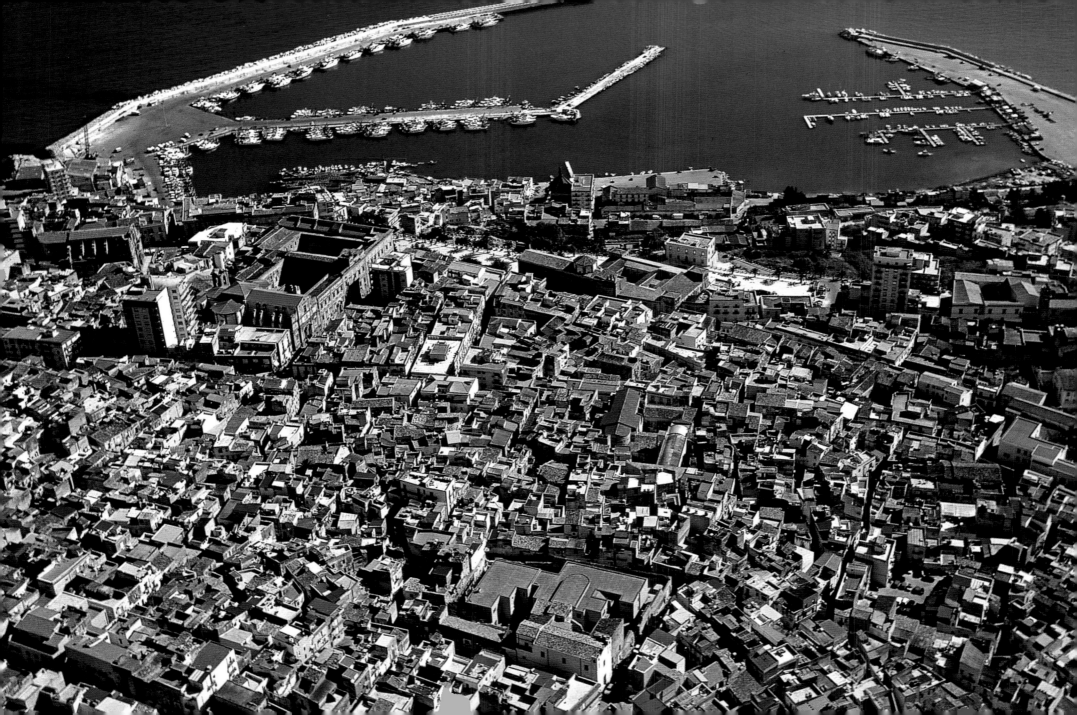

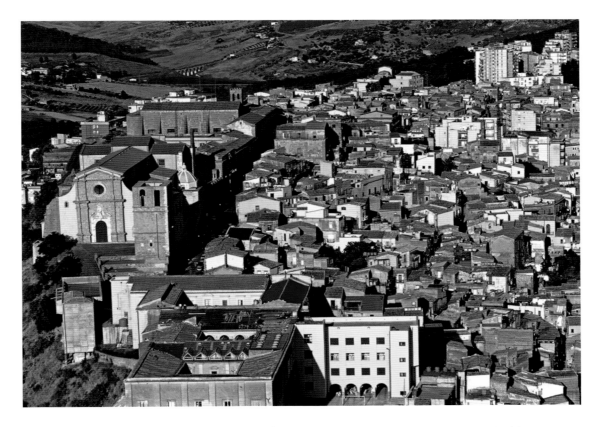

210 The distinctive town of Sciacca (Agrigento), in its picturesque position, with the buildings terraced down from the hilltop as far as the sea. Underground there are rich hydrothermal springs, exploited for therapeutic uses since ancient times.

211 Licata (Agrigento) is located on Sicily's southern coast, heavily colonized in ancient times by the Greeks, and the town is really the successor of a Hellenistic settlement. The first nucleus of today's town only dates back to the 13th century, however, and the most important monuments are from the 1700s.

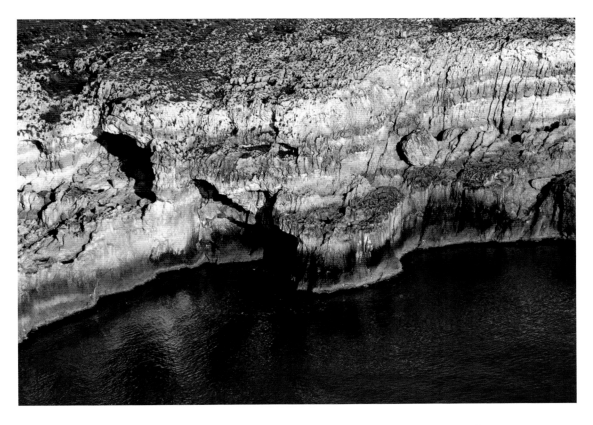

212 and 213 The Sicilian coasts, especially to the south, feature a great range of characteristics. In the space of very few kilometers we will pass from sandy beaches to tall, craggy shores to small coves with pebbles underfoot. Even the sea will reflect these differences, ranging from deep blue to turquoise, from sky-blue to bottle green.

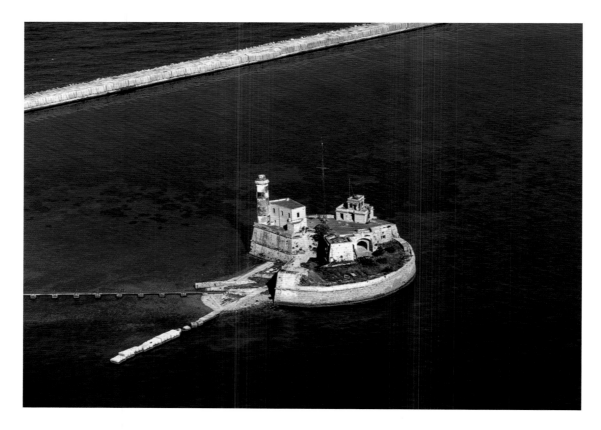

214 Augusta, in the province of Siracusa, was built by order of Frederick II in the 13th century, assigning to it an important function: the control and defense of Sicily's eastern coast.

215 Marzamemi (Siracusa), a popular seaside resort not far from Sicily's southernmost tip, was established as a maritime site (there was a very successful tuna processing plant active here, sadly now abandoned), around which the fishermen gradually installed their homes.

216-217 Legend has it that the stacks seen in the sea opposite Acitrezza (Catania) are really the enormous blocks of lava hurled by the cyclops Polyphemus at Odysseus to prevent him escaping. The stretch of sea where they are located is now a marine reserve.

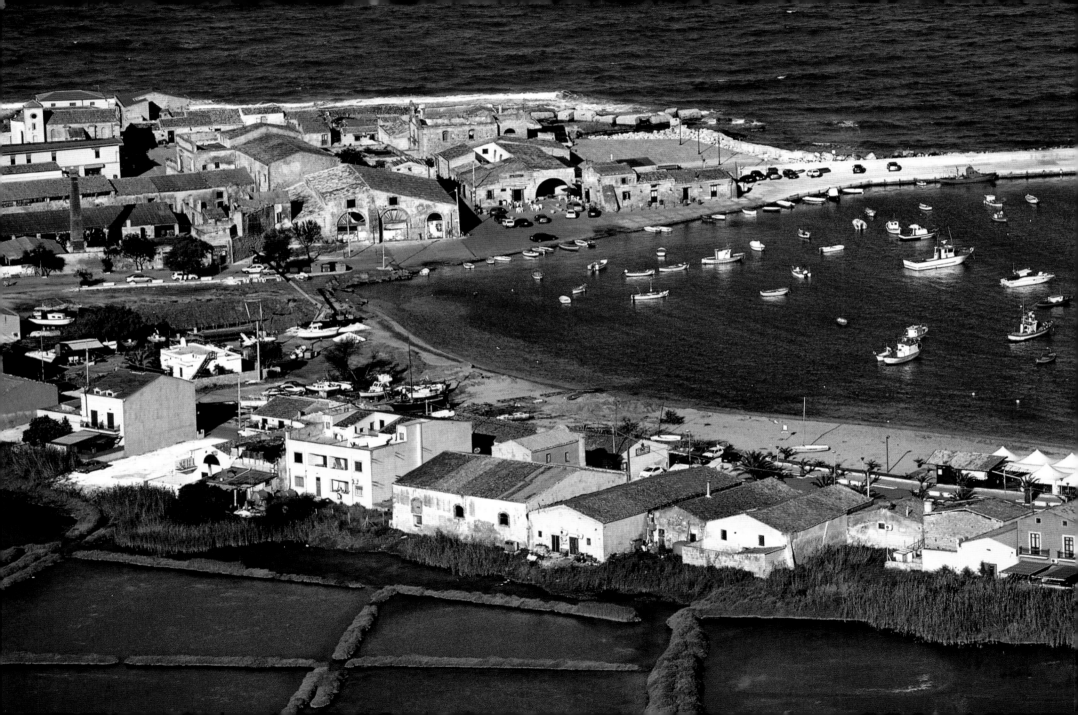

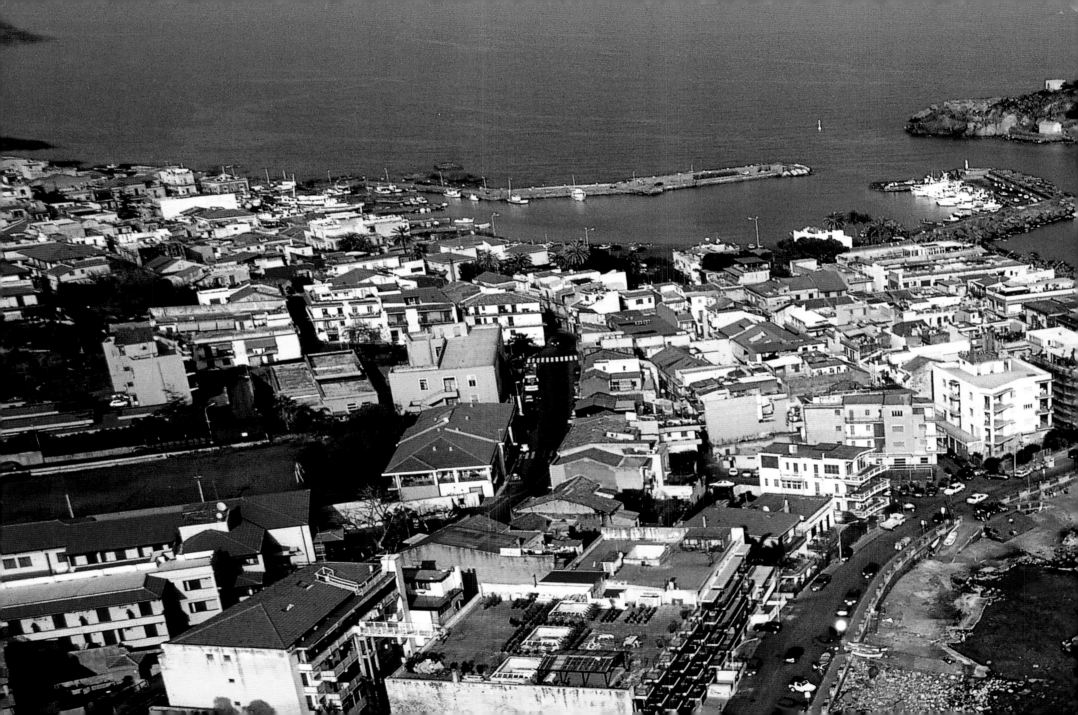

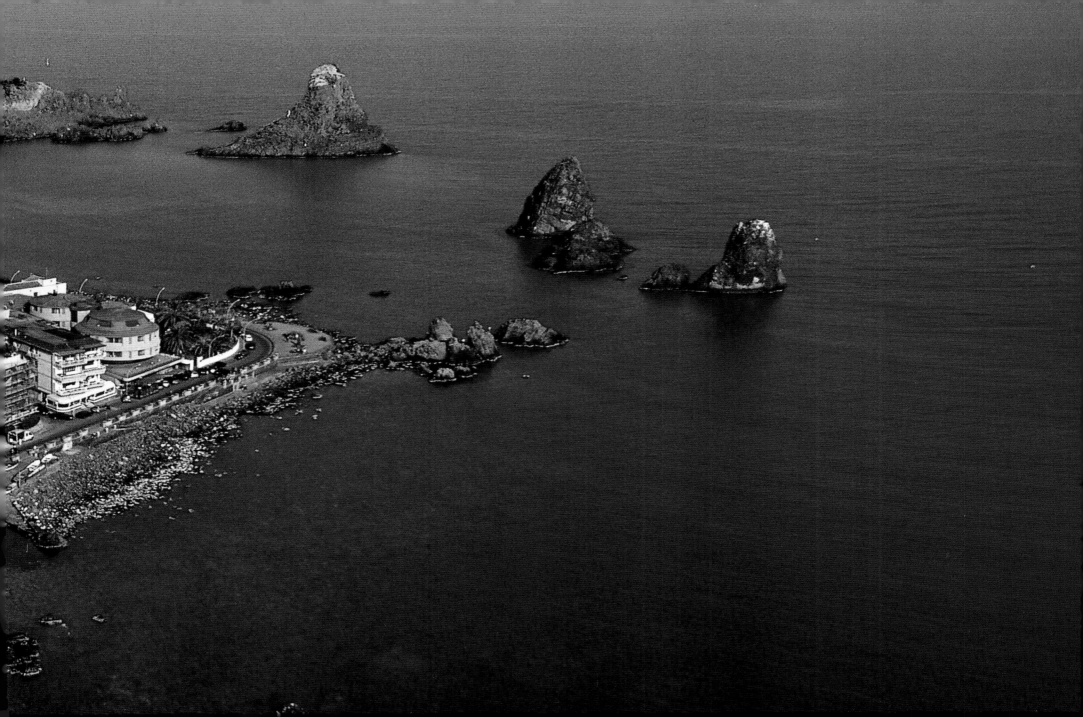

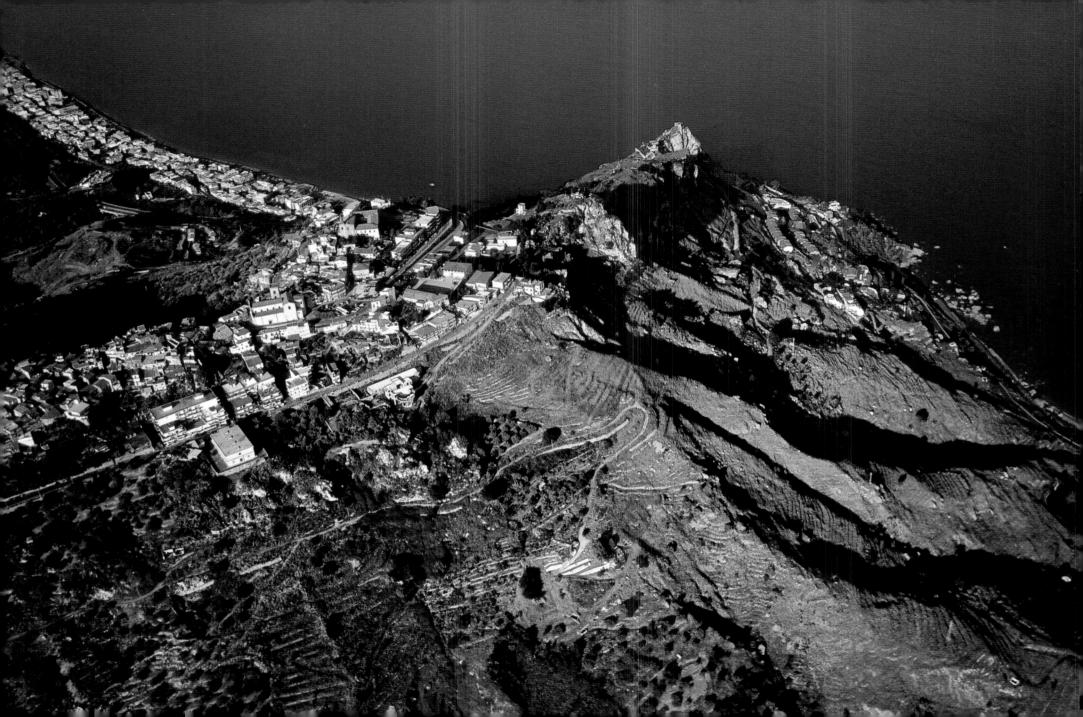

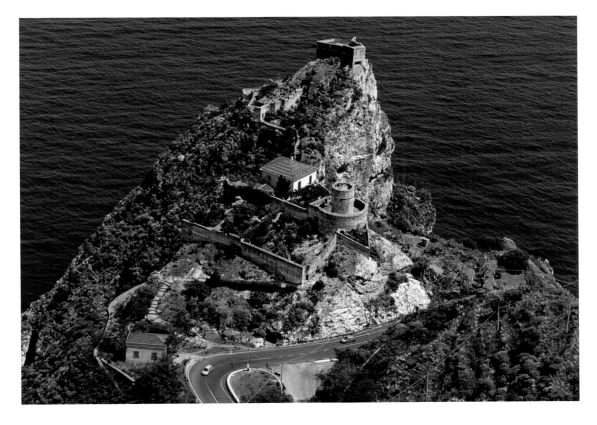

218 and 219 Forza d'Agrò, an ancient territory between Messina and Catania, is famous not only for its position, set on a sheer above the sea, but also for its Norman castle (image to the right), which legend attributes to the great Count Roger, said to have ordered its building between the 11th and 12th centuries. Nowadays it has almost 1,000 residents, of whom about 600 are in the center and the others live in the Scifi district. The provincial capital is Messina, about 42km away, whilst the more famous Taormina dominates just 15km away. The image to the left allows a glimpse of the prestigious duomo, where several scenes from "The Godfather" were filmed.

220 and 221 Beneath the promontory that is the site of excavations of ancient Tindari and the venerated sanctuary of the Black Madonna (image to the right), there is a long beach that stretches its sandy strips out to sea: the effect of the wind and the current causes these strips to change shape and size, and within their edges small saltwater lakes form.

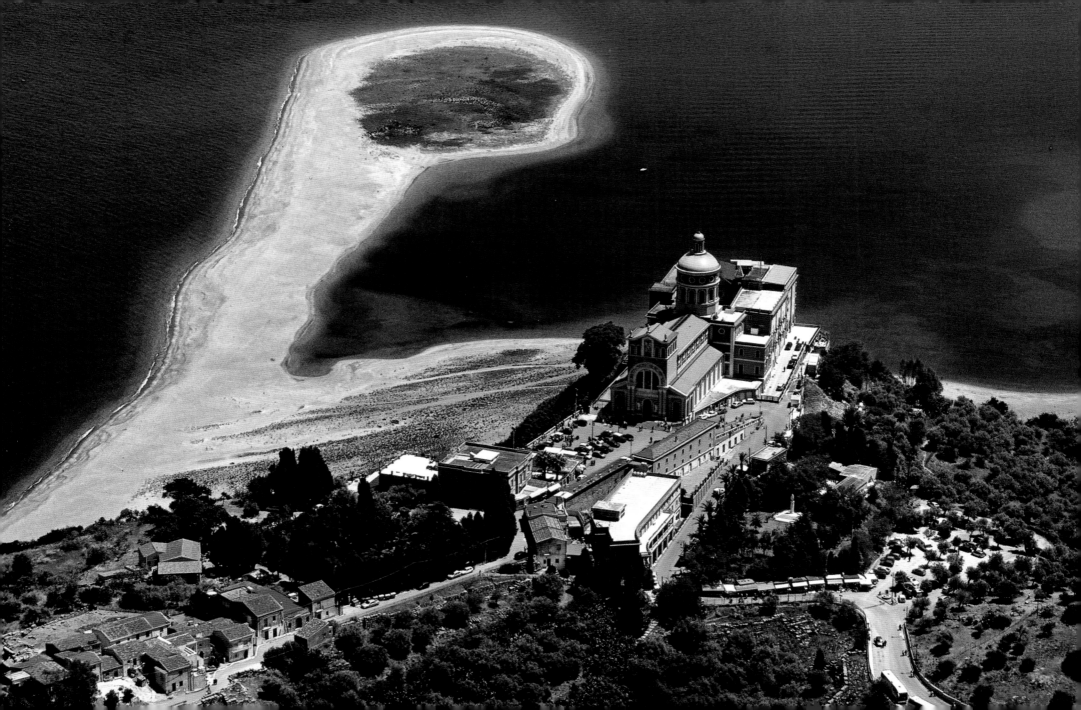

Index

Index

Credits:

All photographs are by Antonio Attini/Archivio White Star
except page 16: WorldSat International Inc.

Photographs
Antonio Attini

Text
Maria Cristina Castellucci

Editor
Valeria Manferto De Fabianis

The publisher would like to thank:
Elio Rullo of Volitalia

© 2007 White Star s.p.a.
Via Candido Sassone, 22/24
13100 Vercelli, Italy
www.whitestar.it

TRANSLATION: ANGELA MARIA ARNONE

ISBN-10: 88-544-0222-2
ISBN-13: 978-88-544-0222-5

REPRINTS:
1 2 3 4 5 6 11 10 09 08 07

Printed in China